VOX POPULI

VOX POPULI

The Perils & Promises of Populism

———

EDITED BY

Roger Kimball

ENCOUNTER BOOKS NEW YORK · LONDON

First American edition published in 2017 by Encounter Books,
an activity of Encounter for Culture and Education, Inc.,
a nonprofit, tax exempt corporation.
Encounter Books website address: www.encounterbooks.com

Manufactured in the United States and printed on
acid-free paper. The paper used in this publication meets
the minimum requirements of ANSI/NISO Z39.48–1992
(R 1997) (*Permanence of Paper*).

FIRST AMERICAN EDITION

LIBRARY OF CONGRESS CATALOGING-IN-PUBLICATION DATA IS AVAILABLE

Names: Kimball, Roger, 1953– editor.
Title: Vox populi : the perils and promises of populism / edited by Roger Kimball.
Other titles: Vox populi (Encounter Books)
Description: New York : Encounter Books, 2017. | Includes index.
Identifiers: LCCN 2017039035 (print) | LCCN 2017049412 (ebook)
ISBN 9781594039584 (Ebook) | ISBN 9781594039577 (hardback : alk. paper)
Subjects: LCSH: Populism. | Populism—United States.
Classification: LCC JC423 (ebook) | LCC JC423 .V68 2017 (print) | DDC 320.56/62–dc23
LC record available at https://lccn.loc.gov/2017039035

CONTENTS

Introduction *ix*

American Conservatism & the Problem of Populism I
 George H. Nash

Populares & Populists 27
 Barry Strauss

Insects of the Hour 43
 Daniel Hannan

The German Victory over American Populism 58
 Fred Siegel

A Bulwark Against Tyranny 81
 James Piereson

Populism versus Populism 97
 Andrew C. McCarthy

Representation & the People 119
 Roger Scruton

The Unlikeliest Populist 135
 Victor Davis Hanson

Avenue to Renovation 153
 Conrad Black

The Imperative of Freedom 171
 Roger Kimball

Contributors 191

Index 195

Introduction

The ten essays that comprise this book began life in *The New Cri-terion* throughout the course of our thirty-fifth anniversary season beginning in September 2016. We had already begun thinking about commissioning a series on populism when the world was stunned by the successful British referendum, in June 2016, to take Britain out of the European Union. In the United States, the effervescent presidential campaigns of Bernie Sanders and Donald Trump were, in their different ways, pushing the term "populism" to the forefront of public debate and, indeed, public anxiety. In continental Europe, kindred phenomena had focused public attention on a wide variety of figures and movements that were hailed or dismissed as "populist."

Still, I don't suppose that there is any term that has instilled more confusion over the last couple of years than "populism." In many ways, it is a word in search of a definition. For many people, "pop-ulism" is like the term "fascism" as George Orwell saw it: a handy negative epithet, a weapon, whose very lack of semantic precision is one of its chief attractions. Anything or anyone you don't like can be effectively impugned if you manage deploy the F word and get it to stick. But what does it mean? Ninety-nine times out of a hundred it means little more than "I don't like this person or this policy."

Connoisseurs of cant will have noticed that the term "racism" has a similar all-purpose, content-free aura of malignity, but exploring that malodorous development is a topic for another day.

When it comes to understanding populism, history can be as confusing as it is illuminating because many of the standard historical examples one encounters have but a tenuous connection with what is today denominated as "populist." Most surveys of the subject start with Tiberius and Gaius Gracchus, the Roman Tribunes who in the late Republic agitated for land reform and grain allotments for the poor. As Barry Strauss reminds us in "Populares and Populists" below, they also introduced mob violence to the metabolism of Roman political life and were, a decade apart, murdered, in the case of Tiberius, or driven to suicide, as for Gaius, by their patrician opponents.

But what lessons do the Gracchi brothers, or later Roman populists like Gaius Marius or Julius Caesar, have to tell us about the signal populist movements of our own day? Doubtless, they offer a salutary admonition, but, at least in the United Kingdom and the United States, any supposed parallels seem tenuous. I would extend that epistemic stinginess to more modern allotropes of populism like Huey Long and Father Coughlin, two other figures who make at least cameo appearances whenever populism is the topic du jour.

It is often said that "populism" is "anti-elitist," but again, when it comes to phenomena like Brexit or the election of Donald Trump, I am not sure that the effective opposition is between *elites*, on the one hand, and us common folk, on the other. Often, I believe, the putative "elites" turn out not to be particularly "elite" or elevated, merely to be possessed through no virtue of their own of an abundance of state power.

My own feeling is that most contemporary examples of what are called "populist" movements are at bottom movements to force the question "Who rules?" Populism, in this understanding, is primarily

about the question of sovereignty. I am convinced that the issue of sovereignty, of what I call in my concluding essay in this volume the *location* of sovereignty, has played a large role in the rise of the phenomenon we describe as "populism" in the United States as well as in Europe. For one thing, the question of sovereignty, of who governs, stands behind the rebellion against the political correctness and moral meddlesomeness that are such conspicuous and disfiguring features of our increasingly bureaucratic society.

The issue of sovereignty also stands behind the debates over the relative advantages and moral weather of "globalism" vs. "nationalism," as well as the correlative economic issues of underemployment and wage stagnation. Those whom James Madison castigated as "theoretic" politicians may advocate "globalism" as a necessary condition for free trade. But the spirit of local control tempers the cosmopolitan project of a borderless world with a recognition that the nation state has been the best guarantor not only of sovereignty but also of broadly shared prosperity. What we might call the ideology of free trade—the globalist aspiration to transcend the impediments of national identity and control—came to seem to its critics an abstraction that principally benefits its architects.

Below, I quote Edmund Burke's 1770 essay *Thoughts on the Cause of the Present Discontents* on the Court of George III. Burke criticized the Court party of his day for circumventing Parliament and establishing by stealth what amounted to a new regime of royal prerogative and influence-peddling. It was not as patent as the swaggering courts of James I or Charles I. George and his courtiers maintained the *appearance* of parliamentary supremacy. But a closer look showed that the system was corrupt. "It was soon discovered," Burke wrote with sly understatement, "that the forms of a free, and the ends of an arbitrary Government were things not altogether incompatible." That discovery stands behind the growth of today's administrative

state. Under the cloak of democratic institutions, its essentially un-democratic activities pursue an expansionist agenda that threatens liberty in the most comprehensive way, by circumventing the law.

At the same time, however, a growing recognition of the totalitarian goals of the administrative state has fed what many have called a populist uprising here and in Europe. "Populist" is one word for the phenomenon. An affirmation of sovereignty, underwritten by a passion for freedom, is another, possibly more accurate, phrase.

Obtaining a fuller, more historically informed understanding of that passion is the common aim of the essays collected in this volume.

RK

October 2017

GEORGE H. NASH

====

American Conservatism and the Problem of Populism

For more than a decade the air has been filled with assertions that American conservatism is in terminal disarray—exhausted, fractured, and no longer capable of governing. The spectacular populist insurgency of 2015–16 appears to many observers to mark the demise of an intellectual and political establishment that has outlived its time.

Is this true? Before we can properly assess conservatism's present predicament, we first need to understand how the present came to be. I propose to do this through the lens of the intellectual history of American conservatism after the Second World War, when the conservative community as we know it took form.

Perhaps the most important fact to assimilate about modern American conservatism is that it is not, and has never been, monolithic. It is a coalition—a coalition built on ideas—with many points of origin and diverse tendencies that are not always easy to reconcile.

In 1945, at the close of World War II, no articulate, coordinated conservative intellectual force existed in the United States. There were, at most, scattered voices of protest, some of them profoundly pessimistic about the future of their country and convinced that

they were an isolated Nockian Remnant on the wrong side of history. History, in fact, seemed to be what the Left was making. The Left—liberals, socialists, even Communists—appeared to be in complete control of the twentieth century.

In the beginning, in the aftermath of the war, there was not one right-wing renaissance but three, each reacting in different ways to challenge from the Left. The first of these groupings consisted of classical liberals and libertarians, resisting the threat of the ever-expanding, collectivist State to individual liberty. Convinced in the 1940s that post–New Deal America was rapidly drifting toward central planning and socialism—along what the economist Friedrich Hayek famously called "the road to serfdom"—these intellectuals offered a powerful defense of free-market economics. From scholars like Hayek and Ludwig von Mises in the 1940s and 1950s, to Milton Friedman and the Chicago School economists in the 1960s and 1970s, to Arthur Laffer, George Gilder, Robert Bartley, and the supply-side economists and publicists of the 1980s, and to thinkers like Thomas Sowell and Richard Epstein today, the classical liberal and libertarian conservatives produced a sophisticated defense of free-market economics and exerted an enormous influence over the American Right. They helped to make the old verities defensible again after the long nightmare of the Great Depression, which many people had seen as a failure of capitalism.

In the 1980s the Reagan administration's policies of tax-rate cutting, deregulation, and encouragement of private sector economic growth were the direct product of this rich intellectual legacy. More recently, the Republican Party's agenda for tax-cutting can be traced intellectually to the supply-side orthodoxy that captured that party during the Reagan era and remained ascendant for the next thirty years.

Much of the classical liberal perspective was enunciated in powerful books, such as Hayek's polemic *The Road to Serfdom* (1944), a

book now recognized as one of the most influential works published in the twentieth century. On a more popular level, the libertarian novels of Ayn Rand shaped the minds of many, including the current Speaker of the House, Paul Ryan.

Concurrently, and independently of the libertarians and classical liberals, a second school of anti-modern-liberal thought emerged in America shortly after World War II: the so-called "traditionalism" of such writers as Richard Weaver, Peter Viereck, Robert Nisbet, and Russell Kirk. Appalled by totalitarianism, total war, and the development of secular, rootless, mass society during the 1930s and 1940s, the traditionalists (as they came to be called) urged a return to traditional religious and ethical absolutes and a rejection of the moral relativism that in their view had corroded Western civilization and produced an intolerable vacuum filled by demonic ideologies on the march. More European-oriented and historically minded, on the whole, than the classical liberals, and less interested in economics, the traditionalist conservatives extolled the wisdom of such thinkers as Edmund Burke, Alexis de Tocqueville, and T. S. Eliot, and called for a revival of religious orthodoxy, of classical natural law teaching, and of mediating, communitarian institutions between the solitary citizen and the omnipotent State. Why did they advocate this? In order, they said, to reclaim and civilize the spiritual wasteland created by secular liberalism and by the false gods it had permitted to enter the gates.

In provocative books like Richard Weaver's *Ideas Have Consequences* (1948), the traditionalists expounded a vision of a healthy and virtuous society antithetical to the tenets of contemporary liberalism. From Russell Kirk's monumental tome *The Conservative Mind* (1953), the traditionalists acquired something more: an intellectual genealogy and intellectual respectability. After Kirk's book appeared, no longer could contemporary conservatives be dismissed, as John Stuart Mill had dismissed British conservatives a century before, as "the

stupid party." In books like *The Conservative Mind* the highbrow academics of the 1950s struck a blow at the liberals' superiority complex and breached the wall of liberal condescension.

More than any other single book, *The Conservative Mind* stimulated the emergence of a self-consciously conservative intellectual movement in the early years of the Cold War. Without Kirk's fortifying book the conservative intellectual community of the past three generations might never have acquired its distinctive identity or its name.

Third, there appeared in the 1940s and 1950s, at the onset of the Cold War, a militant, evangelistic anticommunism, shaped by a number of ex-Communists and other ex-radicals of the 1930s, including the iconic Whittaker Chambers. It was also reinforced by exiled anticommunist scholars from eastern and central Europe. These former men and women of the far Left and their allies brought to the postwar American Right a profound conviction that America and the West were engaged in a titanic struggle with an implacable adversary—Communism—which sought nothing less than the conquest of the world.

Each of these emerging components of the conservative revival shared a deep antipathy to twentieth-century liberalism. To the libertarians, modern liberalism—the liberalism of Franklin Roosevelt and his successors—was the ideology of the ever-aggrandizing, bureaucratic, welfare state, which would, if unchecked, become a collectivist, totalitarian state, destroying individual liberty and the private sphere of life. To the traditionalists, modern liberalism was inherently a corrosive philosophy, which was eating away like an acid not only at our liberties but also at the moral and religious foundations of a healthy, traditional society, thereby creating a vast spiritual vacuum into which totalitarianism could enter. To the Cold War anticommunists, modern liberalism—rationalistic, relativistic, secular, anti-traditional, and quasi-socialist—

was by its very nature incapable of vigorously resisting an enemy on its left. Liberalism to them was *part* of the Left and could not, therefore, effectively repulse a foe with which it shared so many underlying assumptions. As the conservative Cold War strategist James Burnham eventually and trenchantly put it, liberalism was essentially a means for reconciling the West to its own destruction. Liberalism, he said, was the ideology of Western suicide.

In the late 1950s and early 1960s the three independent wings of the conservative revolt against the Left began to coalesce around *National Review*, founded by William F. Buckley Jr. in 1955. Apart from his extraordinary talents as a writer, debater, and public intellectual, Buckley personified each impulse in the developing coalition. He was at once a traditional Christian, a defender of the free market, and a staunch anticommunist (a source of his ecumenical appeal to conservatives).

As this consolidation began to occur, a serious challenge arose to the fragile conservative identity: a growing and permanent tension between the libertarians and the traditionalists. To the libertarians the highest good in society was individual liberty, the emancipation of the autonomous self from external (especially governmental) restraint. To the traditionalists (who tended to be more religiously oriented than most libertarians) the highest social good was not unqualified freedom but *ordered* freedom grounded in community and resting on the cultivation of virtue in the individual soul. Such cultivation, argued the traditionalists, did not arise spontaneously. It needed the reinforcement of mediating institutions (such as schools, churches, and synagogues) and at times of the government itself. To put it another way, libertarians tended to believe in the beneficence of an uncoerced social order, both in markets and morals. The traditionalists often agreed, more or less, about the market order (as opposed to statism), but they were far less sanguine about an unregulated moral order.

Not surprisingly, this conflict of visions generated a tremendous controversy on the American Right in the early 1960s, as conservative intellectuals attempted to sort out their first principles. The argument became known as the freedom-versus-virtue debate. It fell to a former Communist and chief ideologist at *National Review*, a man named Frank Meyer, to formulate a middle way that became known as fusionism—that is, a fusing or merging of the competing paradigms of the libertarians and the traditionalists. In brief, Meyer argued that the overriding purpose of government was to protect and promote individual liberty, but that the supreme purpose of the free individual should be to pursue a life of virtue, unfettered by and unaided by the State.

As a purely theoretical construct, Meyer's fusionism did not convince all his critics, then or later. But as a formula for political action and as an insight into the actual character of American conservatism, his project was a considerable success. He taught libertarian and traditionalist purists that they needed one another and that American conservatism must not become doctrinaire. To be relevant and influential, it must stand neither for dogmatic antistatism at one extreme nor for moral authoritarianism at the other, but for a society in which people are simultaneously free to choose *and* desirous of choosing the path of virtue.

In arriving at this modus vivendi, the architects of fusionism were aided immensely by the third element in the developing coalition: anticommunism, an ideology that nearly everyone could share. The presence in the world of a dangerous external enemy—the Soviet Union, the mortal foe of liberty *and* virtue, of freedom *and* faith—was a crucial, unifying cement for the nascent conservative movement. The life-and-death stakes of the Cold War helped to curb the temptation of right-wing ideologues to absolutize their competing insights and thereby commit heresy.

Politically, the postwar, Buckleyite Right found its first national

expression in the campaign of Senator Barry Goldwater for the presidency of the United States in 1964. It was not long after that election that a new impulse appeared on the intellectual scene, one destined to become the fourth component of the conservative coalition: the phenomenon known as neoconservatism. Irving Kristol's definition conveys its original essence: "A neoconservative," he said, "is a liberal who has been mugged by reality." One of the salient developments of the late 1960s and 1970s was the intellectual journey of various liberals and social democrats toward conservative positions and affiliations. Their migration was manifested in such journals as *The Public Interest*, co-edited by Kristol, and the magazine *Commentary*, edited by Norman Podhoretz. By the early 1980s many of these neoconservatives (as they came to be labeled) were participating in the "Reagan Revolution."

The stresses that produced this transition were many. In part, neoconservatism may be interpreted as the recognition by former liberals that good intentions alone do not guarantee good governmental policy and that the actual consequences of liberal social activism in the Sixties and Seventies, like the so-called War on Poverty, were often devastating. In considerable measure neoconservatism was also a reaction by moderate liberals to the cultural upheavals of the 1960s, particularly on college campuses, and to the eruption of the so-called New Left, with its tendency to blame America first for world tensions and its neoisolationist opposition to a vigorous prosecution of the Cold War.

To the already existing conservative community, the entry of chastened liberals and disillusioned socialists into its precincts was to have many consequences. One of these was already discernible in the 1970s. Since the days of the New Deal, American liberals had held a near monopoly on the manufacture and distribution of prestige among the intellectual classes. From a liberal perspective the libertarian, traditionalist, and Cold War conservatives of the 1950s

and 1960s—the Buckleyites, if you will—were eccentric and marginal figures, no threat to liberalism's cultural hegemony. The emerging neoconservatives, however, were an "enemy within" the liberal camp who had made their reputations while still on the Left and who could not therefore be so easily dismissed. By publicly defecting from the Left, and then by critiquing it so effectively, the neoconservatives helped to undermine a hitherto unshakable assumption in academic circles: the belief that only liberalism is an intellectually respectable point of view. By destroying the automatic equation of liberalism with intelligence, and of progressivism with progress, the neoconservative intellectuals brought new respectability to the Right and greatly altered the terms of public debate in the United States.

Meanwhile another development—one destined to have enormous political consequences—began to take shape in the late 1970s: the grassroots "great awakening" of what came to be known as the Religious Right or (more recently) social conservatives. Initially the Religious Right was not primarily a movement of intellectuals at all. It was, rather, a groundswell of protest at the grassroots of America by "ordinary" citizens, many of them Protestant evangelicals, fundamentalists, and pentecostals, with some Roman Catholics and Orthodox Jews as well. While early Religious Right leaders generally shared the foreign policy and economic perspectives of other conservatives, their guiding preoccupations lay elsewhere, in what became known as the "social issues": pornography, drug use, the vulgarization of mass entertainment, and more. Convinced that American society was in a state of vertiginous moral decline, and that what they called secular humanism—in other words, modern liberalism—was the fundamental cause and agent of this decay, the populistic Religious Right exhorted its hitherto politically quiescent followers to enter the public arena as a defense measure, in defense of their traditional moral code and way of life. Above all,

the religious conservatives derived their fervor from an unremitting struggle against what most of them considered the supreme abomination of their time: legalized abortion on demand.

In time the Religious Right acquired intellectually influential voices, notably the journal *First Things*. It also gained strength from its organic ties to a growing, evangelical Protestant subculture and by forging an alliance with like-minded Roman Catholics and Orthodox Jews—a conservative ecumenical movement without precedent in American religious history.

By the end of President Ronald Reagan's second term in 1989, the American Right had grown to encompass five distinct impulses: libertarianism, traditionalism, anticommunism, neoconservatism, and the Religious Right. And just as Buckley had done for conservatives a generation before, so Reagan in the 1980s did the same: he performed an emblematic and ecumenical function—a fusionist function, giving each faction a seat at the table and a sense of having arrived.

Yet even as conservatives gradually escaped the wilderness for the promised land inside the Beltway, the world they wished to conquer was changing in ways that threatened their newfound power. Ask yourself this question: aside from conservatism, what have been the most important intellectual and social movements in America in the past forty years? As a historian I will give you my answer: feminism, environmentalism, and multiculturalism. Since the 1970s America has been moving Right *and* Left at the same time.

Next, ask yourself this: what has been the most historically significant date in our lifetime? September 11, 2001? Perhaps. But surely the other such date was November 9, 1989, the night that the Berlin Wall came down.

Since 1989, since the downfall of Communism in Europe and the end of what Ronald Reagan called the "evil empire," one of the hallmarks of conservative history has been the reappearance of factional

strains in the grand alliance. One source of rancor has been the ongoing dispute between the neoconservatives and their noninterventionist critics over post-Cold War foreign policy. Another fault line divides many libertarians and social conservatives over such issues as the legalization of drugs and same-sex marriage.

Aside from these built-in philosophical tensions, with some of which the conservative coalition has been living for a long time, two fundamental facts of political life explain the recrudescence of these intramural debates in recent years. The first is what we may call the perils of prosperity. In the 1950s and early 1960s the number of publicly active, self-identified conservative intellectuals in the United States was minuscule: perhaps a few dozen at most. Today how can we even begin to count? Since 1980 prosperity has come to conservatism, and with it a multitude of niche markets and specialization on a thousand fronts. But with prosperity have also come sibling rivalry, tribalism, and a weakening of "movement consciousness," as various elements in the coalition pursue their separate agendas. The "vast right-wing conspiracy" (as Hillary Clinton has called it) has grown too large for any single institution or magazine, like *National Review* in its early days, to serve as the movement's gatekeeper and general staff. No longer does American conservatism have a commanding, ecumenical figure like Buckley or Reagan.

Underlying these centrifugal impulses is a phenomenon that did not exist twenty-five years ago: what Charles Krauthammer recently called the "hyperdemocracy" of social media. In the ever-expanding universe of cyberspace, no one can be an effective gatekeeper because *there are no gates.*

The second fundamental fact of political life that explains the renewal of friction on the Right was the stunning end of the Cold War in the 1990s. Inevitably, the question then arose: could a movement so identified with anticommunism survive the disappearance of the Communist adversary in the Kremlin? Without a common

foe upon whom to concentrate their minds, it has become easier for former allies on the Right to succumb to the bane of all coalitions: the sectarian temptation. It is an indulgence made infinitely easier by the internet.

The conservative intellectual movement, of course, did not vanish in the 1990s. Nevertheless, it is undeniable that unyielding anticommunism supplied much of the glue in the post-1945 conservative coalition and that the demise of Communism in Europe weakened the fusionist imperative for American conservatives.

One of the earliest signs of this was the rise in the 1980s and early 1990s of a group of conservative traditionalists who took the label "paleoconservatives." Initially, paleoconservatism was a response to the growing prominence within conservative ranks of the erstwhile liberals and social democrats known as neoconservatives. To angry paleocons, led by Patrick Buchanan among others, the neocons were "interlopers" who, despite their recent movement to the Right, remained at heart secular, crusading Wilsonians and believers in the welfare state. In other words, the paleos argued, not true conservatives at all.

As the Cold War faded, paleoconservatism introduced a discordant note into the conservative conversation. Fiercely and defiantly "nationalist" (rather than "internationalist"), skeptical of "global democracy" and post–Cold War entanglements overseas, fearful of the impact of Third World immigration on America's historically Europe-centered culture, and openly critical of the doctrine of global free trade, Buchananite paleoconservatism increasingly resembled much of the American Right *before* 1945—before, that is, the onset of the Cold War. When Buchanan himself campaigned for president in 1992 under the pre–World War II, isolationist banner of "America First," the symbolism seemed deliberate and complete.

Despite the initial furor surrounding the paleoconservatives, they have remained a relatively small faction within the conservative

community of discourse. Still, as the post–Cold War epoch settled in during the Nineties and beyond, they were not alone among conservatives in searching for new sources of unity—a new fusionism, as it were, for a new era. Thus the first term of President William Clinton saw the rise of the "Leave us Alone" coalition, united in its detestation of intrusive government in the form of higher taxes, Hillary Clinton's health care plan, and gun control. Not long thereafter a number of "second generation" neoconservatives associated with *The Weekly Standard* issued a plea for a new conservatism of "national greatness," an adumbration of the muscular foreign policy of George W. Bush. Bush himself, before he became president, championed what he called "compassionate conservatism," in part a deliberate rebuke of the antistatist thrust of the Leave Us Alone movement. For a time after the trauma of 9/11, the global war on terrorism became for most conservatives the functional equivalent of the late Cold War against Communism.

Meanwhile social conservatives have waged a long and increasingly frustrating "culture war" against a postmodern, post-Christian, even anti-Christian secular elite whom they perceive to be aggressively hostile to their deepest convictions. More recently there has been much discussion of "constitutional conservatism," "reform conservatism," "crunchy" conservatism, and "American Exceptionalism," among other formulations of what conservatives should stand for in a new age.

American conservatism, then, remains at heart a coalition. Like all coalitions, it contains within itself the potential for splintering—and never more so than right now.

For as the Cold War and its familiar polarities continue to recede from public memory, new challenges and conflicts have been filling the vacuum. Consider this datum: more people are now on the move in the world than at any time in the history of the human race, and more and more of them are making America their desti-

nation. The number of international students, for instance, attending American colleges and universities now exceeds one million per year—more than triple what it was in 1980. More than 800,000 of these students are from China. In addition, the United States is now admitting a million immigrants into permanent, legal residence every year—more than any other nation in the world. And the number of *illegal* immigrants currently within America's borders is estimated as at least eleven million.

This unprecedented, worldwide intermingling, not just of goods and services but of *peoples and cultures*, is accelerating, with consequences (and concomitant trends) that we have barely begun to fathom. Among them: the rise in the past twenty years of a post-national, even anti-national, sensibility among our cosmopolitan, progressive elites and young people. Closely linked to these denationalizing tendencies is the now entrenched ideology of multiculturalism, with its relativistic celebration not of America's achievements and singularity but of its "diversity" defined in racial and ethnic terms. In precincts where "transnational progressivism" (as it has been called) holds sway, the very idea of a permanent and praiseworthy American identity seems increasingly passé if not slightly sinister.

Compounding conservative unease is another trend: a rising tide of amnesia about America's past and animating principles. According to a report by the Bradley Project on America's National Identity in 2008, "America is facing an identity crisis," brought on in part by the failure of the country's education system to impart an adequate knowledge of "our history and founding ideals" to the next generation. As a result, the Bradley study concluded, "America's memory appears to be slipping away." It seems no accident that Americans under thirty—the demographic most steeped in multiculturalism from grade school to graduate school—adhere less strongly as a group to the tenets of American Exceptionalism

than do any other segments of the population. For conservatives of a patriotic/nationalist inclination, it is a disconcerting development indeed.

This brings us to the phenomenon of the hour: insurgent populism on the Left and the Right. In its simplest terms, populism—defined as the revolt of ordinary people against overbearing and self-serving elites—has long existed in American politics. In its most familiar form, populism has been leftwing in its ideology, targeting bankers, wealthy capitalists, and corporations as villains—the "millionaires and billionaires" in Bernie Sanders's parlance. From Andrew Jackson's feud with the Second Bank of the United States to William Jennings Bryan's crusade against the gold standard, from Franklin Roosevelt's appeal to the "forgotten man at the bottom of the economic pyramid" in 1932 to the demagogic theatrics of Huey Long and Father Charles Coughlin (in his early days) during the Great Depression, populism has quite often been a leftwing phenomenon, vocalizing the anger of those at the bottom of the economic ladder toward those sitting pretty at the top.

But populism in America has sometimes taken a conservative form as well, particularly since 1945. In the early 1950s Senator Joseph McCarthy and his conservative allies denounced liberal Democratic politicians and pro–New Deal elites as dupes and even enablers of Communist espionage and subversion at home and of Communist aggrandizement abroad. In the 1960s William F. Buckley Jr. famously declared that he would rather be governed by the first 2,000 names in the Boston telephone directory than by the entire Harvard University faculty. In 1969 President Richard Nixon, under fire from a militant, leftwing antiwar movement during the Vietnam conflict, appealed on national television to the "great silent majority" of the American people to support him. Nixon's first vice president, Spiro Agnew, was more colorful. Taking aim at the antiwar Left—much of it based in and around the universities—he thundered: "A spirit

of national masochism prevails, encouraged by an effete corps of impudent snobs who characterize themselves as intellectuals." Criticism of an allegedly smug and decadent Liberal Establishment became a staple of conservative discourse in the 1960s and persisted long thereafter.

Populism, conservative-style, achieved its greatest success in the 1970s and 1980s under the leadership of Ronald Reagan, who brilliantly articulated a populistic, libertarian aversion to meddlesome and unaccountable government—an aversion long ingrained in the American psyche. Consider these words from Reagan's Farewell Address in 1989: "Ours is the first revolution in the history of mankind that truly reversed the course of government, and with three little words: We the people. 'We the people' tell the government what to do, it doesn't tell us. 'We the people' are the driver, the government is the car. And we decide where it should go, and by what route, and how fast." No conservative has ever said it better.

But notice the crucial distinction between these two manifestations of anti-elitism so long imbedded in our politics. Leftwing populism has traditionally aimed its fire at Big Money—the private-sector elite entrenched on Wall Street. Rightwing populism of the Reaganite variety has focused *its* wrath on Big Government—the public-sector elite ensconced in Washington (and its votaries in Academe). Leftwing populism was most popular in America when powerful financiers and captains of industry appeared to control the nation's destiny. Rightwing populism gained traction when the capitalist establishment was displaced by a competing establishment centered in the ever more bureaucratic and intrusive administrative state.

A few years ago, American conservatives experienced a revival of Reaganite, populistic fervor in the form of the Tea Party movement, with its slogan "Don't tread on me!" In some circles there has been a tendency to dismiss this phenomenon as either the artificial cre-

ation of rightwing billionaires or as the ugly expression of the racial anxieties of white people. The truth is more complicated. Rightly or wrongly, a powerful conviction has arisen among virtually all conservatives that public policy in the United States has in some profound sense gone off the rails since the Great Recession of 2008. Rightly or wrongly, conservatives of all persuasions increasingly believe that ours has become a government not *of* and *by* the people but only *for* the people: government by edict from above. The much criticized "inflexibility" of the political Right during the two terms of President Obama was a direct response to *its* perception of inflexibility and autocratic hubris on the political Left.

The great symbol of this for conservatives is the Affordable Care Act of 2010 and the manner in which it was enacted and implemented. At the time the bill was enacted, a CNN poll revealed that 59 percent of the American people opposed it, and only 39 percent supported it. It passed anyway, by a convoluted parliamentary procedure, on a bitterly divided, virtually party-line vote. No other comparably ambitious, federal economic or social legislation in the past one hundred years was enacted in this way, and the consequences for America's social fabric have been severe. If the polls in 2010 were accurate, the Affordable Care Act was passed *in willful defiance of the majority sentiment of the American people.* To understand the fury and ferment on the Right since Obama took office, historians must take into account this sobering fact.

The leftward lurch of the Obama administration—it soon transpired—was not the only source of Tea Party discontent. The populist-conservative revolt of 2009–10 quickly morphed into a bitter struggle, not only against the perceived external threat from the Left, but also against a perceived *internal* threat from the conservative movement's imperfect vehicle, the Republican Party. Despite massive Republican victories in the Congressional elections of 2010 and 2014, many Tea Party populists felt frustrated and betrayed by

what they saw as the inability and, even worse, the unwillingness, of elected Republican officials in Washington to fight effectively for the conservative agenda. Many at the grassroots—encouraged by populist sympathizers on talk radio—began to suspect that some of their elected leaders were not merely craven or inept but essentially on the other side, particularly on the question of dealing with illegal immigration. The mounting anger of "grassroots" conservatives— often derided by their critics as rubes and nativists—became part of the tinder for the firestorm that was about to occur.

By late 2015 the perception that America's governing elites were no longer heeding the will of the people extended far beyond the Tea Party Right. It helped to propel the improbable presidential candidacy of an outright socialist, Bernie Sanders. Early in 2016 a national polling organization asked Americans the following question: "The Declaration of Independence says that governments receive their authority from the consent of the people. Does the federal government today have the consent of the people?" An astonishing 70 percent of the respondents said no.

Until the first pre-primary debates among the presidential aspirants, it seemed to this writer that the election of 2016 might become a showdown between these two competing brands of populism: the progressive, anticapitalist form and the conservative, antistatist one. Victory, I thought, would go to whichever political party better explained the causes of the Great Recession of 2008 and the years of malaise that have followed. Capitalism or statist progressivism: which is the problem? Which is the solution? On this perennial point of issue the election would be decided. What I did not foresee before the summer of 2015 was the volcanic eruption of a new and even angrier brand of populism, a hybrid that we now call Trumpism.

Politically, Trumpism's antecedents may be found in the presidential campaigns of Ross Perot and Patrick Buchanan for president in 1992 and 1996. Stylistically, the Trump campaign of 2016 recalled

the turbulence and rough rhetoric of George Wallace's campaign rallies in 1968. Ideologically, Trumpism bears a striking resemblance to the anti-interventionist, anti-globalist, immigration-restrictionist, and "America First" worldview propounded by various paleoconservatives during the 1990s and ever since. It is no accident that Buchanan, for example, was thrilled by Trump's candidacy.

But instead of focusing its anger exclusively on leftwing elites, as conservative populism in its Reaganite variant has done, the Trumpist brand of populism simultaneously assailed rightwing elites, including the Buckley–Reagan conservative intellectual movement described earlier. In particular, Trumpism in 2016 dramatically broke with the proactive, conservative internationalism of the Cold War era and with the pro–free trade, supply-side economics ideology that Reagan embraced and that has dominated Republican Party policymaking since 1980. It thus posed not just a factional challenge to the Republican political establishment but an ideological challenge to the separate and distinct conservative establishment, long headquartered at Buckley's *National Review.*

So what manner of "rough beast" is this, "its hour come round at last"? I believe we are witnessing in an inchoate form a phenomenon never before seen in this country: the emergence of an ideologically muddled, "nationalist–populist" major party combining both leftwing and rightwing elements. In its fundamental outlook and public policy concerns it seems akin to the National Front in France, the United Kingdom Independence Party in Great Britain, the Alternative for Germany party, and similar protest movements in Europe. Most of these insurgent parties are conventionally labeled rightwing, but some of them are noticeably statist and welfare–statist in their economics—as is Trumpism in certain respects. Nearly all of them are responding to persistent economic stagnation, massively disruptive global migration patterns, and terrorist fanatics with global designs and lethal capabilities. In pro-Brexit Britain and

continental Europe as well as America, the natives are restless—and for much the same reasons.

Trumpism and its European analogues are also being driven by something else: a deepening conviction that the governing elites have neither the competence nor the will to make things better. When Donald Trump burst onto the political scene in 2015, many observers noticed that one source of his instant appeal was his brash transgression of the boundaries of acceptable political discourse. The more he did so, the more his popularity seemed to grow, particularly among those who lack a college education.

What was happening here? The rise of Trumpism in the past two years has laid bare a potentially dangerous chasm in American politics: not so much between the traditional Left and Right but rather (as someone has put it) between those *above* and those *below* on the socio-economic scale. In Donald Trump many of those "below" have found a voice for their despair and outrage at what they consider to be the cluelessness and condescension of their "betters."

Facilitating the Trumpist "revolt of the masses" is a revolutionary transformation of the structure and velocity of mass communication, another facet of the phenomenon called globalization. In the past, upsurges of populist sentiment have often coincided with innovations in communication technology that rendered the voices of the "little people" more discernible and easier to mobilize. The era of Jacksonian Democracy (1828–1860) saw the proliferation of inexpensive urban newspapers that both catered to, and shaped, the tastes and political sympathies of their non-elite readership. The "populistic" 1890s witnessed the dawn of sensationalized, yellow journalism. One of its pioneers was the flamboyant business mogul William Randolph Hearst—a millionaire and Democrat who attempted to become President in 1904. In the 1930s the careers of Franklin Roosevelt, Huey Long, and Father Coughlin (the "radio priest") benefited from the immense popularity of the new medi-

um of radio and from the growing distribution of newsreels that millions of Americans saw every week in movie theaters. In the early 1950s the mass marketing of millions of television sets and the rise of political interview shows on television networks enhanced the visibility and popularity of Joseph McCarthy (though ultimately the new medium helped do him in).

Similarly, in our own time, the spectacular efflorescence of talk radio, cable news networks, the internet, smart phones, and social media have radically enhanced "the power in the people" and diminished the ability of elites to control and manipulate public opinion. In 2015 and 2016 the success of Donald Trump owed much to his masterful exploitation of these relatively new media, including two—Facebook and Twitter—that did not exist a mere fifteen years ago. It is noteworthy that the three most prominent (and comparatively highbrow) conservative organs rooted in the print journalism era—*National Review*, *Commentary*, and *The Weekly Standard*—have been centers of outspoken resistance to Trump, while some of the most popular conservative talk radio hosts and websites have supported him with zeal.

As globalization accelerates—in cyberspace and elsewhere—it has become plain that the United States is experiencing a potentially profound political and cultural realignment, pitting (in the words of social scientists) "globalist" and "transnational progressive" elites against those who style themselves "nationalists" and "populists." In the past two years the tensions on these fault lines have flared into what can only be described as an ideological civil war on the American Right: a struggle for the mind and soul of American conservatism.

As the debate has proceeded, many conservative intellectuals have attempted to accommodate what they see as the valid grievances expressed by Trump's supporters. According to the libertarian social scientist Charles Murray, "the central truth of Trumpism" is

that "the entire American working class has legitimate reasons to be angry at the ruling class." Conservative intellectuals in general now seem inclined to agree.

But the problem for conservatives goes much deeper than expressing sympathy for the grievances of the aggrieved. If Trumpism were simply a *cri de coeur* of a sector of the population that feels left behind economically, it would seem possible for conservative power brokers in Congress and the think tanks to hammer out tax reform legislation, immigration control policies, and other measures that would begin to address the sources of anxiety.

Several obstacles, however, stand in the path of a smooth and total accommodation. The first is that the contest between Trumpism and its conservative critics has become not just a dispute over economics and details of public policy but a conflict of visions not easily papered over by pragmatic compromise. To many of its conservative critics, Trumpism is little more than a mishmash of protectionist, nativist, and (in foreign policy) neo-isolationist impulses. To the Trumpists, conservative internationalism is a rusty relic of a bygone era, and supply-side economics (with its corollaries of free trade, open borders, and uncapped immigration) is an ossified dogma whose real-world consequences have been catastrophic for globalization's "losers."

For many years, during the Reagan era and beyond, the leading exponent of supply-side economics in Washington was the late Representative Jack Kemp. Today Kemp's chief political disciple (who in fact worked for him as a speechwriter) is the Speaker of the House, Paul Ryan, a man who shows no sign of moderating his Kempian worldview. Nor does the editorial page of *The Wall Street Journal*—the ideological citadel of supply-side economics—appear to be yielding to the Trumpian barrage. Meanwhile President Trump's former chief ideologist and strategist, Stephen Bannon, proudly labels himself an "economic nationalist," intent on

building what he has called an "entirely new political movement." "The conservatives," he said, "are going to go crazy." It is not easy to see how—at the level of high principle and rhetorical advocacy—Kempism and Trumpism can be reconciled.

In short, as the Age of Trump begins, Trumpist populism is defiantly challenging the fundamental tenets and perspectives of every component of the post–1945 conservative coalition described in this essay. In its perspective on free trade, Trumpism deviates sharply from the limited-government, pro–free market philosophy of the libertarians and classical liberals. Despite some useful support for the right to life and religious freedom, Trumpism on the whole has shown relatively little interest in the religious, moral, and cultural concerns of the traditionalist and social conservatives. In foreign policy it has harshly criticized the conservative internationalism grounded in the Cold War, as well as (until recently) the post–Cold War "hard Wilsonianism" and distrust of Putinist Russia espoused by many national security hawks and neoconservatives.

What Trumpism *has* addressed, loudly and insistently, is the insecurity and disorientation—both economic and cultural—that large numbers of conservatives now feel about conditions at home and abroad. Whether this attentiveness to the travails of ordinary Americans will be enough to bridge the legislative and ideological gap between Trump and Congressional Republican leaders remains to be seen.

The second hurdle that Trumpism faces is the polarizing character and temperament of the man who has become its vessel and champion. To conservatives in the "Never Trump" movement who refused to vote for him in the 2016 election and remain apprehensive, Trump is an ignoramus and carnival barker at best, and a bullying protofascist at worst. To many on Trump's side of the great divide, it is not the new president who imperils conservatism, but an allegedly corrupt and intransigent Republican and conservative

establishment sustained by a "globalist" donor class. The ideological tug of war has become personal, and arguments that turn personal are rarely easy to resolve.

Conceivably, of course, this intramural polemicizing may taper off. Many years ago an American humorist was asked what he thought of Richard Wagner's music. He replied that it was better than it sounds. Perhaps conservatives and other Americans who are currently ambivalent about the man in the White House will eventually decide that, like Wagner's music, Trumpism is better than it sounds. But whatever conservatives think (or come to think) of Trump's policies, it is a sobering fact that well into his first year of office Trump himself has yet to receive the approval of a clear majority of the American people in the opinion polls. This is, I believe, unprecedented in the modern history of the presidency, and it is not a harbinger of sunny weather ahead.

The third obstacle to the success of Trumpism may be more formidable still: the signs that the new president may not be as deeply committed to some of his policy positions as he seemed to be during his presidential campaign. Years ago H. L. Mencken popularized the sardonic maxim that "in politics a man must learn to rise above principle." In his first months in office, and on many occasions, President Trump has shown a breathtaking willingness to "rise above principle" and either abandon or substantially modify some of the Bannonite positions that he favored with gusto only months before. Moreover, he has changed course unabashedly, priding himself on what he calls his "flexibility." Could the populist, insurgent outsider of 2016 be on his way to becoming a rather conventional, establishment Republican? The portents remain ambiguous.

The final obstacle to the success of Trumpism may be the most daunting of all: the intrinsic nature of populism itself. Although populist attitudes and sentiments have long been present in Ameri-

can politics, major outbreaks of populist agitation have tended to be spasmodic and relatively brief.

In part, this is because the most spectacular populist revolts in American history have generally occurred in times of great economic dislocation, as in the 1890s and 1930s. Once the economy has improved, however, the populist clamor has tended to subside. In part also, it is because, historically, American populism has almost always been a reactive phenomenon. And those doing the reacting at the grassroots are almost by definition people who are not engaged in politics on a daily basis—unlike the elites against whom they rebel. Sooner or later, populist eruptions, like most volcanic eruptions, simmer down, and politics returns more or less to normal—that is, to rule by elites. It raises the question: how much time does Donald Trump have to steer the American ship of state in a different direction before the current populist tide abates?

Meanwhile, as the White House merry-go-round spins with disorienting speed, various elements on the American Right are attempting to fill the perceived ideological vacuum. Two have received much attention in the press. Joining the Trumpist—or perhaps one should say Bannonite—effort to reconfigure the Republican Party on nationalist-populist lines is an array of aggressive dissenters called the "alternative right" or "alt-right," many of whom openly espouse white nationalism and white identity politics and denounce their conservative opponents in the most vituperative terms. For many conservatives of the Buckley-Reagan persuasion who have prized their movement as an intellectual edifice built on ideas and enduring truths, the strident ethno-nationalism emanating from the "alt-right" represents a "return of the repressed" with which there can be no rapprochement.

In another corner a group of dissident conservative intellectuals loosely associated with the *Claremont Review of Books*, the website "American Greatness," and the new quarterly journal *American*

Affairs, is seeking to give intellectual substance and rigor to the sentiments enunciated by Trump last year. If there is a systematic case to be made for Trumpist themes and initiatives, its articulation will come, I suspect, from the academics affiliated with these organs.

In these stormy circumstances, it would be foolish to prophesy with confidence the future of the American Right. In all my years as a historian of conservatism I have never observed as much dissension on the Right as there is at present. It is unlikely to disappear anytime soon.

Now some may see in this cacophony a sign of vitality, and perhaps it will turn out to be. Perhaps, too, the escalating external challenge from the perfervid political Left will rescue the political Right from its internal feuding. But conservatives, more than ever, need minds as well as voices, arguments as well as sound bites, and civility as well as indignation. In this season of discontent, it might be useful for conservatives of all persuasions to step back from the fray for a moment and ask themselves a simple question: What do conservatives want? What *should* they want? Perhaps by getting back, very deliberately, to basics, conservative intellectuals can begin to restore some clarity and direction to the debate.

What do conservatives want? To put it in elementary terms, I believe they want what nearly all conservatives since 1945 have wanted: they want to be free; they want to live virtuous and meaningful lives; and they want to be secure from threats both beyond and within our borders. They want to live in a society whose government respects and encourages these aspirations while otherwise leaving people alone. Freedom, virtue, and safety: goals reflected in the libertarian, traditionalist, and national security dimensions of the conservative movement as it has developed over the past seventy years. In other words, there is at least a little fusionism in nearly all of us. It is something to build on. But it will take time.

For three generations now, American conservatives have commit-

ted themselves to defending the intellectual and spiritual founda-
tions of Western civilization: the resources needed for a free and
humane existence. Conservatives know that we all start out in life as
"rough beasts" who need to be *educated* for liberty and virtue if we
are to secure their blessings. Elections and presidencies come and
go, but this larger work is unending.

It is quite possible that the years just ahead will be turbulent ones,
that "the beating down of the wise" will intensify, and that some
conservatives will choose to withdraw from the political arena—re-
calling, perhaps, these lines from the eighteenth-century play *Cato*:

> When vice prevails, and impious men bear sway,
> The post of honour is a private station.

But however events unfold politically, conservative intellectuals
must remain true to their heritage and rededicate themselves to
their fundamental mission of cultural renewal.

BARRY STRAUSS

—————

Populares and Populists

It was the summer of 133 B.C. In Rome, Tiberius Sempronius Grac-chus, Tribune of the Plebs, and his supporters gathered in the pre-dawn hours and occupied the Temple of Jupiter on the Capitoline Hill high above the Forum. The political situation was tense and had been escalating ever since he passed a land reform bill over the Senate's opposition earlier that year. To protect himself and his legislation, Gracchus was now running for an unprecedented second term in succession as tribune. The Senate opposed this un-constitutional procedure. Many Senators thought that Gracchus wanted to ride a wave of popular support to make himself tyrant. For their part, Gracchus and their supporters feared for their lives.

Rome was a republic. Its champions saw it as the epitome of what the ancients called a mixed constitution. The historian Poly-bius, writing during Gracchus's lifetime, praised it as a regime that balanced monarchy, aristocracy, and democracy. Rome's powerful magistrates, headed by two consuls annually elected for one-year terms, represented the monarchical element. The Senate (literally, the Elders), a council of ex-magistrates who supervised the regime, represented the aristocracy. The people took part in electoral and legislative assemblies—the democratic element. Furthermore, the

people had special representatives, the ten tribunes, elected annually for one-year terms. The tribunes had the power to veto the action of any other part of the Roman government, but they rarely used that potent tool. Ordinarily the tribunes were ambitious men, on the way up, and took care not to offend the powerful. Gracchus was different.

He wanted to solve the knotty problem of land, poverty, and the army. The ideal Roman soldier was a peasant farmer. To serve in the military he had to meet a minimum property requirement—the Romans did not want to give weapons to landless men. By 133 B.C., however, things were out of joint. While off for years fighting Rome's wars, many soldiers had lost their farms to creditors at home. To add to the problem, they also lost the ability to graze their herds on so-called "public land," that is, land that the Romans had confiscated in the process of conquering Italy. Wealthy and powerful senators had gobbled up public land in violation of an earlier law limiting private ownership of such land. Gracchus wanted to solve the crisis by settling Roman citizens on public land in Italy and thereby making them eligible for military service.

To his supporters Gracchus was a hero, to his opponents a rogue aristocrat. Who was Gracchus? His father, also Tiberius Sempronius Gracchus, had served twice as consul; his mother, Cornelia, was the daughter of the great Scipio Africanus, the conqueror of Hannibal and a general whom J. F. C. Fuller judged greater than Napoleon. His great-uncle had conquered Macedon; his brother-in-law had destroyed Carthage. Gracchus was, in short, a man of the establishment—and then he turned reformer. Some said he was a revolutionary. He started out with a certain amount of restraint and with the backing of other powerful elites, but he quickly generated enormous opposition. He responded by becoming increasingly radical and lost some of his original elite support. He certainly

broke the rules, and he threatened powerful interests by proposing to redistribute land from the rich to the poor, with only limited compensation paid to those who lost property; the land belonged to the Roman people anyhow, he argued, and the rich had taken it in an illegal power grab.

He was a powerful speaker, as even Cicero, who was no admirer, attests. Earlier that year when addressing the crowd from the Rostra, the speakers' platform in the Forum, Gracchus spoke on behalf of his proposed law. As Plutarch notes, he pointed out that many of those who would benefit had lost their land while away fighting for their country in the legions:

> "The wild beasts that roam over Italy," [Gracchus] would say, "have every one of them a cave or lair to lurk in; but the men who fight and die for Italy enjoy the common air and light, indeed, but nothing else; houseless and homeless they wander about with their wives and children. And it is with lying lips that their imperators exhort the soldiers in their battles to defend sepulchers and shrines from the enemy; for not a man of them has an hereditary altar, not one of all these many Romans an ancestral tomb, but they fight and die to support others in wealth and luxury, and though they are styled masters of the world, they have not a single clod of earth that is their own."

Over enormous opposition Gracchus's bill was passed, but its future was a question mark. Its opponents tried to use another one of the ten tribunes to thwart Gracchus, but he countered by having the man deposed from office. Then he intervened in the senate's bailiwick of financial affairs and foreign policy by taking control of a bequest to the Roman state from abroad and earmarked it to fund the commission that would redistribute land. All was turmoil in Roman politics. And so Rome reached the violent summer of 133 B.C.

On that day on the Capitoline Hill, Gracchus and his supporters expected trouble, and they were right. At a meeting of the senate, Scipio Nasica, the Pontifex Maximus, chief priest of Rome's state religion, demanded that the consul stop the tyrant, but the consul refused. He said that he didn't want to condemn a Roman citizen without trial. So Nasica stood up and called on everyone who wanted to save the state to join him. A number of senators did—clearly, they were prepared because their attendants came to the meeting with staves and clubs to use as weapons. As they exited the senate house, Nasica covered his head with his toga. It was a sign of priestly piety, but the Romans were no pacifists; the altars of paganism were stained with blood.

On the Capitoline Hill, Gracchus's followers picked up legs from wooden benches crushed by the crowd as they fled, but it was not enough to protect them from the angry senators. What followed was a massacre: three hundred Gracchans were killed, including Tiberius Gracchus himself. Their bodies were hauled down from the hill and dumped in the Tiber River to float out to sea, in spite of pleas from their families for burial.

So ended what some called the first factional conflict in Rome since the abolition of the monarchy (traditionally, 509 B.C.) to end in bloodshed and the murder of citizens. Modern scholars see it as the start of the Roman Revolution, the intermittently violent—sometimes very violent—process that convulsed the republic and ended up making Rome a monarchy again, this time under the Caesars, about a century after Gracchus's bloody tribunate.

That tribunate also marked the seminal moment for a phenomenon that would shape Roman politics for the next century: the *populares* (singular, *popularis*). The term populares refers to a series of politicians in the Late Roman Republic who said that they were acting on behalf of or with the help of the people. The ancients considered Tiberius Gracchus to be the first of four

great populares, the others being his brother, Gaius Gracchus (People's Tribune, 123–121 B.C.), Saturninus (People's Tribune, 103 and 100 B.C.), and Sulpicius (People's Tribune, 88 B.C.). Also worthy of mention is Cicero's archenemy Clodius (People's Tribune, 59 B.C.). Then there were populares consuls: Cinna (cos. 87–84 B.C.), Lepidus (cos. 78 B.C.)—father of the Lepidus in Shakespeare's *Julius Caesar*—Marius (six times consul between 107 and 86 B.C.), and the most famous popularis of them all, Caesar. Not only was Caesar consul (five times consul between 59 and 44 B.C.), but also dictator, eventually dictator in perpetuity—a new office and one entirely out of keeping with a free republic (four times dictator between 49 and 44 B.C.). If you want to take the fevered temperature of politics in the Late Roman Republic, consider this: except for Marius, who died a natural death, every one of these populares was murdered or forced to commit suicide.

Although no popularis, Cicero too was murdered in the death throes of the republic. The junta that took over the Roman state a year and a half after Caesar's assassination on March 15, 44 B.C., purged him. Before his death, Cicero had worked heroically to form a united front on the part of the wealthy and virtuous in Rome—or, as he later widened it, in all Italy—to save the republic from the populares, whom he blamed for bringing Rome to its knees. He failed but is rightly honored for his courage. Yet we need to ask if the populares were in fact guilty as charged. And we need to consider what lesson we might draw for today. What, if anything, does the story of ancient populares tell us about modern populists?

Begin with definitions. "Popularis" has much in common with the modern word "populist" but the two are not synonyms, although some treat them as such for convenience's sake. I have done so myself: *mea culpa*. Opponents of the populares thought of them not as principled populists but as panderers of the crowd,

rabble-rousers, and fomenters of violence. They condemned them as careerists and unprincipled opportunists.

Populists today represent an ideology, at least a vague ideology: populism. Populism is a modern term derived from the Latin word *populus*, the people or the common people. The People's Party in the United States coined the term "Populists" in the 1890s. Many see populism as democracy's ugly twin. While democracy respects the rule of law, adheres to constitutional limits, and seeks a balance between classes and groups, populism is ambiguous. It promotes the people while denouncing the elite and cares less for law than results.

Admittedly, populism is a loosely defined if not nebulous and constantly shifting ideology, but the term "populares" is arguably vaguer. The ancients did not talk about populism, because the populares represented neither a political party nor a coherent program. And the ancients emphasized the *tactics* of the populares as much as the *substance* of their policies. To the Romans, populares were not just popular champions but men who tended to get business done via popular assemblies instead of by consulting the senate. And as their opponents often complained, a popularis might cynically manipulate the people for his own selfish ends. Still, the ancients had no doubt about the general bent of the populares: they agitated on behalf of the liberty of the people and the improvement of their material condition at the expense of the wealthy, educated, and restrained.

Another difference between populares and populists is that the former had visible opposite numbers while the latter did not. The Populists were a political party, but there was no party of The Elitists. Populares were not a party but a tendency and so were their opponents, men who called themselves the *boni* (the good men) or the *optimates* (the best men; singular, *optimas*). Similarly, they sometimes referred to the populares as the *improbi* (the bad men). The

optimates believed in government by a narrow elite of wealth, birth, and public achievement—that is, the senatorial nobility; some optimates also accorded a measure of political power to the equestrians or Roman knights, a non-senatorial but very wealthy social group. Optimates preferred to accord little or no power or authority to the common people or their political institutions.

Still, for all the differences between ancient populares and modern populists, the two offer a similar diagnosis: there is something rotten in the state because the elite is mistreating the people and denying them their liberty, property, and happiness. They call for overthrowing the elite and empowering the people who would, paradoxically, then be governed by another elite but by one more sympathetic to the people. They often use emotion, in particular, anger. Cicero, for example, records a description that paints the tribune Clodius as one of the furies. He writes:

> As for this monster, what crimes did he not perpetrate—crimes which, without reason or plausible hope, he committed with the fury of some savage beast, maddened with the violence of the brutal mob.

True, this portrayal is less than fair to Clodius, a political opponent who led to Cicero's exile from Rome (he was soon recalled). Yet even on a sympathetic account, Clodius did stir up the urban guilds and engage in violent tactics.

To return to the comparison between ancient and modern, in both cases the leader plays a crucial role. He or she is often charismatic, from the Gracchi to Eva Perón. Not infrequently, populist leaders are demagogues, that is to say, someone who appeals to prejudice rather than reason. One can think of examples from Cleon the Athenian to George Wallace and beyond. The Greek term from which our word derives, *dêmagôgos*, literally means "leader of the people" and did not originally have a pejorative

meaning. It quickly gained that connotation in ancient times, however, as successive generations of Athenian democratic politicians raced to the bottom in order to outbid each other in the pursuit of popular favor, offering ever greater benefits (paid for by redistribution or conquest) and pursuing ever less dignified rhetorical stagecraft—the people preferring slapstick to Aeschylus, after all.

Cleon said that righteous indignation in the heat of anger made for better treatment of wrongdoers than calm and patient reasoning:

> For after a time the anger of the sufferer waxes dull, and he pursues the offender with less keenness; but the vengeance which follows closest upon the wrong is most adequate to it and exacts the fullest retribution.

The populares were not democrats. They came from the ruling elite and had no intention of turning over governmental decision-making power to the poor. Nor do modern populist leaders need to be democrats; in fact, as often as not the leader is a dictator who gets things done for the people without fussing overly about how he does it. So, William Jennings Bryan was a democrat but Hugo Chávez was not. Neither, of course, were various fascist leaders through whose policies there runs a vein of populism. As for the populares, Tiberius Gracchus bent the constitution, but he was a piker compared to Caesar, who, according to a plausible report by Suetonius, dismissed the republic as a mere name, a thing without form or substance.

Lincoln defined democracy as government of the people, for the people, and by the people. Populism, by contrast, advocates measures *for* the people but not necessarily *of* or *by* the people; on that, populares and populists would agree.

Politics sometimes comes down to a popularity contest, but sen-

sible people know that it shouldn't. That points to the problem with populism. Just because the people want something doesn't make it good. The people of Athens, for example, voted to massacre the men and enslave the women and children of Melos during the Peloponnesian War, but the deed rightly lives on as a byword for atrocity. The Roman people enthusiastically reaped the plunder of empire won by violence, theft, destruction, and enslavement and demanded not so much peace as a greater piece of the pie—hitherto hogged by the Roman elite. The people of America's Old South wanted slavery (and so few Northerners were willing to fight them over it that Lincoln had to justify the Civil War as a war to save the Union, not a war to abolish slavery). That didn't make slavery right, of course, although Stephen A. Douglas and others tried to justify it under a doctrine of "Popular Sovereignty."

The highest standard in politics shouldn't be popularity but justice. Rather than adopt the most popular policies, a good regime should choose policies that promote the common good. But how can we establish such a regime? By turning the government over to experts? By making it a series of town meetings instead? By appointing a dictator? Classical political thinkers argued that a mixed constitution, one that combines the best traits of different forms of government, was the practical road to a good and just regime. To be sure, Plato and Aristotle envisioned ideal regimes that would embody the highest form of justice, but they were unrealistic. Aristotle sees a more practical path in what he calls a polity, a regime that blended the wealth of the rich and the freedom of the poor and employed measures—from education to redistribution—to create a large and dominant middle class. Thanks to anti-poverty and full employment programs, most citizens would belong to the middle class. That majority group would be neither rich nor poor but moderately prosperous and content with its lot. It would dominate politics and en-

dow it with its moderate outlook on life. Because there would be relatively few differences of wealth, citizens would be relatively similar and equal. Aristotle believed that the result would be a prudent, stable, and just regime.

As brilliant as Aristotle's description is, and as stimulating and provocative, it feels light years away from life today. Cicero's mixed constitution is messier, less egalitarian, and less stable, which might all be reasons why it speaks more forcefully to our current condition. The rogues, knaves, fools, and infrequent heroes who spring out of his imperishable prose and onto each other's throats with venom, vitriol, and the occasional dagger would have no trouble fitting in with the Washington or Whitehall elite.

Cicero advocated a "tempering of the republic" (*On the Laws*, 3.12), a mixed constitution that was a dynamic balance rather than a blending. He considered equality neither desirable nor possible. The purpose of the state was to protect private property and hence to permit inequality. The people were united by a common law, but inequality would lead to disagreement about its interpretation. Democracy was tantamount to mob rule, but a narrow oligarchy would fail to take the interests of the people into account. The solution was not similarity and equality, as Aristotle recommends, but rather a balancing of the interests of the various groups in society. Thus the people would have *libertas* (liberty), the nobles would have *auctoritas* (authority, influence, weight, dignity), and the magistrates would have *potestas* (power). So Cicero puts it in his *De Republica* (*On the Republic*, 1.69, 2.57). In *De Legibus* (*On the Laws*), he offers a simpler division. He says, "when power is in the people [and the popular Assembly] and authority is in the senate, a moderate and harmonious state of the commonwealth will be maintained." He offers a nice Latin tag: *potestas in populo, auctoritas in senatu*. Cicero leaves no doubt about the relative distribution of powers. "The Senate shall be the

master of public policy," he writes, "and everyone should defend what it decrees."

"What rights did the tribunate of Tiberius Gracchus leave to the good men (that is, to the boni or optimates)?" is the rhetorical question asked by Cicero's brother Quintus, a speaker in one of Cicero's dialogues (*On the Laws*, 3.20). Quintus no doubt accurately reflects the opinions of his class when he blames the populares and the institutions they employed —the tribunate and the popular Assembly—for making the lowest equal to the highest and for introducing violence and revolution.

Cicero was an elitist but not a knee-jerk one. Although generally aligned with the optimates, he called for a more broadly based ruling group than the diehards who wanted to keep power in the hands of a few old senatorial families. He called for a *concors ordinum* (concord of the orders), a union of the two most elite groups in Roman society, the nobles (those whose ancestors were senators), and the equestrians or Roman knights (those of great wealth but not senatorial status). He described this as a *consensus omnium bonorum* (consensus of all good men) and eventually envisioned it including *tota Italia* (all of Italy).

Nor did Cicero entirely neglect the interests of the people. He had no doubt that "the best men" should govern and that private property should be sacrosanct, but he believed that the people should have a modicum of liberty. He did not, for example, want to abolish the People's Tribunes because he thought they could serve to calm the people as well as to incite them. He was all in favor of the people voting as long as there was no secret ballot (as Rome had in certain cases), so that the optimates could supervise the vote and correct it as necessary. "Let the people's vote be free but observed by the optimates," he proposed.

Cicero recognized that government by the elite should also be government on behalf of the people. It was the job of Rome's mag-

istrates, he wrote, to increase the glory of the people (*On the Laws*, 3.9). He stated that those who administer the republic should

> keep the good of the people so clearly in view that regardless of their own interests they will make their every action conform to that; second, to care for the welfare of the whole body politic and not in serving the interests of some one party to betray the rest.

He bemoaned the current state of affairs and looked toward something better:

> Now, those who care for the interests of a part of the citizens and neglect another part, introduce into the civil service a dangerous element—dissension and party strife. The result is that some are found to be loyal supporters of the populares, others of the optimates, and few of the nation as a whole.

For Cicero, agitation by elite leaders on behalf of the people—a kind of populism, if you will—was neither just nor prudent. In fact, he blamed the populares for the troubles of the republic. The best regime, he thought, was a broad-based oligarchy in which the people have limited but genuine powers.

But what would happen if the oligarchs—"the best men"—misbehaved? What if they abused their power and oppressed the people? That is precisely the problem of the Late Republic.

In its early days the gap between rich and poor in Rome was relatively narrow. But as Rome conquered an empire, enormous wealth poured in and it was not shared equally. In fact, as they turned from prosperous farmers into rich herding magnates, Italy's one percent grabbed the public land on which the poor had depended for herding their livestock and converted it to private use. The rich took the lion's share, and then they took the mouse's share too.

The problem that Tiberius Gracchus addressed was the driving of the Italian peasantry off the land. It was a multiplex crisis: so-

cial, economic, humanitarian, political, and also military, since Roman soldiers were supposed to meet a minimum land-ownership requirement. Inequality threatened the stability of the republic by striking at the twin institutions of the small farmer and citizen-soldier. A citizenry composed of small landowners tended to be conservative, moderate, and invested in the future of their society—and so less likely to be swayed by a demagogue. Service in the nation's militia would only add to such a citizen's patriotism and sense of civic duty. On this, Greco-Roman thinkers agreed. Yet Rome's elite was willing to gamble with their society's future by letting the agrarian crisis go unresolved.

It was a bad bet. The failure of land reform ultimately transformed the Roman legions from an army of small farmers to an army of landless proletarians. They no longer had the property to give them a stake in society, but they did have swords. For ambitious military leaders they were political foot soldiers, legionaries who demanded land on demobilization—or else. And so Rome evolved from the era of the Senate and its loyal commanders under Cato and Scipio to the day of *dux* and dictator under Marius and Sulla and Pompey and Caesar. The final outcome of the agrarian crisis and the struggle between optimates and populares was Augustus, Rome's first monarch in 500 years. He "renovated" the republic (as the Latin phrase he proudly advertised, *res public restituta*, may be translated) and turned it into the Roman Empire. He thereby achieved stability but at the cost of liberty. By the way, Augustus was careful to provide land for his veterans. Tiberius Gracchus's proposed solution was much cheaper!

Whatever blame accorded to populares for their opportunism and demagoguery is more than matched by the greed and inflexibility of the optimates for failing to share the wealth of empire with ordinary citizens. Although giants walked among the politicians of the Late Republic, there were too few men of vision, modera-

tion, and willingness to compromise. They couldn't foresee that the price of inflexibility would be liberty itself.

Their character did not rise to the occasion. Cicero recognized the extent to which a regime depended on the good character of its leaders. It was one thing to grant *auctoritas* to the senators, but another for them to be worthy of it. He understood the danger to the commonwealth posed by corrupt elites. Cicero wrote:

> Corrupt leaders are all the more pernicious to the republic because not only do they harbor their own vices but they spread them among the citizenry; they do harm not only because they are themselves corrupt but because they corrupt others—and they do more harm by the example they set than by their own transgressions.

Cicero needed no lessons in how power corrupts. He wrote:

> The great majority of people . . . when they fall prey to ambition for either military or civil authority, are carried away by it so completely that they quite lose sight of the claims of justice.

He added that unfortunately it was the greatest souls and most shining geniuses that had the greatest ambition for power and glory, making them all the more dangerous. He was thinking of Caesar in particular but the same could be said of Cato, Pompey, Brutus, and, to a degree, of Cicero himself. Indeed, it applies to a wide segment of the optimates, in their words and deeds, from the response to Gracchus in 133 B.C. to their last stand a century later at the Battle of Philippi in 42 B.C. In their unwillingness to compromise or recognize the legitimate claims of the people they opened the door to populares with armies at their backs. And so the defenders of the republic contributed to its demise.

Rome offered one solution to the problem of bad elite actors: if senators, they faced ejection from the senate by the censor, a sort of

one-man Supreme Court when it came to public morals. That was hardly adequate, however, for dealing with an elite that was mean and foolish instead of generous and shrewd.

And so we come to populism. When an elite is corrupt, narrow-minded, and grudging; when it fails to recognize the legitimate claims of the people; when its injustice and misbehavior is not merely a rhetorical trope but a fact, then it is legitimate, indeed necessary, for the people to challenge it. In an ideal world, the challenge will be legal, constitutional, and respectful. It will root its claims not in the brute power of the people but in a philosophically defensible principle of justice. Far from engaging in demagoguery, its rhetoric will be as polite as the table manners of the guests reclining on the couches in a dining room of a Roman villa. We don't live in an ideal world, however, any more than Cicero's myopic and rigidly principled contemporary Cato the Younger lived in Plato's Republic—Rome in its turmoil and corruption was more like the Sewer of Romulus. We no longer live in a world run by America's founders, those eighteenth-century gentlemen in powdered wigs; actually, we never did, because those same gentlemen skewered each other in print and murdered each other in duels.

Modern populists, like ancient populares, are likely to be vulgar, angry, and confrontational. Such tactics are regrettable, but at times they are necessary. Principled populists will limit any resort to class conflict, will aim at the rule of law and not at mob rule, and will try to compromise with the elite rather than engage in revolution. Or, more likely, nowadays, when everything's a revolution, they will talk radical change but strike a bargain. Shrewd populists will want to adjust the regime, not destroy it.

Wise elites, for their part, will take populist movements as a wake-up call. Instead of merely denouncing populism as false consciousness, bigotry, resentment, bad manners, mental illness, peevishness, superstition, or class warfare, and instead of adopting a

"Problems? What problems?" attitude when faced with protests, they will inquire as to whether genuine grievances might underlie populism's appeal. Then, having recognized human suffering, they will try to ameliorate it in turn. In that way they will do the right thing while also saving their political skins.

The problem of populism is the problem of elitism. The more just and astute the elite is, the less angry the people are. The more the elite treats politics like a big tent, in which no one should be left out, the less likely they are to face populist challenges.

Let's go back to where we began, in Rome in 133 B.C. If the Roman elite had compromised with Tiberius Gracchus instead of blocking and then killing him, or if they had co-opted his land reform and made it their own, then they might have rescued the republic from a century of war and revolution. They might even have spared their great-grandchildren the loss of political liberty that Augustus's monarchy entailed. To do that, however, would have taken moderation, courage, and wisdom—leadership, in a word—that is beyond the reach of all but the greatest statesmen.

We don't live in Plato's Republic, alas, so we will have populism. Let's respond to it wisely.

DANIEL HANNAN

Insects of the Hour

The vilest slur in Brussels, the insult to end all insults, is "populist." Eurocrats spit it out, rather in the manner of a teenager at a party who mistakenly takes a swig from a beer can that was being used as an ashtray. Yet, monstrous as the word is in a Eurocrat's vocabulary, he is surprisingly vague about its meaning.

The one thing that he unequivocally understands populism to signify is "something that other people like, but I don't." Thus, calling for a referendum is populist. Accepting the result of a referendum is populist. Free speech for Eurosceptics is populist. Tax cuts are populist. Cutting waste is populist.

My neighbor in the European Parliament chamber when I was first elected was a hefty Belgian Christian Democrat. He used the word frequently and ferociously, applying it with particular venom to supporters of Flemish independence. I once asked him whether the Flemish separatists weren't simply representing their voters, just as he represented his. "As politicians we have a duty to lead, not just to do what people want!" he replied. Got it, I said. What you mean by "populism" is "having a legislature that broadly reflects public opinion." In my country, we call that "democracy."

Looking back, I shouldn't have been quite so snippy with him. After all, my Belgian colleague had a point that, in a representative democracy, legislators should follow their consciences. A healthy regard for public opinion doesn't oblige us to contract out our convictions. All parliamentarians—trust me on this—go through moments when we think that the majority of our constituents are plumb wrong about something. At these moments, we like to recall Edmund Burke's Address to the Electors of Bristol:

> Your representative owes you, not his industry only, but his judgment; and he betrays, instead of serving you, if he sacrifices it to your opinion.

What we don't like to recall is what happened next. The Electors of Bristol were unimpressed by Burke's characteristically high-minded argument. In particular, they resented the way in which his generous championing of the Irish cause challenged the mercantile interests of their city. The poor fellow was slung out at the next election. In his private moments, Burke would perhaps have called it populism, though I have no doubt that the Electors of Bristol would have called it democracy.

My point is that populism is not intrinsically a bad thing. It may be either positive or negative according to context. The essential feature of all populist movements is their belief that an elite is governing in its own interests rather than that of the general population. To make an obvious point, the validity of the populist argument depends on the extent to which that assessment is accurate.

Some populist movements rely on scapegoating, on attributing every misfortune to a privileged or powerful minority. These are the ugly movements, the ones that offer anger and division rather than solutions. "Are you poor? Are your children jobless? It's not

your fault! It's all the fault of international financiers/powerful foreigners/Jews/the one percent!"

Such populist movements depend on what we might call a piece of faulty circuitry in the human brain: a tendency to see patterns where none exist. This tendency evolved for good reasons on the savannahs of Pleistocene Africa. Taking short-cuts, spotting minute traces of human involvement, recognizing similarities, and extrapolating from them: all these were vital survival strategies. The trouble is that, in our complicated and populous modern world, our hunter-gatherer brains can overshoot. We infer human agency where none exists. We anthropomorphize. We see faces in potatoes (but not potatoes in faces). We yell at our laptops when they malfunction. We discern hidden hands behind random events.

In *The God Delusion*, Richard Dawkins blames this tendency for religious belief. Our remote ancestors, he thinks, couldn't accept that floods or earthquakes simply happened; they had to have been caused by human misbehavior, which might be mitigated by propitiation or sacrifice.

Is our own age so very different? Why do we have such difficulty accepting that the planet might heat or cool because of factors beyond our control? Could it be that we, too, have a deep intuitive need to find human causality? Do we, too, think we can change the weather through propitiation and sacrifice?

All populist demagoguery depends, to some extent, on the false inference of intentionality. The man who, so to speak, popularized populism, or at least the word, was William Jennings Bryan, the Nebraska firebrand who was immortalized by a Republican opponent as the cowardly lion in *The Wizard of Oz*. Bryan led a political insurgency on behalf of the farmers of the West and, to a lesser extent, the South, who had been badly affected by a collapse in prices in 1893, at one point winning the Democratic presidential nomination.

Bryan was a sincere man, a devout Presbyterian who was very obviously moved by the plight of agrarian America. But his movement set the template for all future populist insurgencies through its false inference of agency. He couldn't bring himself to believe that the agricultural depression was caused by the economic cycle, itself affected by myriad dispersed factors from a coup in Buenos Aires to declining demand in the United Kingdom. No— so much suffering must be someone's fault. And who was that someone? Why, the big corporations! The railroads and the banks! The people who favored a dollar based on gold rather than silver! The speculators!

Bryan set the tone for every populist insurgency that was to follow in the democratic world. Misfortune was not a part of the human condition; it happened because someone somewhere was being selfish. Even if it was too late to soothe the misfortune, at the very least that someone could be made to suffer too. The same anthropocentric impulse that drove pre-democratic peoples to blame ill luck on witches had been transferred to the age of universal suffrage.

When bad times—far worse times—came again after 1929, America channeled its populism through Franklin D. Roosevelt, whose ham-fisted interventions prolonged the recession for many years, to say nothing of prompting a baleful and semi-unconstitutional centralization of power. But at least the United States came through the slump with its democratic values intact.

The same was not true of Europe. Across the Old Continent, other than in a handful of states at its northern and northwestern edge, parliamentary regimes were displaced by populist autocrats of one kind or another. Some of these autocrats were fascists, some communists, some neither. But all, to a greater or lesser extent, justified their regimes through the same message, the message that is at the core of populism: We are protecting you, the decent

majority, against an anti-social, anti-patriotic clique! We will get back at the people who caused this mess!

The target group varied from country to country: it might be bankers or priests or landowners or Jews or national minorities or capitalists or communists. But all agreed on one thing: pluralism was the enemy. Across the continent, from Salazar's Portugal to Stalin's USSR, free parliaments were dismissed as the tools of manipulative and self-interested plutocrats.

I hope *New Criterion* readers will see what is wrong with that critique without my needing to explain it. Individualist democracy—what the Continental autocrats of Left and Right dismissed as "decadent Anglo-Saxon liberalism"—was and remains humanity's least bad option. It lifts the countries that embrace it to a pinnacle of wealth and happiness previously unimagined. Every alternative system ends, paradoxically, in the thing that populists rail against: oppressive oligarchy.

Equally, though, let's not pretend that oligarchy is unknown in democracies. Many polities, from the Roman Republic onwards, have retained the outward forms of representative government while being captured by cliques. The Roman precedent was, indeed, vividly in the minds of America's Founding Fathers and informed many of the checks they put in place to prevent a similar decline in the United States.

Those checks worked. Unlike, say, the near-contemporary French Republic, the American Republic did not follow Rome into autocratic rule. But, even in an open democracy, there is a natural tendency for people in power to rig the rules in their own favor, to give themselves an institutional advantage.

Established political parties passing laws that make it harder for newcomers to challenge them; big corporations using the regulatory regime to erect barriers to entry; public-sector workers ensuring that the system favors producers over consumers; mega-banks persuading

politicians to bail them out with taxpayers' money—all these are, in their ways, examples of oligarchy. And all of them are intrinsic to modern politics, because human beings are naturally self-interested. To the extent that they trigger a populist backlash, that backlash might be considered a proportionate and necessary antibody.

To put it another way, a measure of populism is inherent in any democratic system. The intensity and validity of the phenomenon depend upon circumstances.

When they were small, my children used to enjoy a book called *Vote for Duck*, given to us by a kind American friend. It tells the story of a farmyard duck that rises, first to the leadership of its farm, then to local government, then to state office, and finally to the presidency of the nation. At every stage—my girls were too young to understand why this bit always made their father smile—the duck ran under the slogan "Vote for a duck—not a politician!"

Populism is so well-established—so trite, we might almost say—that a children's author can write in the knowledge that every adult will laugh at it. The populist candidate is a comedian's cliché. Think, to pluck an example more or less at random, of the classic early *Simpsons* episode wherein the evil Montgomery Burns, running to be Governor, keeps telling ecstatic crowds: "We're gonna send a message to those bureaucrats down there in the state capital!!"

The extent to which these slogans work depends on how dissatisfied people are with their lot—and the extent to which the slogans are justified depends on whether people are right to direct their dissatisfaction at the established political class.

Let us consider two contemporary developments that are habitually attributed to populism—and which, indeed, are often linked together in the columns of half-clever pundits: the victory of Donald Trump in the Republican race, and the victory of Euroscepticism in the recent U.K. referendum.

The two movements are different in many important ways. British Euroscepticism is not nativist or protectionist. On the contrary, the chief message of the Leave campaign (of which, to declare an interest, I was a founder) was that, outside the European Union, Britain would be able to pursue a more global, more free-trading, more competitive trajectory. Where Trump railed at Chinese exporters, British Leavers called for a bilateral free-trade deal with China—something that was impossible while their country remained in the European Union.

The thing that both movements had in common was a sense of frustration with the establishment. That frustration stemmed, in both cases, from at least some shared causes. In both Britain and the United States, three factors in particular had contributed to a widespread disenchantment with the political class.

First, there was the Iraq war, and the subsequent belief that it had been launched on the basis of a deliberate lie. For what it's worth—and I write as one who opposed the invasion—I think George Bush and Tony Blair were mistaken rather than mendacious. After all, if they knew that there were no weapons of mass destruction in Iraq, they must also have known that the invading troops wouldn't find any. It would have been the dumbest lie in history. Nonetheless, the episode served to widen the rift between politicians and people. A conviction began to take hold, including among respectable middle-class voters, that their politicians were prepared to send young men off to die for some clandestine cause, a cause, at any rate, whose true purpose had not been fully adumbrated.

Second there was the credit crunch, which saw billions of dollars taken through the tax system from low- and medium-income families and given to ... well, no one is entirely sure what happened to it. Bankers are never going to compete with soldiers or nurses in the popularity stakes but, when things are going well,

criticism is muted. Sure, we're vaguely aware that some people are earning excessive bonuses, but as long as our own investments are also rising, we're relaxed about it. When, however, bankers seem to be making a hash of things, and then helping themselves to bonuses at our expense, our mood alters. The crash that followed the collapse of Lehman saw middle-class families expropriated through the tax system in order to rescue some very wealthy bankers and bondholders from the consequences of their own errors. No wonder the politicians who decreed those bailouts were blamed. And no wonder faith in the system took a knock from which it has still not recovered.

Third, our age is witnessing a mass movement of populations, a *Völkerwanderung*, previously unknown in peacetime. Rising wealth and advances in technology have triggered a migration from the poorer parts of Asia, Africa, and Latin America to developed nations.

I spent part of last summer volunteering in a hostel for underage migrants in the south of Italy. The boys staying there had come mainly from West Africa, and some had had truly Odyssean journeys across first the Sahara and then the Mediterranean.

They were courageous, resourceful, optimistic lads, and the more time I spent with them, the more convinced I became that, in their position, I'd have done exactly as they had. Few of them, though, were refugees, at least not as that term is legally defined. They were fleeing poverty, misery, and corruption rather than war, oppression, and persecution. And for each one, a hundred were waiting to follow.

When we met people being landed by the Italian coastguard, their first question was often "Where can I get Wi-Fi?" I don't mean to suggest that because they had smartphones, they weren't in need. On the contrary, the phone was often their only possession of value. My point is that smartphones are the key to the whole migratory phenomenon, making possible the transfers of credit

and information that allow young people to move from Nigeria or Eritrea through Sicily or Greece into Northern Europe. To their grandparents living on subsistence agriculture, such a trek would have been unthinkable.

People in the receiving countries are aware that these population movements are increasing. They keep hearing their leaders promising to do something about it, but nothing seems to check the flow. Some voters suspect that, for all their promises, the politicians don't really want to do anything about it. They wonder whether their elites secretly want more inward migration than they publicly admit, seeing it as a source of cheap nannies and gardeners rather than as a source of competitive pressure on jobs and amenities.

Put it all together and what do people see? A political class that will send boys to die in distant lands on the basis of, at best, a half-truth; that taxes the poor to bail out the rich; and that supports an immigration policy designed for big business at the expense of ordinary people.

For what it's worth, I think only the second of these assertions is wholly fair. But I can see why a gap has opened up between government and governed, between the *paese legale* and the *paese reale*, between the smirking classes and the working classes. Into this gap have sprung populists of every hue: the Tea Party, the Occupy Movement, Bernie Sanders, Donald Trump, Marine Le Pen, Geert Wilders, Beppe Grillo, Syriza, Podemos.

So, to return to the question, how justified is the sense of popular alienation? Are people right to blame their political elites? Are they right to suspect that the masses are being duped by the classes?

More so, frankly, in Europe than in America. The United States still has a largely eighteenth-century institutional settlement, in which power is devolved, dispersed, and democratized. Sure, the system has gone through spasms of centralization, notably under

the two Roosevelts, Wilson, LBJ, and Obama. But the Jeffersonian substructure remains in place. Very few countries have such institutions as term limits, states' rights, ballot initiatives, open primaries, or competing tax jurisdictions—let alone the direct election of everyone from the sheriff to the garbage guy. All these things serve to strengthen the citizen vis-à-vis the government. If you want to "send a message to those bureaucrats down there in the state capital," you can generally do it through established democratic mechanisms.

The same is not true of the European Union, which is a textbook oligarchy. The President of the United States is elected in the world's most watched election; the President of the European Union is appointed in secret over a sumptuous dinner. The U.S. Constitution was adopted following ratification by thirteen states; the E.U. Constitution was rejected by the French and Dutch electorates, but then imposed anyway under a new name. The U.S. system of government is based around maximum decentralization of power; the European Union's founding treaty declares, in its first article, the goal of an "ever-closer union." The Declaration of Independence promises "life, liberty and the pursuit of happiness"; the European Union's Charter of Fundamental Rights and Freedoms guarantees the right to "strike action," "free healthcare," and "affordable housing."

The E.U. citizen, in short, has far more cause to rage against the system than has his American cousin. I say "against the system" advisedly. There are all sorts of things against which the American voter might rage with reason, from the quality of some of his candidates to the deteriorating debt situation. But the U.S. Constitution is not to blame for these things. On the contrary, it contains the means for their redress.

In the European Union, by contrast, elected representatives are helpless to affect the issues that matter to their constituents. It has

become a cliché to blame the disaffection in Europe on the twin monetary and migratory crisis. The euro and the border-free area, known as Schengen, have indeed proved disastrous. Both were fair-weather schemes; neither withstood the first storm. Just as the debt crisis pitilessly exposed the flaws in the single currency, so the migration surge made a nonsense of Schengen.

But the critical point, in both cases, is that elected politicians were powerless to intervene. It didn't matter how people voted, because Brussels was in charge. The most basic functions of government—securing the national territory and overseeing the economy—had been handed away.

Those who complained were not raging against some imagined group of malign speculators. They were complaining about a system that was there in plain sight: an undemocratic racket based in Brussels that had promised security and prosperity, failed to deliver either, and then left voters unable to do anything about it.

It is in this context that the Brexit vote should be understood. Throughout the referendum, pro–European Union campaigners caricatured their opponents as bigots, racists, Little Englanders. No doubt such people exist, but the tone of the Leave campaign was constantly upbeat, internationalist, and democratic. Accountable government was far and away the top issue for Leave: our private polls matched the published ones. Immigration was a very distant second, and, even among those citing immigration, few wanted or expected a drastic fall in numbers. What they wanted was control: a sense that Britain was ultimately in charge of roughly who came in and roughly in what quantity.

Was there a populist element to the Leave campaign? I won't deny it. Speaking to a rally in Kent a week before the poll, I began to hymn that county's radical past, from the Peasants' Revolt to its support for the parliamentary cause in the civil war. When I mentioned the Peasants'

Revolt, the audience interrupted with prolonged cheers. In their eyes, the E.U. referendum was partly about reminding the grandees and Euro-corporatists that they weren't the only people in Britain.

They had a point, those Kentish patriots. Just as the original Peasants' Revolt was directed at an alien caste, a French-speaking aristocracy that maintained itself in power through a series of legal privileges, so the Leave campaign was aimed at various groups who had learned how to make a living out of Brussels.

The Remain campaign's very first move was to publish a letter in *The Independent* signed by the heads of various green pressure groups warning against Brexit on grounds that E.U. laws had "a hugely positive effect" on the environment. It did not attempt to explain why a post–European Union Britain wouldn't simply retain or replicate—or even improve—these "hugely positive" laws. As so often, there was an insulting implication that voters needed to have such things handed down by their betters.

What was really interesting, though, was the signatures at the end, representing Natural England, the Green Alliance, the Royal Society for the Protection of Birds, the Natural Environment Research Council, and so on. Of the twelve organizations named, the European Commission funded eight directly—and others indirectly. But, of course, "protect our countryside" sounds much prettier than "protect our grants."

Just as NGOS had learned how to parasitize the European Union, so, more damagingly for the ordinary citizen, had large multinationals. The Remain campaign was funded by megabanks and corporate giants, including Goldman Sachs, J. P. Morgan, and Morgan Stanley. Again, it's not hard to see why.

The green grandees' letter was followed by several more from Brussels-sponsored lobbies, including universities, charities, and businesses. A letter in the (London) *Times* was signed by the bosses of thirty-six ftse-100 companies. A moment's research

showed that these companies had collectively spent €21.3 million lobbying the European Union, and got back €120.9 million in grants from Brussels. It's hard to argue with a 600 percent return on investment.

The money, though, is the least of it. Far more damaging is the way big firms lobby to get rules that suit them and hurt their competitors. I was surprised, when I was a new MEP, that corporate giants were forever demanding more regulation. It took me a while to understand why. They could easily assimilate the compliance costs, and were raising barriers to entry so as to secure a more monopolistic position.

The sums poured into lobbying rival anything seen in Washington D.C.—with the difference that, in Brussels, there is no countervailing pressure from the electorate. Here is a summary of what the big firms spent (in euros) on lobbying in the first six months of 2015 (the last six-month period for which figures are available from Transparency International):

Microsoft Corporation	4,500,000
Shell Companies	4,500,000
ExxonMobil Petroleum & Chemical	4,500,000
Deutsche Bank AG	3,962,000
Dow Europe GmbH	3,750,000
Google	3,500,000
General Electric Company (GE)	3,250,000
Siemens AG	3,230,169
Huawei Technologies	3,000,000
BP	2,500,000

There is nothing intrinsically wrong with lobbying. Personally, I have made it a rule not to deal with lobbyists as an MEP, but I'm aware that I'm being unfair to most of them. My complaint here is not about lobbying; it's about the way that the beneficiaries

of lobbying were seeking to prejudice the democratic process, to secure a Remain vote that would serve their interests rather than that of the country as a whole. Is opposition to such a racket populist? If so, it's surely a justified populism: a legitimate reaction against an oligarchic tendency.

If you think "oligarchy" is too strong a word, by the way, ponder this. An official working for the European Union is exempt from national taxation, paying instead a token rate of European tax equivalent to around 21 percent, flat.

Contemplate, for a moment, that extraordinary fact. The bureaucrats in the Commission and Parliament make decisions that have fiscal consequences for ordinary people, while themselves being exempt from those consequences. If that isn't oligarchy, what is?

When we consider the oddities of the French *ancien régime*, one of the greatest iniquities, to modern eyes, is that the aristocracy was largely exempt from taxation. We wonder at a system based on the legal and systematic expropriation by the rich of the poor. Yet we have recreated such a system in Brussels.

The tax exemption is only the most visible and flagrant example; in truth, the entire E.U. system is based around transferring wealth from ordinary citizens to those lucky enough to be part of the machine.

This is perhaps less shocking than it sounds. Formalized confiscation is, historically, the normal form of human organization. The idea that a society should be run by and for the general population, rather than in the interests of its rulers, is a rare and recent one. In their great study *Why Nations Fail*, James A. Robinson and Daron Acemoğlu showed that, in almost every age and nation, the people in power arrange things so that they and their heirs can systematically enjoy the fruits of everyone else's work. They call this model the "extractive state." The alternative—an independent magistracy, secure property rights, and mechanisms to hold rulers to account—came about

only in modern times and largely in English-speaking countries. This they call the "inclusive state."

To put it at its simplest, populism is justified in extractive rather than inclusive states—just as armed resistance is justified in tyrannies rather than democracies.

Whatever its flaws, the United States is unarguably an inclusive state, based on the rule of law, the universal franchise, and the separation of powers. So, individually, are the twenty-eight members of the European Union. But the European Union itself is not.

What we saw in Britain's referendum was an overdue correction, a recovery of power from remote elites. We saw a vote of confidence in democracy itself, based on the conviction that the United Kingdom could flourish under its own laws, trading with friends and allies on every continent. Perhaps most dramatically, we saw the British people politely disregard the advice—no, the instructions—of those who presumed to be their betters. They ignored the hectoring, the bullying, and the scare-stories, and politely voted to recover the right to hire and fire their own lawmakers.

To explain why they were right—and to explain, too, the sheer rage of the defeated—let me return to the greatest of all conservatives, that Irish seer Edmund Burke, to whom I leave the last word.

Because half-a-dozen grasshoppers under a fern make the field ring with their importunate chink, whilst thousands of great cattle, reposed beneath the shadow of the British oak, chew the cud and are silent, pray do not imagine that those who make the noise are the only inhabitants of the field; that of course they are many in number; or that, after all, they are other than the little shriveled, meager, hopping, though loud and troublesome, insects of the hour.

FRED SIEGEL

========

The German Victory over American Populism

American populism, from the time of Andrew Jackson to the agricultural insurgency of William Jennings Bryan and through to the passage of Prohibition in 1920, won broad support by organizing around the concept of a virtuous white Protestant rural majority fighting the power of corrupt and oppressive Northeastern business elites. The concept of populism as a conflict between the average American and morally avaricious elites is embedded in American life.

The imported concepts behind anti-populism—that is, the justifications for lording over the "deplorables"—are, however, relatively little known.

But, beginning with the conflict over whether to enter World War I, populism was increasingly defined by the Midwestern opposition of ethnic Germans to World War I and World War II. The last gasp of rural radicalism came in 1924 when Wisconsin's "Fighting Bob" La Follette, a vehement opponent of World War I, ran on a third-party populist/progressive ticket which, after expelling the Communists, carried only his home state. More broadly, he won the support of many isolationist German and Scandinavian farmers to capture 17 percent of the national vote. But by the 1920s, for the first time, the

cities out-populated rural America and the populists' sense of themselves as the true face of America was challenged by philo-German thinkers such as H. L. Mencken and Theodore Dreiser, who questioned the value of democracy. The famed Baltimorean, who coined the terms "Bible Belt" and "booboisie," was a fount of anti-populism. He was, as he crowed to all who would listen, a very superior person whose Germanic identity immunized him against the depredations of America as imposed by the regular meetings of the Rotary society.

This W. C. Fields of letters went out of his way to insult his audience. "So long as there are men in the world," Mencken clowned, "99 percent of them will be idiots." "The mob-man," whom he described as "the *boobus Americanus*," "must believe in something, and it must be something indubitably not true. The one thing he can't get down is a fact." Facts are something that evaded Mencken in his famous coverage of the Scopes trial. His writings on "the Monkey Trial," though widely accepted by liberals, were that of a fabulist, as is made clear by the historian Edward Larson's *Summer for the Gods: The Scopes Trial and America's Continuing Debate over Science and Religion.*

Contemporary journalists deploy Mencken's marvelous witticisms. "No one," he exclaimed, "ever went broke underestimating the intelligence of the American voter." But for all those who luxuriate in the furrows of Mencken's dithyrambic denunciations of democracy and the "peasants" and "yokels" who cling to it, there are, more importantly, those taken with not the sound but the substance of Mencken's writing.

Mencken remains a fugleman—to use one of his favorite words—for philosophical free marketers who tend to look beyond his amusing animadversions to the Nietzschean core of his writings. Still, even they avert their gaze from the full force of Mencken's Germanophilia. In 1908 Mencken wrote the first account of Nietzsche's thought published in America. The book was more than exposition, it was, notes the Mencken biographer Terry Teachout, "an autobiography in dis-

guise." Nietzsche gave Mencken, a distant cousin of Otto von Bismarck, his grounding, and a worldview from which he never deviated.

Like many of Mencken's admirers, the editor and critic Joseph Epstein describes Mencken as having been harassed during World War I for being "insufficiently patriotic." But that defies the facts. Mencken was a German nationalist and as such both a paladin of anti-Americanism and a champion of the Kaiser's armies in World War I.

Mencken's Nietzschean World War I writings on behalf of imperial Germany have been ignored by his enthusiasts. Opposed to American intervention in the Great War on the side of the Allies, Mencken had no objection to war per se; Drawing on Nietzsche's conception of the "will to power," he wrote: "War is a good thing, because it is honest, it admits the central fact of human nature.... A nation too long at peace becomes a sort of gigantic old maid." What he opposed were British, and then American, efforts at defeating German militarism.

The war, notes the Mencken biographer Fred Hobson, "focused his thoughts." Mencken explained:

> I, too, like the leaders of Germany, had grave doubts about democracy. ... It suddenly dawned on me, somewhat to my surprise, that the whole body of doctrine that I had been preaching was fundamentally anti-Anglo-Saxon, and that if I had any spiritual home at all, it must be in the land of my ancestors. When World War I actually started, I began forthwith to whoop for the Kaiser, and I kept up that whooping so long as there was any free speech left.

In 1914, before the United States entered World War I, Mencken wrote "The Mailed Fist and Its Prophet," in which he presented Germany as a model the United States should emulate. In the 1870s, contended Mencken, writing as much about himself as Nietzsche, their fatherland was so backward that:

No epithet [from Nietzsche] was too outrageous, no charge was too far-fetched, no manipulation or interpretation of evidence was too daring, to enter into his ferocious indictment. He accused the Germans of stupidity, superstitiousness, and silliness; of a chronic weakness for dodging issues, a fatuous "barnyard" and "green-grazing" contentment; of yielding supinely to the commands and exactions of a clumsy and unintelligent government.

And worse yet, 1870s Germany, according to Nietzsche, was guilty "of a slavish devotion to" Christianity, "a spiritual dyspepsia," and "a puerile mysticism."

But, according to Mencken, by 1892 when Nietzsche wrote his masterpiece *Thus Spake Zarathustra*, "an enormous change . . . had come over the German scene," with vast new energies unleashed "not by the old [Junker] aristocracy of the barracks and the court, but by a new aristocracy of the laboratory, the study, and the shop." Germany surged to the forefront of the world.

Germany, insisted Mencken, had transcended the Anglo-American world:

> But this new democracy that thus arose in Germany was not, of course, a democracy in the American sense, or anything colorably resembling it. It was founded upon no romantic theory that all men were natural equals; it was free from the taint of mobocracy; it was empty of soothing and windy phrases. On the contrary, it was a delimited, aristocratic democracy in the Athenian sense—a democracy of intelligence, of strength, of superior fitness—a democracy at the top. . . . [T]he final determination of all matters was plainly vested, not in politicians or in majorities, but in experts, in men above all politics, in the superbly efficient ruling caste.

"The new Germany," which was challenging America in the war to succeed the British as the dominant global power, "was," ex-

plained an adoring Mencken, "even more contemptuous of weakness, within or without, than the old. What had been the haughtiness of a single class became the haughtiness of a whole people."

World War I, as Mencken saw it, was the culmination of Germany's Nietzsche-inspired ascent to power. To prove his point, Mencken quoted from *Zarathustra*:

> I do not advise you to compromise and make peace, but to conquer. Let your labor be fighting, and your peace victory.... What is good? All that increases the feeling of power, the will to power, power itself in man. What is bad? All that proceeds from weakness. What is happiness? The feeling that power increases, that resistance is being overcome.... Not contentment, but more power! Not peace at any price, but war! Not virtue, but efficiency! ... The weak and the botched must perish: that is the first principle of our humanity. And they should be helped to perish! ... I am writing for the lords of the earth.

Thus, concluded Mencken, with Germany's armies on the march in 1914, "Germany becomes Nietzsche; Nietzsche become Germany."

Mencken cheered the sinking of the ocean liner *Lusitania* by a German sub that claimed 128 American lives. He dismissed the slaughter of civilians in Belgium as beneath his concerns, while writing about the greatness of the Kaiser and Germany's commanding general Erich Ludendorff. Mencken's adoring *Atlantic* magazine essay on the authoritarian genius of Ludendorff in fighting a Nietzschean war makes it clear that Mencken's concerns about freedom were secreted when he was presented with what he saw as beautiful Teutonic authority worthy of being obeyed. The essay on Ludendorff revealed that Mencken wanted freedom, not so that the citizen wouldn't be subject to arbitrary authority, but because he didn't want the Übermenschen constrained by ordinary people. The Baltimorean liked unregulated capitalism, not because

it gives the poor a chance to rise, but because it allowed the superior men to have their way unobtruded.

Mencken, who was a courageous critic of censorship, had his reputation saved by an act of self-censorship. His intriguing essay "After Germany's Conquest of the United States"—and in fact the Kaiser planned to launch dirigibles against New York—talked about the benefits to America of being ruled by the hard men of a superior *Kultur*. Known only because of the exchange of letters between Mencken and the editors of *The Atlantic*, the article was withdrawn and never published. Interestingly, despite Mencken's extraordinary efforts to document his own life, the manuscript, according to Vincent Fitzpatrick, the curator of the Mencken collection at the Enoch Pratt Free Library in Baltimore, cannot be found. Mencken's reputation, it seems, was saved by the uncharacteristic decision not to publish what he had written.

The origins of America's political anti-populism lie in the early 1920s when Mencken, Sinclair Lewis, F. Scott Fitzgerald, and the intellectual heirs of Randolph Bourne initiated a cultural politics that defined itself in opposition to middle-class America. The period was described by Alfred Kazin as "the Age of Mencken." It was a time when the clowning curmudgeon expressed better than his peers the post-war disillusionment with Woodrow Wilson, in particular, and America, in general. These writers, wrote Malcolm Cowley, "seized power in the literary world . . . almost like the Bolsheviks in Russia." They all wrote, said the philosopher George Santayana, to "denounce the Constitution . . . the churches, and above all they denounce the spirit that vivifies and unifies all these things, the spirit of Business."

But had Mencken's article been published, it's hard to imagine that even the politically tone-deaf literary critic Edmund Wilson could have insisted in 1921 that "Mencken is the civilized conscience of modern America." Wilson wasn't alone. *The New York Times* thought

Mencken "the most powerful private citizen in America." He was so beloved by the campus smart set that one college newspaper called him "the guiding outlaw of undergraduates." Walter Lippmann admired Mencken. But Lippmann shrewdly noted that Mencken often couldn't tell the difference between ignorance and evil.

Mencken created a liberal demonology out of the Scopes trial with only a loose connection to the evidence. The trial was initiated by the ACLU looking for a test case, not by the locals, as Mencken suggested. Nor were the locals the mean-spirited boobs he depicted. They supported the trial as a bit of boosterism, a way to put their town on the map. Scopes was well-treated and well-liked by the people of Dayton, Tennessee, whom Mencken described as cretins. And the supposedly buffoonish William Jennings Bryan, described by Mencken as "the idol of Morondom," was a well-read world traveler who had debated Darwin's *On the Origin of Species* with Henry Fairfield Osborn, the president of the Museum of Natural History. Bryan, the national symbol of what remained of populism, was indeed completely wrong about evolution, but his criticism of the Social Darwinism that Mencken subscribed to was to prove prescient with the coming of the Nazis. When Bryan died suddenly, shortly after the trial, Mencken gloated, "We killed the son of a bitch."

In 1926, the year after the Scopes trial, Mencken published a book he had been working on for a long time. It explained that a government by yokels was "sure to be a scandal and a farce. The United States is such a farce and scandal." Titled *Notes on Democracy*, the book proved an embarrassment to most, with the exception of the Kaiser, who praised it.

Democracy, Mencken explained, for the umpteenth but far from the last time, was a conspiracy against the superior men who had a monopoly on the higher virtues. But Mencken's efforts demonstrated that, on the subject of democracy, as opposed to his own three volumes of autobiography, Mencken at full length was far

less compelling than in his intentionally comic columns. In the newspapers, his crotchets were overshadowed by his descriptions of histrionic preachers, preachy presidents, and overwrought enthusiasts for golf and political poltroonery. A friend sighed that he wished Mencken hadn't written the book "because it reveals too much about him."

Carried along by the public's animus to the anti-alcoholists, Mencken's star ascended to the heavens in the 1920s. But it descended rapidly in the 1930s. The "sage's" animus towards FDR and indifference to the suffering of the Depression cast a shadow over his once-incendiary wordplay. But, by the time Mencken's reputation crashed, he had taken down populism with him.

Broadly speaking, the Populist movements, starting from the Jacksonian "revolution" of the 1820s and 1830s and on into the twentieth century, were considered left-wing. They were then seen as left-wing insofar as they insisted on the merit of the average American. After the interregnum of the 1920, the last left-wing incarnation of populism came from the Communist-led Popular Front during the New Deal of the 1930s.

In the time of the Popular Front, the great African-American singer Paul Robeson was celebrated for performing the cantata "A Ballad for Americans." The lyrics defined the central trope of populism—what it was to be an American:

Well, you see it's like this. I started to tell you.
I represent the whole ...
I'm the everybody who's nobody,
I'm the nobody who's everybody ...
Deep as our valleys,
High as our mountains,
Strong as the people who made it.
For I have always believed it, and I believe it now,

And now you know who I am.
Who are you?
America! America!

The Popular Front era also brought the first anticipation of a right-wing populism in the form of the Michigan radio preacher Father Charles Coughlin. Coughlin, who had begun his radio career as a staunch supporter of FDR, gradually shifted into philo-German opposition to fighting the Nazis. In the post–World War II years, as the Soviets subverted Eastern Europe and the Cold War raged, Coughlin's heir of sorts was Senator Joe McCarthy. Like La Follette, McCarthy, a senator from Wisconsin, was partially successful in defining anti-Communism as the emblem of Americanism.

What gave McCarthy and, before him, the ranters on the House Un-American Activities Committee their running room was the tardy response of the American government, including the FBI, to information about Soviet espionage that was first brought to light in 1939 by the former Communist Whittaker Chambers. But the Popular Front, which united liberals and Communists in a version of Americanism at home and a common crusade against fascism abroad, blinded many American leftists to the true nature of the Soviet regime. The great literary critic Lionel Trilling saw that, for many artists and intellectuals, Stalinism was seen as just an advanced form of liberalism, rather than as a threat to freedom. In the 1940s:

> No Federal agency was immune to Soviet penetration. There were at least sixteen Soviet agents in the OSS, predecessor to the CIA, including Duncan Lee, chief counsel to General William Donovan. The Office of war Information, the Board of Economic Warfare, United Nations Relief and Rehabilitation Administration, War Production Board, War Department, Signal Corps, Censorship office, the Justice Department were all penetrated. In the State Department Alger Hiss was not the only Soviet spy. Larry Duggan, in

charge of Latin American affairs, was an agent. Lauchlin Currie, one of six presidential assistants, provided information. The most highly placed spy was Harry Dexter White, the number two man [at] the Treasury Department and one of the architects of the post-war international financial order—he designed the World Bank, the International Monetary Fund and the Bretton Woods agreement.

The Soviet penetration of American government was on the back burner while the USSR was America's ally in the fight against Nazi Germany. But Soviet seizures of Eastern European governments—Poland in 1947, Czechoslovakia in 1948—began to reshape American assumptions. In 1949 the anti-Communist North Atlantic Treaty Organization was established, the Soviets—thanks to espionage—detonated their first atomic bomb, and the Communists won the Chinese civil war.

The ensuing trials, in which the disreputable, louche, unattractive Chambers testified against the well-connected, personable Hiss, polarized the country. To the anti-Communists, Hiss was a perfect example of the way liberalism, fellow-traveling, and active support of the ussr all bled into one another. To most liberals, by contrast, Hiss was the innocent victim of Chambers's ideologically motivated denunciations.

Had the Hiss case been the end of the matter, the civil war on the left between anti-Stalinists and Stalin's apologists might have produced a morally clarifying debate that pushed some liberals to come to grips with their own failings. But when Dean Acheson, who was a great anti-Communist Secretary of State, insisted that he would never turn his back on the Communist Alger Hiss, he opened the door to the demagogue Joe McCarthy.

Before McCarthy emerged on the scene in 1950 with his supposed list of spies—he had no new information—anti-Communism had been handled not only by Congressional yahoos on the House

Un-American Activities Committee but also by anti-Stalinist and ex-Stalinist activists and intellectuals who had acquired knowledge of Communism in the course of close combat. But with McCarthy, a Republican senator from Wisconsin, a thug who liked to think of himself as the Rocky Marciano of politics, the yahoos and the pseudo-sophisticates came to the fore.

Our contemporary misunderstanding of both McCarthy and populism derives, in large measure, from a set of 1954 Columbia University seminar papers on the Wisconsin senator. Written in the waning years of McCarthy's political influence, they introduced into American public life a grotesque but lasting misreading of both Nazism and the American middle class. The ideological mis-conceptions were put forth by a group of Marxist intellectuals who had migrated from Germany to the United States known as the Frankfurt School.

The Frankfurt School, first established in 1923, was modeled on the Marx-Engels Institute in Moscow. In the United States, the most influential piece of writing from the Frankfurt School was the 1950 multi-volume account of the Authoritarian Personality. The pseu-do-scientific study purported to depict the American middle class as a hotbed of pre-fascist inclinations. It was based largely on a 1936 tome by the most conceptually fecund of the Frankfurters, Erich Fromm. It was entitled *Autorität und Familie*. It claimed that the Nazis had arisen because of the authoritarian nature of the German middle-class family dominated by a patriarch:

The German middle class would appear to represent this syn-drome of authority—in personality, in family, and in society—par excellence: in its strict familial set-up, with the dominant father and the submissive mother and children; in its attachment to the hierarchies of bureaucracy and military organization; finally, in its creation and acceptance of the authoritarian state in its purest form. And it was this group that was also responsible for the most

murderous form of anti-Semitism ever known. Might it not there-fore be possible that anti-Semitism was a direct expression of the authoritarian personality?

The conceptual heart of *Autorität und Familie* was drawn from Friedrich Engels's 1884 tract, written in Marx's spirit but after his death, entitled *The Origins of the Family, Private Property and the State*. Engels saw the bourgeois family as a bulwark of private prop-erty and capitalism that desperately needed to be displaced.

Max Horkheimer agreed with Engels. A central figure at the In-stitute, Horkheimer was welcomed to Columbia University after he fled Germany. In his 1939 essay "The Jews & Europe," Horkheimer wrote, "those who do not wish to speak of capitalism should be si-lent about fascism." In his 1941 book, *Eclipse of Reason*, Horkheimer, anxious to protect the tradition of German romanticism from crit-icism, argued that Germany had suffered from a surfeit of Enlight-enment reason that in turn led to fascism:

> If by enlightenment and intellectual progress we mean the free-ing of man from superstitious belief in evil forces, in demons and fairies, in blind fate—in short, the emancipation from fear—then denunciation of what is currently called reason is the greatest ser-vice we can render.

It was an extraordinary argument by inversion. In fact Germany under Hitler had suffered from a gaping deficit of rationality. Like the Nazi apologist Martin Heidegger, the Frankfurt School saw mechanization and modernity as the great evils to be combated.

The widespread interest and influence of *The Authoritarian Per-sonality* was part of a new development in American life. In the post-war years, for the first time so-called "social scientists," some drawing on Freud, wielded influence. Books such as Gunnar Myrdal's *An American Dilemma* on race, the Kinsey Reports on sexuality, and *The Lonely Crowd*, a 1950 sociological analysis by Da-

vid Riesman, Nathan Glazer, and Reuel Denney on the sociology of America, made a major mark on how the newly emerged super-power thought about itself.

Though rent by ideological bias, empirical sleights of hand, and a political agenda—the melding of Marxism with a version of Freudian theories of personality development—the "study" evoked widespread interest in intellectual circles. Arbitrary and authoritarian patriarchal families were purported to produce volcanic anger towards parents. But rather than express that anger, the children were supposed to have transferred that hostility into an admiration for authoritarian political figures. In other words, that political and intellectual history of Nazism was replaced by a psychological deception. In the words of the book's famously anti-empiricist author, Theodor Adorno:

> It is a well-known hypothesis that susceptibility to fascism is most characteristically a middle-class phenomenon, that it is "in the culture" and, hence, that those who conform the most to this culture will be the most prejudiced.

"In a real sense," Adorno wrote in 1935, referring to kids who had bullied him as a schoolboy, "I ought to be able to deduce fascism from the memories of my childhood. As a conqueror dispatches envoys to the remotest provinces, fascism had sent its advance guard there long before it marched in." Horkheimer's wife presciently observed of Adorno, "Teddie is the most monstrous narcissist to be found in either the Old World or the New."

In 1955 the collected Columbia seminar papers appeared in a book *The Radical Right* edited by Daniel Bell. The most influential essays in the collection came from the historian Richard Hofstadter. For Hofstadter, populism itself was the great danger in American history, starting with the know-nothings and continuing all the way down to McCarthyism.

The seminar papers on McCarthy and McCarthyism, written by

such distinguished figure as David Reisman, Talcott Parsons, Nathan Glazer, and Seymour Martin Lipset, had very little to say about the events of the Cold War that led Polish and Eastern European Catholics to bitterly denounce FDR's Yalta agreements and Truman's slow response to Soviet subversion. Instead, borrowing from the Frankfurt School, the essays made the problem of "status anxiety" central to McCarthyism. Lower-middle-class and middle-class America—it was argued with very little evidence but dollops of theory—was suffering from fears about its future.

Richard Hofstadter, sometimes known as "the second Mencken," latched onto the concept of status anxiety as he tried to incorporate the Frankfurt school's "social science" into history. In his contribution to *The Radical Right*, he borrowed the idea of "pseudo-conservatism" from *The Authoritarian Personality*. Hofstadter uses it to describe Constitutionalist and free-market critics of the New Deal as psychologically afflicted, ill-tempered, and unreasonable reactionary threats to the Republic. The pseudo-conservatives like McCarthy saw themselves as the victims of a conspiracy that wanted to manipulate them. Like the Nazis, their relationships supposedly involved "more or less complete domination or submission." In that 1955 essay, Hofstadter, little concerned with the question of guilt or innocence, describes Alger Hiss as "the hostage the pseudo-conservatives hold from the New Deal Generation." Better yet, "he is a heaven-sent gift. If he did not exist the pseudo-conservatives," like Hiss's adversary, the "shabby genteel" Whittaker Chambers, "would not have been able to invent him."

Hofstadter returned time and again to his keystone subject, McCarthyism broadly understood. McCarthy was a Catholic with numerous Catholic supporters. But Hofstadter's repeated insistence that America's failing derived from its intense Protestant morality had little to say on the subject of Catholic support for McCarthy.

In 1963, Hofstadter published *Anti-Intellectualism in America*,

a rambling extended essay which updated Mencken by tracing McCarthyism back to nineteenth-century Protestant eruptions of millennialism. The main enemies of the American mind, Hofstadter argues, have been the populist democracy, Evangelical Protestantism, and the business mentality, the same trio that was described by Mencken's adepts as "Bryanism, Babbittry and the Bible Belt." In 1950 Hofstadter insisted that "What was lacking in" Bryan's late-nineteenth-century populism "was a sense of alienation." Bryan was short on "the excitement of intellectual discovery that comes with . . . the revolt of the youth against paternal authority . . . of the artist against . . . the whole bourgeois community."

Anti-intellectualism drove itself into a conceptual dead end that led Hofstadter to outdo his odd-ball accusations about Bryan's lack of alienation. Hofstadter closed his "account" of anti-intellectualism by praising a twentieth-century Greenwich Village version of irrationalism. Norman Mailer's celebrated 1957 essay about hipsterdom, "The White Negro," Hofstadter tells us, was "a really solid kind of estrangement." "Hip," explains Mailer, "is the sophistication of the wise primitive in a giant jungle." Mailer found something admirable in the audacity of two hoodlums who chose to beat in the brains of a shopkeeper. "Courage of a sort is necessary," explains Mailer, "for one murders not only a weak fifty-year-old man but an institution as well . . . one violates private property. . . . The hoodlum is therefore daring the unknown." Of all this, Hofstadter concludes, "Certainly the earlier prophets of alienation never had this much imagination."

Picking up on the nineteenth-century themes that supposedly led to McCarthy, Hofstadter applied them to Goldwater: "American politics has often been an arena for angry minds," Hofstadter wrote. "In recent years we have seen angry minds at work mainly among extreme right-wingers, who have now demonstrated in the Gold-

water movement how much political leverage can be got out of the animosities and passions of a small minority."

It was in anticipation of Goldwater's monumental defeat that he wrote the profoundly influential essay "The Paranoid Style in American Politics." It was published in *Harper's* as America was preparing to go to the polls for the 1964 election. In 1965, "The Paranoid Style in American Politics" and other essays were published as a book. The paperback edition featured a picture of Joe McCarthy wearing glasses filled by the stars and stripes of the American flag. The book has never been out of print since.

In "The Paranoid Style," Hofstadter wrote that the right-wing Republican has "the sense that his political passions are unselfish and patriotic," this "goes far to intensify his feeling of righteousness and moral indignation." The right-wing Republican "feels dispossessed: America has been largely taken away from [him]," but he is "determined to try to repossess it."

Hofstadter wheeled out all the standard Frankfurt School-derived apparatus such as the emphasis on "status loss" and "pseudo-conservatism," but he also added what would become his signature trope—the concept of the "paranoid personality," as Hofstadter borrowed it from the Frankfurt School. They had seen the "crank" and the paranoid as integral to the political right in both Europe and America. In the United States these were said to be frustrated rural Yankee-Protestant and paranoid people for whom ethnic prejudice was sometimes all-consuming. Teetering on the edge of mental illness, cranks were quick to see conspiracies that were out to get them.

After Hofstadter, the American right, notes *The Wall Street Journal's* Daniel Henninger, "wasn't just wrong on policy. Its people were psychologically dangerous and undeserving of holding authority for any public purpose. By this mental geography, the John Birch Society and the Tea Party are cut from the same backwoods cloth."

In the 2010 Congressional elections the now defunct but then newly emergent and Constitutionally oriented Tea Party inflicted a heavy political blow on Barack Obama's congressional supporters. Disoriented by the crushing defeat, liberals put the Paranoid Style on full inverted display after the attempted assassination of an Arizona Congresswoman. On January 8, 2010, twenty-three-year-old Jared Loughner opened fire on the Jewish moderate Congresswoman Gabby Giffords who was holding a meeting in a Safeway supermarket with her Tucson, Arizona constituents. He wounded her severely. He also wounded thirteen others while killing six.

Well before any evidence had been gathered, the *New York Times* columnist Paul Krugman, George Packer of *The New Yorker*, E. J. Dionne of *The Washington Post*, and Jonathan Alter of *Newsweek* concluded, noted William Voegeli, that the carnage was a reflection of right-wing racial hostility to Barack Obama. Krugman asked in his opinion column: "Were you, at some level, expecting something like this atrocity to happen?" The "you" would be his audience, and the answer is "yes," they thought that in these times "something like this" could happen in the United States. (In his 2007 book, *The Conscience of a Liberal*, Krugman, like Hillary Clinton, insisted that "there is a vast right-wing conspiracy.")

Primed, in the wake of the Giffords shooting, Krugman quickly evoked Hofstadter. Krugman noted of the right that "they obviously believe that their dishonesty serves a higher truth.... The question is, what is that higher truth?" In other words, as with *The Radical Right*'s essays on McCarthy, there was no need to take the arguments of "these people" seriously; what was important was exposing the psychological disabilities that produced their worldview in the first place.

It was in that half-baked tradition of Hofstadter and unmasking that Krugman and his ilk quickly decided that the assassin—clearly a right-winger as they saw it—had been driven to his dastardly

and possibly anti-Semitic deed by the ranting of conservative talk radio. But, it soon became clear that Loughner—a conspiratorialist who had neither left- nor right-wing leanings—was not a listener of right-wing radio. Instead, he was quite literally schizophrenic, with a history of mental illness (and had gone off his medication). Needless to say, Krugman never apologized for his inanities.

The initial intimations of what became the Tea Party were first seen in the 2006 mid-term elections when Independents, former Perotistas, and fiscally conservative Republicans deserted the GOP in droves. They did so again in 2008. These Tea Partiers *avant la lettre* were taking the revenge of the Rotarians. They were at the outset ordinary people strongly supportive of self-government and rightly appalled by a government class that had gone into business for itself.

When the initial bailouts for TARP (the Troubled Assets Relief Program) were proposed under President Bush and his Treasury Secretary Henry Paulson, they aroused an angry response. When those same programs were dramatically expanded under President Obama and provided insurer AIG and Goldman Sachs, who both played important roles in generating the financial crisis, a rich bounty at public expense, the nascent Tea Parties were presented with rich targets for their anger. Similarly, when the executives of Fannie Mae and Freddie Mac, the government-sponsored corporations that backed mortgages and were key malefactors in the financial collapse, were similarly rewarded, the public's ire was aroused.

The public looks to a revival of Constitutional restraints to protect themselves and America from a self-serving government and its "expert" flacks. Its ruling passion is a belief in the ability of the ordinary citizen to make decisions for himself or herself without the guidance or "help" of experts and professionals.

The public anger, noted William Voegeli writing in *The Claremont Review of Books*, was crystallized on the morning of February

19, 2009, by Rick Santelli, a correspondent for CNBC. Speaking from the trading floor of the Chicago Board of Trade, Santelli responded to a question from his studio anchors by denouncing a proposed $75 billion government program to help homeowners avoid foreclosure. As the traders around him began to look up from their computers to listen, then to applaud and cheer, Santelli turned to them and asked, "How many of you people want to pay for your neighbor's mortgage who has an extra bathroom and can't pay their bills?" Getting more worked up, Santelli said, "We're thinking about having a Chicago tea party in July. All of you capitalists that want to show up to Lake Michigan, I'm going to start organizing it."

Santelli's CNBC and YouTube viewers launched websites and Facebook pages within hours of the rant heard 'round the world. Within weeks, a new factor in American politics emerged, a "right-wing street-protest movement," according to the liberal journalist Michael Tomasky, something unprecedented in modern American politics. Following Santelli's famous outburst, the Tea Party movement "materialized . . . out of nowhere," Tomasky reported forthrightly but regretfully, "with an intensity no one would have predicted." What the Tea Partiers understood was the big battalions of American life—big government, big business, big labor, and preening professionals—were increasingly intertwined into a ruling oligarchy.

The Tea Party activists wanted to restore America's founding principles. They insisted on a respect for the Constitutional limits on federal power. But they were met with contempt and incredulity. When she was Speaker of the House in 2009 and the Democrats controlled all the elected branches of government, Nancy Pelosi backed the illegitimate parliamentary procedure—the use of a reconciliation bill designed narrowly for fiscal matters—which allowed Obama to ram the Orwellian-named Affordable Care Act

through Congress. When Pelosi was asked by a reporter, "Where specifically does the Constitution grant Congress the authority to enact an individual health insurance mandate?" the Speaker responded: "Are you serious?" The "Are you serious" response was repeated in many town halls across the country in 2010, where members of Congress were stunned by the peaceful but ferocious hostility that met what was presented as health care legislation but which was actually primarily a political matter redistributing income from the middle class to the non-white poor. The upshot, reported an astounded Tomasky, was that, during and after the town-hall session wherein members of Congress were grilled, "the self-identified independent voters flipped on health care . . . from support to opposition."

The Tea Party, notes Henninger, itself got help from history—the arrival of a clarifying event, the sovereign debt crisis of 2010. "Simultaneously in the capitals of Europe, California, New York, New Jersey, Illinois, and elsewhere it was revealed that fiscal commitments made across decades, often for liberally inspired social goals, had put all these states into a condition of effective bankruptcy."

The Tea Party made major contributions to the striking GOP victories in the 2010 and 2014 off-year elections. Barack Obama delivered the worst mid-term performances of any two-term president since Harry Truman in 1946 and 1950. He led 60 senators and 256 members of Congress into the 2010 election, he left 2014 with 45 senators and 192 members of Congress. Democrats were already stunned and dismayed by the 2014 outcomes which left the GOP in control of thirty-two of the fifty statehouses, including in deep-blue Illinois, Maryland, and Massachusetts, and sixty-nine of the country's ninety-nine state legislative houses.

But between November 2014 and the January 2016 Iowa caucuses, the Tea Party was essentially ended by enemies without and scoundrels within. An overwhelming peaceful movement on be-

half of limited government, the Tea Party incited invective and outright fabrication from the Democratic Party and its adjuncts in the media. The Tea Party's "ruling passion," noted the law professor Glenn Reynolds, was "a belief in the ability of the ordinary citizen to make decisions for himself or herself without the guidance or 'help' of experts and professionals." Yet in the style of Frankfurt School/Hofstadter reasoning, the Tea Party was malevolently accused of racism and fascism. Rather than being a grassroots movement, the Tea Partiers were said to be merely an extension of moneyed Republicans. Unlike the charges of racism and fascism, this charge had a modicum of truth. Most of the assaults on the movement were fabrications of panicked liberals who along with moderate business Republicans saw the Tea Party as a threat to their vested interests

The Tea Party's Constitutionalism was dealt a severe blow by the curiously concocted June 2012 ruling by Chief Justice John Roberts allowing for the legality of Obamacare. Obama had repeatedly and vigorously insisted that the fees imposed by Obamacare were not a tax. But in his ruling in which he joined the court's liberals, Roberts, seemingly intimidated by the threats of a liberal backlash if Obamacare was struck down, despite the straightforward language of the legislation, effectively rewrote it to define it as a tax and therefore legal. The language of the Constitution, it turned out, could be explicitly corrupted on behalf of political ends. The Roberts ruling was a severe blow to the Constitutionalist reform movement. It was compounded by the clearly illegal efforts of Obama's IRS to deny Tea Party groups their rightful status as nonprofits.

But for all the external blows, it was the damages done within the GOP/conservative coalition that were the most harmful. Hucksters used the decentralized nature of the Tea Parties, which were organized not nationally but in localities, to siphon money by supposed schemes to aid the effort. At the same time, despite addi-

tional Tea Party/gop victories in the 2014 elections, the GOP leaders in the House, John Boehner, and in the Senate, Mitch McConnnell, seemed incapable of rising to the challenge of Obama's seizure of illegitimate authority as in his repeated rewritings of the Affordable Care Act and his attempt to impose immigration legislation—clearly a province of Congress—by executive order. Boehner and McConnell, both tied to the moneyed interest that too often drives politics, never effectively challenged Obama's incompetence and mendacity.

The winners in Obama's America, where the stock market has doubled even as wages have stagnated, have been the big guys—big business, big labor, big government—in short the people populists despise. Unelected bureaucrats have never had it so good. The Affordable Care Act, for instance, created 159 new boards, commissions, or programs. Elected officials more and more resemble job-for-life bureaucrats, likelier to die in office than to be fired (or voted out) for cause. Washington, D.C., recently passed Silicon Valley as the richest region in the United States. The federal government's reach has become so vast that it suffocates informed debate and political accountability. No one in the Obama administration has been held accountable—as Richard Nixon's operatives were—for using the IRS as a mechanism to punish dissenters.

The void left by the Hofstadterian destruction of the Tea Parties produced the mendacities of Donald Trump, who had no trouble mocking Obama. The President represents the debacles at home and abroad that have left trust in our "leaders" at an all-time low. The many failures of Obama's post-Constitutional presidency have produced Trump's post-Constitutional populism with its calls for a great, forceful leader to set things right. Trump's patchwork populism builds on something new under the sun: it melds Trump's anti-elitism with the showman's monied connections in New York. In the presidential election, Trump matched up against Hillary

Clinton, whose honesty was continuously in question, as she campaigned for a third Obama term.

The Germans have won: Mencken and the Frankfurt School each in their own way have displaced civic egalitarianism. Their disdain has become commonplace among upper-middle-class liberals. This might not have produced the current nausea if the pretensions of our professionals were matched by their managerial incompetence. It isn't, and the German victory is moving us towards a soft civil war.

====

A Bulwark Against Tyrany

In a pre-election issue of *The New Yorker*, the editors placed a cartoon on the cover of the magazine depicting George Washington and Abraham Lincoln looking in horror at a television screen showing Donald Trump delivering one of his campaign speeches. The message was clear enough: Mr. Lincoln and the Founding Fathers, if they could be with us today, would be appalled at the spectacle of the billionaire mogul running for president as the authentic voice of the people. Many commentators on the left and right, and in between, joined in agreement to say that the Founders designed the Constitution precisely to prevent populist demagogues from getting anywhere near the presidency. There was considerable confusion in these circles as to whether they judged Mr. Trump to be an authentic populist or just another standard-brand candidate claiming to speak for the people—or, indeed, if they were saying nothing more than that a successful candidate who disagrees with them must be by definition a demagogue. Nevertheless, now that Mr. Trump has won the election, they are singing a slightly different tune, now relying upon the checks and balances in the Constitution to keep him from carrying out some of the policies he called for during his campaign.

It is heartening to hear these appeals to the Founding Fathers from liberals and leftists who typically scorn the Constitution as an out-of-date relic from the eighteenth century that does far too much to protect minorities and not enough to empower majorities. This is the refrain that we have been hearing for close to a century since Progressives like Woodrow Wilson and Theodore Roosevelt launched the modern critique of the Constitution. The separation of powers promotes gridlock and governmental ineffectiveness; the equal representation of the states in the Senate gives too much power to small states at the expense of the large ones; federalism is a tool that permits states to resist national majorities; the Supreme Court has more power than it should have in a popular system; the Constitution is far too difficult to amend and far too complex for the average citizen to understand. These critics, and there are many of them, prefer a framework of government that is less complex and more democratic or majoritarian than the one the Founders left us with, perhaps something resembling the parliamentary system in Great Britain or the initiative and referendum system for making policy used in California and in a few other states. In those systems, electoral majorities are able quickly to translate their victories into public policy without much regard for the opinions of the minority, which is the standard the critics use to measure "democracy" and "majority rule."

Many find these arguments against the Constitution persuasive from an intellectual point of view—at least until they find themselves on the losing side of an election or two, at which point the indirect and complicated character of the Constitution looks like a political lifeboat that is conveniently available to save them from being overwhelmed by the majority. This seems to be where we are today with those in the national press or others close to the centers of power in Washington who never imagined that Mr. Trump could be elected President, much less carry his

party into majorities in the House and Senate. Many who yesterday saw the Constitution as an impediment to their desires are relieved today to find that it also acts as a reciprocal impediment for their adversaries. Their credo, to paraphrase Mr. Dooley, might be summarized as, "Throw out the Constitution—on the other hand, not so fast!"

The framers of the Constitution did not use the term "populism," but they were aware of the phenomenon it describes—that is, an uprising by the voters against what they judge to be a corrupt or out-of-touch elite, with an eye toward trampling upon the rights of other citizens or violating established rules of politics and governance. James Madison, for example, referred to something roughly similar in his extensive discussions in the *Federalist* of factions and "factious majorities." To a considerable degree, the challenges posed by "populism" were front and center in the debates that eventually produced the Constitution, and indeed the framers designed the structure of government to blunt the effects of such movements that might arise in the future. For better or worse, the framework Madison was instrumental in creating does not easily allow for the kind of popular referendum through which a majority of voters in Great Britain decided to pull that country out of the European Union, or the more recent referendum in Italy through which voters turned down a package of constitutional reforms. In this sense, the U.S. Constitution operates as an impediment to populism because it substitutes representation and deliberation for national referenda and direct democracy.

In the United States, of course, voters can decide to pull out of a treaty or an alliance or repeal a law, but they must do so indirectly by first electing a willing President and Congress, and then hoping that the two can find enough common ground to enact a program—and then sustain that program through subsequent elections. Under the U.S. Constitution, a populist "moment" is not suf-

ficient to win the long game; the moment must be sustained over a sequence of elections such that a temporary uprising of voters is translated into a durable governing majority, which is a difficult thing to accomplish in a country as large and diverse as the United States, as the Founders well understood.

We have had many populist-type movements in the United States since the early decades of the 19th century, including the abolitionist and "Know Nothing" movements of the 1850s, the Populist insurgency of the 1890s, the Huey Long and Father Coughlin insurgencies of the 1930s, the McCarthy movement of the 1950s, and the George Wallace, Ross Perot, and Patrick Buchanan uprisings in more recent decades. Though none managed to win power, they often played important roles in bringing neglected issues into the open and forcing the established parties to address them. Thus, populist movements are not necessarily bad or dangerous, assuming that the Constitutional system in America is strong enough to deflect, moderate or discipline them. Donald Trump, the first populist since Jackson to capture the presidency, will soon learn the difficulties of governing within such a system.

The populist moment that we seem to be in, here and abroad, is a propitious occasion to reconsider some contemporary assumptions about democracy and majority rule in relation to the arguments advanced by the Founders on those same subjects. Many today are instinctively inclined toward democracy and majority rule but are also worried about the implications of "populism." Can they have it both ways? After all, populism, to the extent that we use it in a pejorative way, implies that majority rule is not always a good thing, and that, as James Madison argued in the *Federalist*, there can be "bad" majorities as well as "good" ones. How do we tell the difference? And how does one design a system to deter or to deflect these "bad" majorities? Once we raise such questions, we enter into the political and intellectual world of Madison and the Founders.

If George Washington was "the father of his country," then, according to one of his contemporaries, James Madison was the "father of the Constitution." Madison outlined the first draft of the Constitution, kept a diary of the debates at the federal convention, set forth the philosophical foundations of the document in several key entries in the *Federalist*, maneuvered it through to ratification, and then wrote the Bill of Rights as a series of amendments to the Constitution. Later he helped to implement and guide the system as a Congressman, party leader, Secretary of State, and, finally, as President of the United States. No other member of the founding generation could lay claim to such an impressive list of accomplishments.

Nevertheless, it is as the principal intellectual architect of the Constitution that Madison is most well known to us today, and it is in that role that he is the target of barbs claiming that he was hostile to popular rule due to various features he or his colleagues inserted into the Constitution. These barbs usually point in two directions—toward Madison's theory of the extended republic that makes it difficult for majorities to form and sustain themselves; and toward his defense of the separation of powers under the Constitution that supposedly works against majority rule and renders the federal government weak and ineffective.

These criticisms are either wrong or overstated in connection with Madison and the Founders, and by inference with the Constitution itself. From the beginning of his career during the revolutionary years, Madison expressed strong support for popular government and majority rule, because from a republican point of view there is no other objective standard to determine political legitimacy. While it is true that he disapproved of "populism" (as we call it today), he did so mainly because it threatened to discredit republicanism as a form of government by rendering it unstable and unreliable. Madison was concerned about the potential abuses

of majority rule but not opposed to majority rule itself. According to Irving Brant, Madison's biographer, Madison fought throughout his career for three great principles: a strong union of the states as the guardian of liberty; freedom of conscience and personal liberty; and a republican form of government, based broadly upon the will of the people. As Greg Weiner argues effectively in a recent book, *Madison's Metronome: The Constitution, Majority Rule, and the Tempo of American Politics*, Madison strongly supported popular government and majority rule, but wished to slow down the tempo of national politics to provide space for reasoned deliberation. Madison surely agreed with Thomas Jefferson, who said in his first inaugural address, "though the will of the majority is to prevail in all cases, that will to be rightful must be reasonable."

Madison and many of his political allies began their political careers during the years of the Revolution, most of them as members of the Continental Army or the Continental Congress, or as office holders of some kind under the continental government. It was in this way that the Revolution produced a division within the governing class of the new nation between those who experienced the war in various continental or national posts and those who fought the war in the state militias or devoted their careers to state or local offices. The "nationalists" traveled abroad and up and down the continent conferring with colleagues from other states, while wrestling with national issues like taxation, foreign affairs, and overall military strategy. They were a relatively small but tightly knit group that included Madison (who served both in the Continental Congress and the Virginia legislature), Jefferson, Franklin, Adams, Hamilton, and, of course, General Washington. They disagreed then and later on many important issues, but they were of one mind about the fatal weaknesses of the Articles of Confederation. After all, they were the ones who had struggled and largely failed to turn the continental system into an effective

political force. They were the first to conceive of the United States as a nation in need of a government worthy of the name. Those who labored in the states came more slowly to this outlook. Most could not reconcile themselves to the concept of a strong national government located in a faraway capital.

Madison, along with several others of this national outlook, began to press in the mid-1780s for revisions in the Articles out of concern that the national union was too weak to sustain itself and, indeed, was on the verge of falling apart. In the aftermath of the Revolution, the states drafted and ratified constitutions that allocated the preponderance of power to the legislatures in keeping with the theory that the executive poses a threat to liberty and the legislature is the appropriate repository of popular power. By the mid-1780s, the various legislatures in the states were erecting trade barriers against neighboring states, issuing worthless paper currency, interfering with treaties with other nations, and allowing mobs to threaten courts of law—all of it under the banner of populism and popular rule. In addition, those legislatures withheld taxes and revenues due to the Continental government, thereby weakening it further and leaving it vulnerable to possible attacks from European powers. One might describe this as the original "populist" moment in the history of the United States.

By 1787, the national group, led by Madison and Hamilton, persuaded the various legislatures to approve a national convention to meet in Philadelphia for the purpose of recommending revisions to the Articles. They also maneuvered in their respective states to win appointment as delegates to that convention.

In preparation for the convention in Philadelphia, Madison drafted a memorandum outlining the key weaknesses of the Articles of Confederation and the features that he felt should be incorporated into a new framework of government. He saw two near-fatal defects in the Articles—first, that they relied upon the

good will of the states to implement the policies or to collect the taxes approved by the Continental Congress, because the continental government possessed no powers to sanction recalcitrant states; second, the Articles required the approval of nine of the thirteen states before any policy could be carried into operation, thereby allowing a minority of states to veto measures approved by a majority. Both were features that tended to enfeeble the continental government—the first by making it impossible for the Congress to enforce its policies, the second by giving to a minority the power to stymie the operations of government. The minority veto he saw as a double-edged weapon that may have protected the minority but at the expense of paralyzing the government. When a few months later the convention discussed methods for ratifying the Constitution, he rejected proposals to require unanimous agreement from the states because, as he wrote in *Federalist* No. 40, it would be absurd to subject "the fate of twelve states to the perverseness or corruption of the thirteenth."

Madison, working in league with other delegates, proposed to dispense entirely with the Articles of Confederation and to draft an completely new constitution for a strengthened national government. He arrived a week early in Philadelphia in May 1787 to plot strategy and to prepare for the task ahead. He used those days to draft his Virginia Plan, which he introduced early in the proceedings to serve as a template for discussion and debate over the form of the Constitution. His Virginia Plan was majoritarian or popular in character, in that it called for both houses in the legislature to be apportioned by population, with elected members of the House of Representatives empowered to select members of the Senate, and then a group of Senators and Representatives in turn selecting the executive. This was in keeping with his theory that the national government should be based upon a representative body answerable to the people, with that body then select-

ing higher officers in the government. By that means he hoped to "refine" public opinion by using the popular branch as the basis for selecting the most able individuals to hold the higher posts in government. He lost those battles in the convention when the smaller states insisted upon an equal representation of the states in the Senate—a compromise that Madison saw as necessary to win support for the Constitution but also not entirely consistent with the principles of republican government. Still, as he saw it, the Constitution that emerged from the convention was a vast improvement over the Articles of Confederation.

With the drafting of the Constitution complete, Madison threw himself into the ratification process, with a focus on two key states—his home state of Virginia and New York. Opponents in his home state did all they could to deny him a seat in the ratifying convention in recognition of his mastery of the arguments for and against the proposed constitution. His eventual success in winning that seat was a critical step in the ratification fight, for, as his biographers agree, without Madison's presence in the convention, the Constitution might easily have gone down to defeat in Virginia, and probably in other states, too.

During these months, Madison shuttled back and forth from his home in Virginia to New York City as a delegate to the Confederation Congress, which provided an opportunity to collaborate with Alexander Hamilton in the ratification debates in New York. Hamilton conceived of a plan to issue a series of essays to be published in a local newspaper answering critics of the Constitution and explicating its various controversial and unfamiliar features. The two men (with the initial help of John Jay) produced eighty-five essays between October (1787) and June (1788), with Madison producing a third of them—often writing them as quickly as his publishers could set the type. Though the essays were published anonymously, most readers suspected that Hamilton and Madison were the true

authors. Still, for that reason, no one knew at the time or for decades afterwards which man wrote which essays.

The essays proceeded according to Madison's analytical style. The papers are closely reasoned and answer objections raised by critics without resorting to personal attacks, overstatement, or hyperbole. Jefferson would later describe the *Federalist* as "the best commentary on the principles of government which ever was written." With the *Federalist*, along with his *Notes of the Debates in the Federal Convention*, Madison authored the two great commentaries on the federal Constitution.

It was in the *Federalist* that Madison authored his most influential essays—especially Numbers 10 and 51—outlining his theories of the extended republic and the separation of powers. These papers are notable for Madison's realism in incorporating conflicts of interest into the operations of government, somewhat in contrast to traditional theories of politics that tended to rely on the good will and virtue of participants. Madison's theories are thus modern in pointing toward self-interest as a principal motivation in politics and in harnessing conflicts of interest as instruments for arriving at the public good—somewhat parallel to Adam Smith's use of self-interest in his theory of free markets.

In *Federalist* 10 Madison addressed the issue that gave rise to the constitutional convention in the first place—the instability in the states due to powers given to the legislatures in the new state constitutions. There were many complaints, he noted, that governments are "too unstable," and that "measures are too often decided, not according to the rules of justice and the rights of the minor party, but by the superior force of an interested and over bearing majority." The root cause of the problem was "faction," which he defined as any group, amounting either to a majority or a minority, activated by some impulse of passion adverse to the rights of others of to "the permanent and aggregate interests

of the community." Since factions cannot be eliminated short of destroying the freedom that gives rise to them, the only solution is to find some means of keeping them in check and limiting the damage they can do. If a faction amounts to a minority of the whole, then, as Madison argues, they can be checked in a popular system by resort to elections and majority rule. But when a faction amounts to a majority, the form of popular government permits it to have its way at the expense of the public good or the rights of the minority. As he developed his argument, it was clear that Madison was worried mostly about factions of interest rather than of passion, and particularly those that pitted the poor against the rich with an eye to redistributing wealth and property.

This, then, was the basic challenge the Constitution addressed—"to secure the public good and private rights against the danger of such a (majority) faction and at the same time to preserve the spirit and form of popular government."

In providing his solution, Madison, perhaps with some help from David Hume, turned on its head the anti-federalist claim that popular governments can operate effectively only in cities or in small territories where the people can form close bonds with representatives. Hume had argued in "The Idea of a Perfect Commonwealth" (1752) that though it is difficult to set up a republican government in a large territory "there is more facility, when once it is formed, of preserving it steady and uniform without tumult and faction." In a large territory, as Hume argued, "the parts are so distant and remote, that it is very difficult, either by intrigue, prejudice, or passion, to hurry them into any measures against the public interest."

Madison's argument, as the late Douglas Adair pointed out, runs parallel to Hume's. While majority factions may run amok in a city or a small territory, they are less likely either to form or to win power in a large system made up of many subordinate parts. "Ex-

tend the sphere," Madison wrote, "and you take in a greater variety of parties and interests; you make it less probable that a majority of the whole will have a common motive to invade the rights of other citizens." But even if such a common motive could be found, the faction would have difficulty communicating it to like-minded citizens across a large system. Thus, he argued that the extended republic formed by the union of the states had an advantage over the individual states in controlling the effects of majority factions. This, he wrote, represented a "republican remedy for the diseases most incident to republican government."

The extended republic, strictly speaking, is not a republican remedy in that it relies upon the expansion of territory and the multiplication of interests (and not representation, per se) to discipline majority factions. Madison certainly had in mind the concept of limited government when he articulated this idea, because the extended republic would prevent government from acting except in rare occasions in which a national consensus could form, organize, and win power. Critics over the years have pointed out that while Madison may have preserved the spirit and form of popular government, his solution effectively dispensed with the actuality of popular rule. Yet the critics miss Madison's main point—which was to design a popular system that tended to temper and slow down the operations of government in order to allow opportunities for deliberation and debate. Determined majorities might still govern, but in the extended republic they would have to sustain themselves across a broad territory and through several election cycles.

Madison was not thinking of the American polity as a nation state in the modern sense but rather as an empire or confederation composed of a jumble of conflicting and dispersed interests with not much in common to unite them. This he judged to be a virtue because he saw that tyranny of the majority is most likely to arise where the people are organized around some common

principle. The contrast here is striking between Madison and his extended republic and the French revolutionaries of the same period, who declaimed about "the people" and "the nation" in interchangeable terms. Madison, though (like Jefferson) an enthusiast for the French Revolution, articulated a theory in *The Federalist* that would have branded him a traitor in Paris in 1792 and 1793. Partly for this reason Madison came later to understand that secession and disintegration posed greater threats to the American constitutional order than populism and tyranny of the majority.

There is an influential critique of Madison that suggests that, if the extended republic is effective in preventing tyranny of the majority, then the separation of powers into three competing departments of government is redundant and unnecessary. Yet the separation of powers in the Constitution was not designed principally to discipline majorities but rather as an instrument to force government to control itself. It was an accepted principle at that time—and remains so today—that the concentration of all powers into a single person or department is the very definition of tyranny. The separation of powers into different and conflicting departments—executive, judicial, and legislative—is the foundation for the rule of law as an alternative to arbitrary power. As Madison argued in *Federalist* 51, "In framing a government which is to be administered by men over men, the great difficulty lies in this: you must first enable the government to control the governed; and in the next place oblige it to control itself." The separation of powers was a device to prevent tyranny, and operated on the basis of conflict out of which something akin to the public interest was expected to emerge.

As Madison wrote, "the policy of supplying by opposite and rival interests the defect of better motives might be traced through the whole system of human affairs, private as well as public . . . the constant aim is to divide and arrange the several offices in such a

manner as that each may be a check on the other." But it is true, to give critics their due, that the separation of powers does to some extent discipline majorities by forcing them to win control of all three branches in order to impose their will, though it is also true that disciplined minorities also face the same challenge. As with the extended republic, the separation of powers tends to slow down the operations of government to permit deliberation.

Madison may have been too sanguine in his belief that the problem of minority faction can be readily taken care of by an appeal to the ballot box. In the first decade following the ratification of the Constitution, Madison and Jefferson, along with many allies in the states, found themselves fighting against Hamilton's commercial program that relied on government borrowing, a national bank, subsidies and tariffs to aid commercial enterprises, support for Great Britain in her wars against France, and loose construction of the Constitution. Madison, taking up his pen against Hamilton, accused the Federalists of trying to organize the new republic on the model of Great Britain and by building support through office seekers and corrupt bribes through the operations of the Bank of the United States. In order to make their opposition effective, Jefferson and Madison saw that they would have to build an opposition party based upon the voters in the states to oppose the schemes of consolidation taking place in the Capitol. Their party—the Democratic-Republican Party—succeeded in winning the contested election of 1800, along with the next five presidential elections through 1820, thereby providing the instrument for that durable majority that Madison felt was necessary to permit a majority to govern. In the process, they also created the needful instrument (the mass political party) for the expression of populist impulses.

In 1836, Madison was in the final year of his life, and as he noted in one of his letters, he was the last surviving member of Consti-

tutional Convention of 1787 and of the Virginia Assembly that in 1777 approved the Virginia Statute for Religious Freedom. "Having outlived so many of my contemporaries," he wrote, "I ought not to forget that I may be thought to have outlived myself."

He had been born a British subject and had survived nearly through the administration of Andrew Jackson, the populist president who resurrected the Democratic Party as an instrument for majority rule. Alexis de Tocqueville had only just the year before published the first volume of *Democracy in America*, the widely-read work that declared that, notwithstanding the Constitution, democracy and majority rule had won the battle in America against the rule of aristocracy and elites. John C. Calhoun, Jackson's Vice-President, would concur disapprovingly a few years later in *A Disquisition on Government*, where he argued that majority tyranny is inevitable in any system of popular government. A majority, he argued *contra* Madison, will eventually discover itself in any popular system, and when it does it will approve measures for taxes and regulation that will be oppressive to minorities. Calhoun, who in those years flirted with nullification and secession, favored a system that would permit influential minorities to veto measures supported by majorities.

As his health declined in that final year of his life, Madison had every reason to think that his constitutional measures for regulating factions had failed in the face of the populist resurgence of the Jackson years, the rise of sectionalism, and the general movement in America at that time toward the equality of condition. Yet, given the views he expressed in the letters he wrote at this time, Madison did not seem especially worried about majority tyranny, populism, or the capacity of the Constitution to deal with those particular challenges. He feared instead that his extended republic might fall victim to the centrifugal forces of secession and disunion. In 1834, knowing that the end was not far off, he wrote a letter titled "Ad-

vice to My Country," to be opened and published only after his death. "The advice nearest to my heart and deepest in my convictions," he wrote,

> is that the Union of the States be cherished & perpetuated. Let the open enemy to it be regarded as a Pandora with her box opened; and the disguised one, as the Serpent creeping with his deadly wiles into Paradise.

Those fears proved prescient at the time: the generation of leaders that followed disregarded his advice and interpreted the outcome of one election in 1860 as a signal to break up the union. Who knows?— Madison's advice may yet be pertinent today. The Constitution by its design can handle threats of populism and majority tyranny. Its undoing—should that ever happen—will come from other sources. George Washington and Abraham Lincoln, emancipated from the perfervid imagination of the media, can rest easily.

ANDREW C. McCARTHY

Populism versus Populism

The West is abuzz with reports of a populist wave: rolling through Europe, sweeping across the Atlantic, and crashing into Gomorrah-by-the-Potomac. Donald Trump's election as president of the United States—a watershed event as unthinkable as it was improbable to many across the ideological spectrum of American punditry—followed hard on the British people's vote to exit the European Union, a cognate popular rejection of bipartisan elite opinion.

In short order, Matteo Renzi was the next shoe to drop. Italy's now-former prime minister, a young, attractive, politically "progressive" technocrat, darling of the European cognoscenti, had been hailed—it seemed like only yesterday—as Rome's (or is it Brussels's?) answer to Barack Obama. He resigned in November, though, after the Italian people resoundingly defeated his proposed constitutional "reform." The scare-quotes are offered advisedly: Italy having been virtually ungovernable since Garibaldi forced what passes for its unification, Sig. Renzi's reform was a scheme to end the paralysis by accreting power to himself at the expense of the legislature. Think of it as a gambit to codify U.S. President Barack Obama's "I've got a pen and I've got a phone" style of centralized rule.

The victorious Trump had the populist wind at his back. Thus, efforts to caricature the real-estate mogul and reality-television star as a budding Hitler fell flat. Renzi, by contrast, ran into the teeth of that wind. The hyperbole casting him as a would-be Mussolini took its toll.

Renzi's fall is the continental aftershock of the Brexit earthquake. The "Remain" camp's failure ushered out David Cameron of the Europhile center-right. He was succeeded by Theresa May, who promised to carry out the public will despite her (understated) support for "Remain." Ms. May proceeded to overplay her hand, gambling on a call for new elections. In the event, the Tories *lost* seats and she nearly lost control of the government. Nonetheless, Brexit is proceeding, albeit at a snail's pace.

In France, the socialist President François Hollande's favorability rating so plunged—under 10 percent in some polls—that a reelection bid was inconceivable. The bruising campaign to succeed him was a wholesale rejection of the French political establishment. Former Prime Minister François Fillon got the social conservative nod after adopting an economic program that was downright Thatcherite (*sacré bleu!*), its sights trained on Paris's bloated public sector. But he faded due to a corruption scandal, making the finale a duel between outsiders, both riding the populist wave: the virulently anti-Islamist Marine Le Pen of the Nationalist Front, and the eventual victor, Emmaneul Macron, an assertedly reformed socialist who created a new party in order to make his run and who has gone out of his way to forge a working relationship with President Trump, despite the latter's unpopularity among Europe's cognoscenti.

Meanwhile in Germany, Angela Merkel, who set Europe's tinderbox ablaze by rolling out the red carpet for millions of Muslim migrants from North Africa and the Middle East, is suddenly advocating strict anti-Islamist measures—such as ban-

ning Muslim women from donning the full veil in public. These eleventh-hour concerns over Islamic resistance to assimilation in the West arise as she campaigns to seek a fourth term amid poll numbers that, while still good (60 percent in March 2017), have sagged.

Certainly, change of some potentially transformative kind is gripping the West. But is "populism" the right diagnosis for it? Count me a skeptic. Oh, it is not that the populist impulse is to be doubted; the question is whether attaching the label "populism" to the dynamic helps us comprehend the multi-layered, internally contradictory angst behind it. In recent years, the misdiagnosis of the complex grassroots surge in the Middle East, the so-called Arab Spring, led to disastrous policy choices. Oversimplifying such a phenomenon has consequences.

For one thing, turning our attention back to the American election, one might think a victorious populist candidate would win the popular vote. Fully 54 percent of Americans cast their ballots against Donald Trump. His principal rival, Hillary Clinton, outpaced him by nearly 3 million votes, slightly over 2 percent of the 137 million votes cast—about the same amount as Jimmy Carter beat Gerald Ford by in 1976. In fact, though she did not win a majority of the electorate (she garnered about 48 percent), the percentage edge by which Mrs. Clinton's popular-vote plurality exceeds Trump's is greater than that of ten elected presidents, five of whom won the popular vote (Nixon in 1968, Kennedy, Cleveland, Garfield and Polk), and four—in addition to Trump—who won electoral majorities despite losing the popular vote (George W. Bush in 2000, Harrison, Hayes, and John Quincy Adams).

Yes, the story of the election *is* a popular surge, but it is less a rush to Trump than a stampede away from Democrats. Trump performed impressively in attracting 2 million more voters than the 61 million the Republican standard-bearer Mitt Romney had in

2012. But Democrats have now hemorrhaged over 4 million voters since Obama's high-water mark of nearly 70 million in 2008. In that same eight-year time frame, the U.S. population has *grown* by about 18 million.

All that said, had just 80,000 votes (roughly half a percentage point) shifted to Clinton in three tightly contested battleground states (Michigan, Pennsylvania, and Wisconsin), we would not be talking about a populist revolt in the United States. We would be talking about how Americans elected a former First Lady and twice-elected U.S. senator who has been a pillar of the political establishment for a generation. Trump won by a hair, so the pillar is now a relic.

There is, in addition, more than a little irony in the fact that Trump, the populist, was rejected in the "direct democracy" sense but nonetheless prevailed thanks to the Electoral College, one of the most anti-democratic institutions created by the U.S. Constitution.

At the start of the Republic, the Framers frowned, at least for public consumption, on political parties and the notion of national campaigns. "The office," it was said, "should seek the man," not vice versa. The Electoral College was the constitutional contrivance by which the states, through carefully chosen electors (rather than the populace), would exercise patriotic good judgment in picking the right man—it would surely be a man back then—to lead a far more modest federal government. The functioning of the College changed in short order, and drastically over time, as the societal shift toward direct democracy made the electors more beholden to the voters. Yet the College still performs its essential role of ensuring that the presidential election is decided by the states, not by a national popular vote that would render small states irrelevant. (Note that California, a single huge state that Clinton won by a staggering margin of 4.3 million, accounts for her entire popular-vote edge over Trump.) That is as it should be.

George Will sums matters up with characteristic clarity: "[T]he Electoral College shapes the character of majorities by helping to generate those that are neither geographically nor ideologically narrow, and that depict, more than the popular vote does, national decisiveness."

Still, it is not the mechanism on which one would expect a populist to rely.

It cannot be gainsaid, though, that populism, at a certain elevated level of generality, is a significant factor in the West's electoral tumult. The question is whether it is a quantifiable factor because the populism has evolved into a single, identifiable movement. I do not believe so.

As the prior essays in this series have eloquently related, populism is a grass-roots phenomenon oriented against the establishment. But "establishment" is an amorphous term that means different things in different places, and thus the reasons for resistance to it vary widely. As has become increasingly obvious, moreover, a single establishment can meet resistance for divergent reasons because the grass-roots are not monolithic.

The populist urge is no stranger to envy and scapegoating; it is thus comfortably at home on the political left, fueling dark narratives of exploitation, colonialism, mercantilism, and income equality when the establishment to be opposed is private wealth. It has found a home on the right, particularly in the era of Reagan and Thatcher, when the targeted establishment was statist government and its incursions into the shrinking realm of individual liberty.

What does that tell us, though, in our own age of crony socialism, an expanding combination of statist governance and private wealth, often unabashedly allied in their euphonious "private-public partnerships"?

As the administrative state grows ever more intrusive, favored business interests extend the chasm between haves and have-nots.

Small competitors, unable to keep up with the costs of regulatory compliance, are crowded out. The behemoths meanwhile bask in the glow of too-big-to-fail status, battening on the profits while their losses are socialized. The objections to these cozy arrangements between big government and big business are surely popular. Yet, they are often antithetical to each other: the left clamoring for more regulation to cut the tycoons down to size; the right demanding the dismantling of Washington's metastasizing bureaucracy.

In today's populism, globalization is frequently cited as the lightning rod that harmonizes the diverse populist strands. But putting aside whether a global anti-globalism can be viable, here again we encounter as much division as unity.

Crusading to save the planet from the scourges of industrialization, fossil-fuel production, and climate change, the left's post-nationalist populists seek more muscular global governance to rein in international commerce—heedless of the stubborn fact that the welfare state, already on an unsustainable cost-benefit trajectory, is dependent on economic growth. The right's populists see the transfer of national sovereignty to supra-national tribunals as a peril to be opposed; they want the evisceration of multi-lateral arrangements in the hope that the benefits of commerce (rising employment and wages) can be hoarded at home—heedless of the stubborn fact that international trade provides millions of domestic jobs while lowering consumer costs.

Clearly, wrath against the established order is bubbling up. To bumper-sticker it as "populism" may be technically accurate, but it is not very edifying. Whether as a weathervane or in search of a villain to blame, a bumper-sticker tells us what we seem to believe or want to believe, not why or whether we should believe it. In *Liberal Fascism*, his magnificent "Secret History of the American Left from Mussolini to the Politics of Meaning," Jonah Goldberg recalls a proclamation by America's proto-populist. "The people of Nebras-

ka are for free silver," thundered William Jennings Bryan, "and I am for free silver." Okay, but why? On that core question, Bryan could only burble, "I will look up the arguments later." That, in a nutshell, is populism. As a lawyer, I think it would be unseemly to look too far down my nose at the facility to argue whatever side of the question expedience (or "Mr. Green") dictates. That facility, however, is a professional skill, not a philosophical position.

Like fascism, populism is a term often bandied about with little or no consensus about its meaning or direction. It is the callow voice of a culture that gushes about its *values* while its *principles* fade from memory. To be sure, in a democratic society, a politician who loses touch with what the public is thinking, with the angst it is feeling in threatening times, is apt to have an aborted career. One remains mindful, though, of the Burkean wisdom that "your representative owes you, not his industry only, but his judgment; and he betrays instead of serving you if he sacrifices it to your opinion."

Donald Trump's judgment has been an issue throughout his four-plus decades in the public spotlight. He has dramatically changed his business model (after multiple bankruptcies), his political affiliation (five times since the late 1980s), and even his view of "crooked" Hillary Clinton (until recently, a "terrific person," a "great senator," and "a great wife to ... a great president"). Similarly elastic have been his positions on such matters as protection of the unborn (he says he is now pro-life but continues to support government funding for the rabidly pro-abortion Planned Parenthood), socialized medicine (he now says Obamacare must be repealed and replaced, but he has applauded the Canadian and British government-run healthcare systems), and the war in Iraq (he claims to have opposed it from the start, though he is on record offering tepid support before the U.S. invasion and scathingly condemns Obama's premature pull-out).

Even on his signature campaign issues of immigration, trade,

and national security, Trump has not exactly been a model of clarity—a distinct asset for the successful populist, who must never plant his feet too firmly. His quest for the Republican nomination in a talented seventeen-candidate field caught fire when he called for mass deportations and border security. "Make America Great Again" was the campaign's slogan but "Build that Wall!" was its battle cry. Indeed, the Left's tireless narrative that Trump is a racist is built on a melding of these two messages into a smear that Trump's idea of American greatness is the absence of Mexican immigrants.

Once the GOP nomination was secured, however, and the campaign shifted to the more centrist general electorate, Trump's rhetoric softened, with traces of his history as a supporter of amnesty detectable in promises to "bring back" many of the aliens he has committed to deport—with legal status. As some of us predicted during the campaign: there being neither the public will nor enforcement resources necessary to deport upwards of 11 million people, Trump's actual immigration enforcement program was bound to look a great deal like the Mitt Romney "self-deportation" plan he once ridiculed: step up border security, deport aliens with serious criminal records, prosecute businesses that knowingly hire the "undocumented," and rely on the aliens themselves to draw the conclusion that leaving—or not coming in the first place—is the best option. So far, it's working—there has been a dramatic decrease in illegal border crossings since Trump took power. Yet, he has reneged on the campaign promise to undo Obama's "DACA" program, an effective amnesty for illegal aliens who were brought to the U.S. as children. We should expect to find the new president working with the dreaded political establishment to give legal status (likely, citizenship) to these so-called Dreamers, and perhaps other sympathetic categories of aliens.

Trump professes himself a free-trader who nonetheless sees America being taken for a ride by "bad trade deals" and greedy

American corporations that move operations to friendlier overseas business climes. This toxic combination, in which China and Mexico are the main culprits, has in Trump's telling robbed the American middle class of tens of millions of manufacturing jobs, which he promised to reclaim. The narrative clearly resonated in rust-belt states like Michigan and Pennsylvania, which voted for the Republican presidential candidate for the first time since 1988—back when blue-collar workers were known as "Reagan Democrats."

Still, Trump's anti-trade rhetoric sounded the Manichean wiles of left-wing populists from Bryan to Saul Alinsky, whose *Rules for Radicals* (Rule 12) instructed aspiring "community-organizers" to "pick the target, freeze it, personalize it, and polarize it."

Contrary to popular belief, American manufacturing is up. It is manufacturing *employment* that has suffered. That is the fallout of robotics and other technological innovation, not trade. In recently rehearsing Economics 101 at *National Review*, Kevin D. Williamson illustrated that the putatively negative side of a trade imbalance reflects not a budgetary deficit but a *surplus in capital*—i.e., foreign vendors, rather than using the dollars they make to buy American goods, invest in American assets.

As the reality set in of potential ruin from tariff and trade wars portended by the campaign rhetoric, Trump in the Oval Office bears little resemblance to Trump on the hustings. His promised overhaul of the North American Free Trade Agreement ("the single worst trade deal ever approved in this country") has been more like cosmetic tweaking. He did fulfill his commitment to torpedo the Trans-Pacific Partnership (a multilateral agreement signed by Obama—a cornerstone of the ballyhooed but unachieved "pivot to Asia"—that has no chance of Senate approval); but he says he will replace it with a series of bilateral accords, such that the end result could be a gaggle of disjointed agreements, rather than one

over-ambitious one. Trump is still talking tariffs, but the punitive ones of campaign lore—upwards of 35 percent, on companies that transfer divisions to foreign countries and then seek to sell their (consequently cheaper) products in American markets—seem highly unlikely.

Trump's national security positions are similarly Delphic. He has been unfairly pegged as an isolationist for rebuking Bush's Islamic democracy project and Obama's war on Qaddafi's regime in Libya. In fact, Trump's objection has been to what he regards as ill-conceived interventions, not interventions in furtherance of America's vital interests. Nevertheless, his perception of those vital interests is not clear. He has been largely successful in "wiping out" the Islamic State, as he promised to do. The "caliphate" has been defeated in Iraq and is shriveling in Syria. Trump, moreover, has reinvigorated ties with Sunni Arab states (Saudi Arabia, Egypt, Jordan), which could blunt the advance of Shiite Iran, which Obama did much to empower. The cost of this, however, has been an enmeshing of U.S. forces in the complex Syria conflict, which he had vowed not to do. Already there have been U.S. attacks on regime targets, and there remains the specter of crossfire with Russia and Iran, the Assad regime's backers.

On the campaign trail, Trump depicted NATO as a senescent remora, filled with fading powers that divert military dues to fund lavish welfare states while American taxpayers foot the bill for their security. Since being sworn in, he has embraced the alliance in fits and starts: true to his word to pressure member countries to pony up more defense funding, but resigned to NATO's usefulness, as the better relations he hoped to establish with Russia seem unlikely to materialize.

On Iran, Trump variously vowed to rip up, rework, or strictly enforce Obama's Iran nuclear deal (the "Joint Comprehensive Plan

of Action" between the jihadist regime in Tehran and the United States, plus its negotiating partners—Russia, China, Britain, France, and Germany). It seems clear there will be no near-term decision to renounce it, and there remains indecisiveness about how to deal with the mullahs. On Russia, Trump's campaign rhetoric was alarmingly admiring of dictator Vladimir Putin, a "strong leader" who has "very strong control over his country"—characterizations jarring to hear from a would-be American president. The fear is that these rose petals reflect naiveté rather than vapid diplo-banter: On the one hand, Trump appears to envision a strategic alliance with Russia to fight ISIS and other Islamic terrorists . . . notwithstanding Russia's ongoing, operational alliance with Iran, the world's leading state sponsor of jihadist terror.

On the other hand (with populists, there are always many hands), Trump's latent interest in invigorating NATO and commitment to reverse Obama's hollowing out of the armed forces have predictably put him at loggerheads with Putin. The pursuit of better relations is also complicated by the continuing controversy over whether Trump's campaign "colluded" in what U.S. intelligence agencies conclude was a Kremlin influence operation to interfere in the election—in hopes of damaging Clinton and aiding Trump's unlikely victory. The media-Democrat narrative along these lines has made it difficult for the new president to press his domestic agenda, while incenting him to be more confrontational with Moscow than he'd probably prefer.

It is in the nature of populism that neither supporters nor detractors can predict with confidence what Trump will actually do as president. It should come as no surprise, then, that Trump's victory has spurred efforts to give content to his populism. Most notable of these from conservative Republican circles has been a plea by Mike Lee, the stellar senator from Utah, for the pursuit of "principled populism"—an exercise in cognitive dissonance over which I

caused a minor stir (at *National Review*) by likening it to a call for "a sober Bacchanalia."

The senator's brief strangled in its own illogic, as odes to populism inevitably do. The "characteristic weakness" of populism, he conceded, is the lack of "a coherent philosophy," which inevitably makes its "proposals" (I'd have said "careenings") "inconsistent" and "unserious." Well, yes . . . that is because populism is inherently unprincipled, inconsistent, and unserious, such that arguing for "principled populism" is a fool's errand. Lee is anything but a fool. His is a clever effort to appeal to Trump—who will need cooperation from the Republican-controlled Congress—by exploiting this supposed populist moment for conservative ends. As he dilated on the subject, Lee's "principled populism" emerged as a menu of conservative proposals "focused on solving the problems that face working Americans in a fracturing society and global economy." The menu is highly appealing, but it is not "principled populism"; it is conservatism—or, as Lee modified it, "authentic conservatism" (the modifier seems a subtle rebuke of the progressive-lite "compassionate conservatism" of the Bush-43 years).

As I observed at the time, Lee's entrée into the trendy populist brand was his critique of the "chief political weakness of conservatism," which he took to be the failure to perceive problems. This is a misdiagnosis. Conservatives are quite good at perceiving problems—especially problems demagogically manufactured into crises for the purpose of rationalizing populist solutions, which historically run in the statist direction. In reality, the chief political "weakness" of conservatism—it is better to think of it as a *challenge*—is that modern Americans are conditioned to expect that government can solve all our problems, or must at least try to solve them. It is the lot of conservatives to resist solutions that are popular but barmy. Populism cannot change the fact that government is incapable of solving problems upstream of government—prob-

lems of culture and complexity that government amelioration efforts, however well-intentioned, often exacerbate.

There is obvious incompatibility between conservatism's "don't just do something, stand there" nature and populism's demands for action that is forceful even if rash. Yet Lee managed to convince himself that populism is capable not only of ratcheting up limited-government approaches but even "anchor[ing] conservatism to the Constitution and radically decentraliz[ing] Washington's policymaking power." Again, these are worthy conservative objectives. They are rooted, however, in a deep understanding of why the Constitution's separation-of-powers framework and promotion of individual liberty are, in the long run, good for society. That is not an understanding populism is wont to help along. Populism is more mood than theory, and is thus notoriously content to have big-government preening overrun limited-government caution.

Senator Lee deserves credit nonetheless for trying to wage conservatism by defining populism in a manner that might be enticing to Trump. The new president simply is not ideological. Neither is he a conventional politician, much less a technician steeped in policy wonkery. His learning curve will be steep.

On the positive side, Trump's learning curve, like the America he envisions leading, is open for business. His exhilarating victory paved the way for a ritual pilgrimage to Trump Tower in midtown Manhattan by political heavyweights and those who crave that lofty status, all vying for the new president's heart and mind.

The parade gave conservatives no shortage of appointments to celebrate. Senator Jeff Sessions from Alabama, a highly accomplished former prosecutor and Senate scourge of illegal immigration, is now the attorney general. A triumvirate of battle-tested former generals—H. R. McMaster, James Mattis, and John Kelly—lead crucial national-security agencies (the National Security Council and the Departments of Defense and Homeland Securi-

ty).[1] Congressman Mike Pompeo, first in his class at West Point and a Harvard Law School graduate after distinguished military service, heads the CIA. Scott Pruitt, the excellent Oklahoma state attorney general who made a habit of suing the Environmental Protection Agency over its economically ruinous, Obama-driven excesses, now runs that very agency. Rick Perry, the extraordinarily successful former governor of Texas, was tapped by Trump to lead the Energy Department, despite once famously forgetting its name in a 2012 presidential debate—which seemed forgivable since it was then an entity he hoped to abolish. Tom Price, the longtime Georgia congressman and medical doctor who has vigorously opposed Obamacare, is now charged with administering it—and managing the transition away from it—as Secretary of Health and Human Services. A passionate school-choice advocate, Betsy DeVos is the new Education Department Secretary. And so on.

But yet another "on the other hand": For a populist who thrilled his base with promises to "Drain the Swamp"—a chant that rivaled the intensity of "Build that Wall" during Trump rallies in the campaign's closing weeks—the new President is installing many political establishment honchos in key administration posts. Reince Priebus, the former chairman of the Republican National Committee, is the White House chief-of-staff, responsible for who and what the President sees.[2] At the helm of the Labor Department is Elaine Chao, the former Bush Labor Secretary and the wife of the Senate Majority Leader Mitch McConnell, the D.C. establishment personified. The administration features several alumni of Goldman Sachs, the investment bank nes-

1 Trump's original National Security Adviser, Michael Flynn, was forced to resign after only a few weeks of service, over his failure to report accurately on a post-election meeting with Russia's ambassador. What should have been a minor flap was magnified by the aforementioned "collusion with Russia" controversy.

2 In July 2017, Priebus resigned as chief-of-staff. He was replaced by the retired general John Kelly. A replacement for Kelly as Homeland Security secretary had not been named as we went to press.

tled at the intersection of government and finance that Trump disparaged throughout the campaign: the senior adviser Stephen K. Bannon[3] (who is actually an anti-establishment firebrand); the Goldman president Gary Cohn as chief economic adviser; and Treasury Secretary Steven Mnuchin, Trump's campaign finance chairman (whom the left, in grand populist hyperbole, accused of once foreclosing on a ninety-year-old widow over a twenty-seven-cent payment error).

Trump appointed another "master of the universe," Exxon Mobil CEO Rex Tillerson, to serve as Secretary of State. A corporate titan whose diplomatic experience was earned not on the chancellery cocktail circuit but by making hardnosed international business deals, Tillerson is a self-proclaimed close friend of Vladimir Putin. He accepted Russia's Order of Friendship medal in 2013. The following year, he opposed sanctions against Russia after Putin's annexation of Crimea, and—against the Obama administration's wishes—attended a petroleum conference in Moscow at which he shared a stage with a Putin crony under sanctions.

Tillerson is also a climate-change enthusiast who supports imposition of a carbon tax and has lavished praise on the Paris Agreement on climate change. This was intriguing since, in campaign mode, Trump railed against corporate taxes and pledged to retract America's signature from the Paris Agreement.

Trump's position was that climate change is essentially a hoax peddled by China to saddle the U.S. with stifling restrictions on commerce. Following his election, however, the new president told *The New York Times* his mind was "totally open" on this "very complex subject." His post-election guest list included enviro-zealots Al Gore and Leonardo DiCaprio. There was also the Tesla CEO Elon Musk, who agreed to join Trump's business advisory council. Though dismissive of Trump during the campaign, Musk hoped to persuade him to lead on the Paris

3 In August 2017, Bannon resigned.

Agreement rather than abandon it. So, evidently, did hundreds of major American corporations, 360 of which—including such heavyweights as General Mills, Hewlett Packard, Nike, DuPont, and Unilever—co-signed a letter urging Trump to reaffirm Obama's Paris pledge.

The Paris Agreement, which President Obama formally signed in September 2016, is a useful measure of populism's weaknesses as a diagnosis of, and prescription for, the current political moment. The pact regards the climate as a global corporate asset that must be managed by a supra-national institution, the United Nations, to which nation-states make commitments to reduce greenhouse gas emissions (including such ubiquitous substances as water vapor and carbon dioxide). Of course, the U.N. has no means of compelling its members to honor their commitments. Thus, the point of the deal is to make these aspirational reduction targets politically viable and, ultimately, legally enforceable.

In theory, an international agreement may not be legally enforced in the United States absent compliance with the Constitution's treaty process. In addition, legislation is often necessary because treaties are presumed to be understandings between nations that do not create rights and obligations for individual citizens. That means the people's representatives are supposed to weigh in. Popular opinion is supposed to matter.

So, what does public opinion tell us? Well, the airy notion of "saving the planet" is undeniably popular. In polling touted by the *Washington Post*, the Chicago Council on Global Affairs maintains that 71 percent of Americans (including 57 percent of Republicans) favor the Paris Agreement goal of cutting carbon emissions, although the paper concedes that many Americans are unaware of the agreement's terms. It is not to be doubted that support is significant among younger people educated in our universities. The Bernie Sanders populists do not engage in much economically productive activity but have been

reared on green activism as a substitute for religious devotion.

Inconveniently, though, the green cause has decidedly less appeal when consideration shifts from its elusive goals to the concrete, painful means of their achievement. Notwithstanding the absence of any assurance that compliance would meaningfully decrease temperatures, the Paris Agreement calls for the United States to reduce emissions by over 25 percent by 2025. That would necessarily cause a spike in energy prices, significantly driving up the cost of consumer goods and, in turn, gutting employment as producers struggle to cut expenses.

There is a conceptual debate about global warming—the extent to which it exists and to which human activity is a material cause—despite the alarmist left's best efforts to marginalize climate-change skeptics as "deniers." Still, the practical political debate, as ever, is about costs and benefits. A society that eschews the pain of balancing its budget, regardless of the obvious damage mounting debt will do to future generations, is not about to volunteer for painful economic contractions in order to achieve speculative climate benefits to be realized decades from now. Consequently, there is no way the Senate would approve the Paris Agreement—not even by a bare majority, much less the two-thirds supermajority required by the Constitution's Treaty Clause. Nor would Congress as a whole enact legislation that would implement the agreement's terms.

Knowing all of this, Obama signed it anyway. He calculated that climate-change pain could be imposed without Congress's consent—just as he unilaterally subjected the nation to the security risks of the Iran nuclear deal, another multilateral agreement that was never ratified under U.S. law but was "endorsed" by the United Nations (specifically, by the Security Council).

Alas, Obama's calculation was shrewd. Transnational progressives have developed cagey ways to circumvent democratic obstacles to their globalist agenda. International agreements are drafted

to include terms purporting that they "enter into force" when a certain modest number of nations sign them, regardless of whether this is sufficient to bind any particular signatory nation under its domestic law. The Paris Agreement, for example, is said to have "entered into force" on November 4, 2016, on the strength of acceptance by a mere fifty-five nations (out of 197 that are "parties to the convention"). Once an agreement is "in force," international lawyers and bureaucrats begin claiming that it has created "norms" with which even non-signatory nations must comply under "customary international law."

Moreover, another international agreement, the 1969 Vienna Convention on Treaties, holds that a nation's signature on a treaty, even if not adequate for ratification under that nation's law, obliges that nation to refrain from any action that could undermine the treaty's objectives. Since the United States has never ratified the Convention on Treaties, you might think its provisions are irrelevant to our consideration. But the post–World War II web of multilateral conventions is the maddening thicket of transnational progressivism, where "the law" is whatever end progressives seek to achieve—and the principle of democratic consent is a quaint oddity. The U.S. State Department, a devotee of international legal structures despite their erosions of American sovereignty, tells us that because several other nations have ratified the Convention on Treaties, "many" of its provisions are now binding customary international law even if the treaty remains unratified. Thus—voila!—the conceit that presidents (progressive ones, anyway) may unilaterally subject the nation to international obligations, even ruinous burdens, without any input, much less approval, by the people's elected representatives.

To his credit, after much hemming and hawing, President Trump defied the climate alarmists and followed through on his commitment to withdraw the United States from the pact. Still,

there is a whiff of his approach to the aforementioned Trans-Pacific Partnership. Trump did enough strategic handwringing to take the pulse of his base and learn that reneging on the campaign pledge would be politically crippling. Still, he was sensitive to the tug of the left, and has been responsive to the E.U. tirade that followed his decision. At a gut level, he grasps that the best solution to the threat of global warming is private-sector innovation, not public-sector regulation. That, moreover, is consistent with the drive for the economic growth he desperately needs to address such looming perils as debt and bankrupt entitlement programs. Yet, climate change is an article of faith among young voters, opinion elites, and world leaders whose approving cooperation he covets even as he bashes them rhetorically. He has withdrawn from the agreement, he assures them, but he has not abandoned it—encouraging hope that he will renegotiate: The Art of the Deal.

That is the fate of the populist: transactional, not principled; the follower of public opinion, not the shaper; a reflection, not a compass. The stubborn truth is that there is no "the people" in the sense of one mind. The people may think they want the swamp drained, but few of them actually want the swamp to disappear—they just want a better breed of swamp creature. On climate change, as on much else, what they want is contradictory: a pristine earth and its exploitation for their benefit—*sustainably*, of course.

Though he feared pure democracy's tendency toward tyranny of the mob, Hamilton probably did not say that the "people is a great beast." However apocryphal the attribution, there is much to be said for the sentiment, and for de Tocqueville's wisdom: "The will of the nation is one of those phrases most widely abused by schemers and tyrants of all ages." The "Arab Spring" is case in point.

Legend has it that a democratic uprising erupted on January 4, 2011, when a fruit vendor named Mohamed Bouazizi set himself ablaze outside the offices of Tunisian klepto-cops who had seized

his wares. According to Western lore, the suicide protest ignited a sweeping revolt against the corruption and caprices of Arab despots by repressed populations desperate to determine their own destinies—desperate to actuate the "desire for freedom" that, in President George W. Bush's telling, "resides in every human heart."

It was a tragic misreading, transmogrifying a complex phenomenon in an anti-democratic culture into a relentless wave of democratic populism. This is not to say that the Arab Spring was bereft of young, tech-savvy, secular democrats. It was delusional, though, to showcase them as the face of the revolution. The claim that democracy had animated the Muslim masses was sheer projection by Western analysts, an elevation of hope over experience regarding a region whose authoritarian culture of voluntarism (conception of Allah as pure will) and hostility to non-Muslims rejects liberty, equality, and the unity of faith and reason. Looking back now at Turkey, Egypt, Syria, Libya, Iraq, and so on, it is obvious—as some of us maintained at the time—that the Arab Spring was better understood as a populist ascendancy of sharia supremacism. Its Islamist leaders were quite content to exploit democratic means (particularly, popular elections) for an end that was the antithesis of democracy's liberty culture: the installation of authoritarian sharia governance.

By interpreting the revolt as democratic populism, Western leaders rationalized the provision of aid and encouragement to anti-Western Islamists. Support for Islamists inexorably empowered their jihadist soul mates. Inevitably, the region exploded in conflict, causing massive population dislocations. Yet, unwilling to let go of the Arab Spring illusion, Germany's Chancellor Merkel and her allied Euro-progressives laid out the welcome-mat for millions of Muslim refugees, even though it was well known—though studiously unmentioned—that influential Islamist leaders have instructed the diaspora to migrate into Western societies but resist assimilation, to pressure the host countries to accede to demands

that swelling enclaves govern themselves under Islamic law and mores. The result: European nations are under jihadist siege, and their citizens are rebelling against not only their political establishments but against a modern conception of "Europe" that bears little resemblance to a West once worth fighting for.

Over-interpreting the latest wave of American populism would also be a mistake. It is freely conceded that the 2016 campaign elucidated a nation's rage against the political establishment. But it is a deeply divided nation that rebels for different reasons.

Progressive populists indict the capitalist system for wage stagnation, under-employment, and the explosion of education and healthcare costs. They demand a more robust safety net (i.e., ever more redistribution of wealth) and an even more extensive, aggressive administrative state (i.e., ever less democratic choice) to tame the tumult of market cycles, "save the planet," and impose their anti-bourgeois pieties. As much as I'd like it to be, this is not a fringe position. So stunning was Trump's narrow victory that we've quickly forgotten what preceded it. Nevertheless, the other major story line of 2016 was how close the populist candidacy of Bernie Sanders, an avowed socialist, came to prying the Democratic nomination away from Hillary Clinton. It failed only because the party establishment rigged the contest for its preferred epigone. Sanders's shock troops have not gone away; today, they are the dynamic faction on the American left.

Trump's populist following is more difficult to read. It is dead set against big government . . . except when it's not. It wants its wall built, but with a big door through which legal immigrants will stream in. It wants government regulation pared back, but with more tariffs and restrictions against foreign manufacturing and currency manipulation. It wants ISIS destroyed, but without committing American troops. There are, however, several things on which it is clear: It is proudly pro-American, ostentatiously patriot-

ic, pro-military (without being adventurous), pro-law enforcement, and opposed to an open-door for Muslim immigration in the absence of "extreme vetting" to weed out potential terrorists and anti-Western agitators.

The left and several of Trump's detractors on the right imputed to his "America First" rhetoric the pre–Pearl Harbor isolationism of that name, which sought to appease Hitler and refrain from war in Europe. It is unlikely, though, that Trump was even aware of the connection. His "movement," as he came to call it, was an unapologetic blowback against the Obama left. It is because he accurately read this mood and became its vehicle that Trump emerged victorious. But the nearly implausible narrowness of his triumph and the enduring strength of progressive populism caution against construing the 2016 election as a wholesale rejection of Obama's transformative program. For that to happen, Trump will have to govern well.

Deep dissatisfaction with the established order is convulsing the West. It is plainly fueled by dimming hopes for upward mobility in society's lower economic rungs and by the aggression of sharia-supremacist Islam. The environment is a fertile one for competing strains of populism. They illuminate our unease, but they tell us precious little about how to rectify it.

ROGER SCRUTON

————

Representation and the People

Looking back over the events of 2016, liberal-minded commentators are apt to sound a warning against "populism," a disorder that they observe everywhere on the right of the political spectrum. Populists are politicians who appeal directly to the people when they should be consulting the political process, and who are prepared to set aside procedures and legal niceties when the tide of public opinion flows in their favor. Like Donald Trump, populists can win elections. Like Marine Le Pen in France and Geert Wilders in the Netherlands, they can disrupt the long-standing consensus of government. Or, like Nigel Farage and the Brexiteers in Britain, they can use the popular vote to overthrow all the expectations and predictions of the political class. But they have one thing in common, which is their preparedness to allow a voice to passions that are neither acknowledged nor mentioned in the course of normal politics. And for this reason, they are not democrats but demagogues—not politicians who guide and govern by appeal to arguments, but agitators who stir the unthinking feelings of the crowd.

Underlying the attack on populism, therefore, is a belief in two contrasting social motives. On the one hand there are the legiti-

mate and day-to-day political interests that lead people to trust in the democratic process and to cast their vote in full acceptance that the result may not go in their favor. On the other hand there are the dark emotions that the political process is designed to neutralize, but which cynical politicians manipulate at our peril. These dark emotions, summoned in the name of democracy, threaten to bring democracy to an end. For they are at war with the civic attributes on which democracy ultimately depends: fair-minded hesitation, legitimate opposition, and open debate.

To some extent history supports this diagnosis. Hitler and Mussolini gained power by exciting emotions that have no place in a civilized government, and that the political process exists in order to neutralize. And once in power they quickly abolished all democratic constraints on their behavior and all voice to the opposition. We should not forget, however, that this abolition of the democratic process has ensued equally from revolutionary movements on the left. It is not the specific emotions stirred by Hitler that jeopardized democracy, but the abolition of the constraints that would have put a stop to their exercise. Nor did the danger lie in the fact that the racist passions unleashed by the Nazis were widely shared. A small band of revolutionaries, fired by class resentments, can be just as destructive of the political order, and with similar genocidal consequences, as we know from the Russian and Chinese revolutions.

The fact remains, however, that the accusation of "populism" is applied now largely to politicians on the right, with the implication that they are mobilizing passions that are both widespread and dangerous. On the whole liberals believe that politicians on the left win elections because they are popular, while politicians on the right win elections because they are populist. Populism is a kind of cheating, deploying weapons that civilized people agree not to use and which, once used, entirely change the nature of the

game, so that those of gentle and considerate leanings are at an insuperable disadvantage. The division between the popular and the populist corresponds to the deep division in human nature, between the reasonable interests that are engaged by politics, and the dark passions that threaten to leave negotiation, conciliation, and compromise behind. Like "racism," "xenophobia," and "Islamophobia," "populism" is a crime laid at the door of conservatives. For the desire of conservatives to protect the inherited identity of the nation, and to stand against what they see as the real existential threats posed by mass migration, is seen by their opponents as fear and hatred of the Other, which is seen in turn as the root cause of inter-communal violence.

The shocks and surprises of 2016 have made it imperative to understand what, if anything, is true in this charge, and just when, if at all, it is legitimate for politicians to appeal directly to the people, in ways that by-pass or marginalize the political process. Democracy depends upon institutions, procedures, and the famous "checks and balances" established by the American Constitution. And if populism means direct rule by plebiscite, it must surely be a threat to that form of government.

Rousseau famously objected to representative government as a denial of the free choice of the people, whose "general will" emerges only if all of them participate in the important decisions. But he had no clear idea how to govern a large modern society by direct appeal to the people. Now, with everyone armed with a smartphone, it might be said that Rousseau's ideal is within our reach. The result is not just Donald Trump and Brexit, however, but a constant rain of petitions touching on everything that happens to be briefly in the news. Thanks to the internet, the iPhone, and all the other gadgets that permit instant messages and twitter storms, people can make their opinions and wishes directly influential on the legislature, without passing through the forum of political debate.

The Brexit referendum was therefore in part an official version of something that is now happening all the time—the instant plebiscite, which casts aside the political process and appeals directly to the people. Twitter and Facebook played their part in enabling the outsider Donald Trump to sweep away all the carefully screened professionals from the Republican primaries. It mattered not a jot that the media, the party machine, and the official channels of Republican opinion were united against him. Those old voices belonged to the political process, which moves slowly and sedately like a distant galaxy, while the social networks dance in the here and now. The old-fashioned media of communication, like the old-fashioned congressional committees and hearings, were filters through which popular feeling had to pass, in order to achieve overt and public expression. Now there are no filters, and thanks to social media every kind of person, and every kind of opinion, has an equal chance to be heard.

The phenomenon of the instant plebiscite—what one might call the "webiscite"—is therefore far more important than has yet been recognized. Nor does it serve the interests only of the Right in politics. Almost every day there pops up on my screen a petition from Change.org or Avaaz.org urging me to experience the "one click" passport to moral virtue, bypassing all political processes and all representative institutions in order to add my vote to the cause of the day. Avaaz was and remains at the forefront of the groups opposing the "populism" of Donald Trump, warning against his apparent contempt for the procedures that would put brakes on his power. But in the instant politics of the webiscite such contradictions don't matter. Consistency belongs with those checks and balances. Get over them, and get clicking instead.

It is not that the instant causes of the webiscites are wrong: without the kind of extensive debate that is the duty of a legislative assembly it is hard to decide on their merits. Nevertheless, we are con-

stantly being encouraged to vote in the absence of any institution that will hold anyone to account for the decision. Nobody is asking us to think the matter through, or to raise the question of what other interests need to be considered, besides the one mentioned in the petition. Nobody in this process, neither the one who proposes the petition nor the many who sign it, has the responsibility of getting things right or runs the risk of being ejected from office if he fails to do so. The background conditions of representative government have simply been thought away, and all we have is the mass expression of opinion, without responsibility or risk. Not a single person who signs the petition, including those who compose it, will bear the full cost of it. For the cost is transferred to everyone, on behalf of whatever single-issue pressure group takes the benefit.

We are not creatures of the moment; we do not necessarily know what our own interests are, but depend upon advice and discussion. Hence we need processes that impede us from making impetuous choices; we need the filter that will bring us face to face with our real interests. It is precisely this that is being obscured by the emerging webiscite culture. Decisions are being made at the point of least responsibility, by the man or woman in the street with an iPhone, asked suddenly to click "yes" or "no" in response to an issue that they have never thought about before and may never think about again.

Reflect on these matters and you will come to see, I believe, that if "populism" threatens the political stability of democracies, it is because it is part of a wider failure to appreciate the virtue and the necessity of representation. For representative government to work, representatives must be free to ignore those who elected them, to consider each matter on its merits, and to address the interests of those who did not vote for them just as much as the interests of those who did. The point was made two centuries ago by Edmund Burke, that representation, unlike delegation, is an *office*, defined by its responsibilities. To refer every matter to the constituents and

to act on majority opinion case by case is precisely to avoid those responsibilities, to retreat behind the consensus, and to cease to be genuinely accountable for what one does.

This brings me to the real question raised by the upheavals of 2016. In modern conditions, in which governments rarely enjoy a majority vote, most of us are living under a government of which we don't approve. We accept to be ruled by laws and decisions made by politicians with whom we disagree, and whom we perhaps deeply dislike. How is that possible? Why don't democracies constantly collapse, as people refuse to be governed by those they never voted for? Why do the protests of disenchanted voters crying "not my president!" peter out, and why has there been after all no mass exodus of liberals to Canada?

The answer is that democracies are held together by something stronger than politics. There is a "first person plural," a pre-political loyalty, which causes neighbors who voted in opposing ways to treat each other as fellow citizens, for whom the government is not "mine" or "yours" but "ours," whether or not we approve of it. Many are the flaws in this system of government, but one feature gives it an insuperable advantage over all others so far devised, which is that it makes those who exercise power accountable to those who did not vote for them. This kind of accountability is possible only if the electorate is bound together as a "we." Only if this "we" is in place can the people trust the politicians to look after their interests. Trust enables people to cooperate in ensuring that the legislative process is reversible when it makes a mistake; it enables them to accept decisions that run counter to their individual desires and which express views of the nation and its future that they do not share. And it enables them to do this because they can look forward to an election in which they have a chance to rectify the damage.

That simple observation reminds us that representative democracy injects hesitation, circumspection, and accountability into the

heart of government—qualities that play no part in the emotions of the crowd. Representative government is for this reason infinitely to be preferred to direct appeals to the people, whether by referendum, plebiscite, or webiscite. But the observation also reminds us that accountable politics depends on mutual trust. We must trust our political opponents to acknowledge that they have the duty to represent the people as a whole, and not merely to advance the agenda of their own political supporters.

But what happens when that trust disintegrates? In particular, what happens when the issues closest to people's hearts are neither discussed nor mentioned by their representatives, and when these issues are precisely issues of identity—of "who we are" and "what unites us"? This, it seems to me, is where we have got to in Western democracies—in the United States just as much as in Europe. And recent events on both continents would be less surprising if the media and the politicians had woken up earlier to the fact that Western democracies—all of them without exception—are suffering from a crisis of identity. The "we" that is the foundation of trust and the *sine qua non* of representative government, has been jeopardized not only by the global economy and the rapid decline of indigenous ways of life, but also by the mass immigration of people with other languages, other customs, other religions, other ways of life, and other and competing loyalties. Worse than this is the fact that ordinary people have been forbidden to mention this, forbidden to complain about it publicly, forbidden even to begin the process of coming to terms with it by discussing what the costs and benefits might be.

Of course they have not been forbidden to discuss immigration in the way that Muslims are forbidden to discuss the origins of the Koran. Nor have they been forbidden by some express government decree. If they say the wrong things, they are not arrested and imprisoned—not yet, at least. They are silenced by labels—"racism,"

"xenophobia," "hate speech"—designed to associate them with the worst of recent crimes. In my experience, ordinary people wish to discuss mass immigration in order to *prevent* those crimes. But this idea is one that cannot be put in circulation, for the reason that the attempt to express it puts you beyond the pale of civilized discourse. Hillary Clinton made the point in her election campaign, with her notorious reference to the "deplorables"—in other words, the people who bear the costs of liberal policies and respond to them with predictable resentments.

But it is precisely at this point that a dose of direct democracy may be needed. For political questions are of two distinct kinds: those that concern how we should be governed, and those that concern who we are. Questions of policy are questions for our representatives, who can draw on expert opinion and Congressional committees, in order to produce answers that can be justified in the legislature and argued to the people. Questions of identity are questions for the people themselves, for they alone can answer them. They alone know the nature and components of the "we" to which their loyalty is owed. The political elite can tell them to subscribe to some project or ideal. But it is not projects and ideals that produce the pre-political "we"; it is not for such abstract reasons that the working-class Republican and the middle-class Democrat recognize, through all the mist of their mutual antagonism, that they belong together. And when the pre-political "we" has, for whatever reason, been jeopardized, it is too late for the political process to deal with it. Emerging from behind the politics there then appears another and deeper question, the question *who we are*.

The United States has been governed from the beginning by a document that begins "We, the people of the United States ..." And this "we" resounds through all that follows. It is the voice of the first-person plural, the collective identity that makes democratic government possible, and which arises from a shared history, ter-

ritory, language, and law. It is precisely this identity that has been put in question by demographic and constitutional changes, and the shock of the recent Presidential election has made Americans fully aware of this.

Likewise people are beginning to understand the recent referenda in Britain and Italy as addressed to the question *who we are*. When the electorate of Scotland was asked whether Scotland should remain part of the United Kingdom, the question was one of pre-political identity. Who was to be included in the first-person plural? The Scots voted to remain part of the United Kingdom, which allows them to govern themselves through the Scottish Parliament. But they also continue to vote for the Scottish National Party in the Westminster Parliament. Had the English been permitted to vote in this referendum, in the outcome of which they had as great an interest as the Scots, they would probably have voted for English independence, in order to free themselves from the niggling presence in their Parliament of people who ostentatiously and continuously vote against English interests, whenever Scotland or the SNP might benefit. Some might say that, in this case, there was not a real referendum—not a real referral of the matter in hand to the people as a whole—since only some of the relevant people were allowed to vote. This was certainly not "politics as usual." But it was still politics, with the people brought in only because it had become impossible to proceed without appearing to consult them.

The referendum on EU membership was a more genuine appeal to the people, and here too the question of identity was also at issue. Three factors seem to have influenced the "no" vote: immigration, the top-down dictatorship exercised by the European Commission in all matters that remotely touch on economics (which means in all matters), and the effect of the European courts on the law and customs of the British people. The political class has failed in recent decades to address popular concern about these things, with

protests, however muted, dismissed as "racism and xenophobia": an accusation that was unhesitatingly repeated both in the run-up to the vote and, more bitterly, in the wake of it.

These ritual denunciations of people who are, by recent standards, about as un-racist and un-xenophobic as you are likely to find, meant that there was a marked reluctance by politicians on the left either to speak up for or even to notice the indigenous working class. The "no" vote of traditional Labour voters was the consequence of immigration from Eastern Europe that has both lowered the price of labor and radically impacted on their native environment and sense of community. No political question has been more important to them since suffering the effects of the ill-considered Maastricht Treaty than the question *who we are—* who is entitled to the benefits of social membership and what exactly is "our" birth-right, as the people who were born "here" from parents who fought for this "here" to be "ours"? Living now among foreigners, sending their children to schools where English is the second language, competing with the newcomers for housing, social services, and health-care, and above all *with nowhere else to go*, they can hardly be blamed for thinking that they are paying the cost of political decisions that benefit only distant elites.

But the concern about migration reaches further than the old working class. Identity has been an issue all across the continent, as the EU's "freedom of movement" provisions open the borders to mass population transfers. Those who argued that we should remain in the EU tended to see the matter purely in economic terms: the Poles, Czechs, Hungarians, Lithuanians, Romanians, and Bulgarians flooding into Britain bring with them energy, enterprise, and skills that boost production and foster economic growth. Like those who justify recruiting doctors and nurses from the third world, the enthusiasts for immigration ignore the countries that pay the cost of this. The fragile and nascent democracies of Eastern Europe are striving to

join the world of global trade, while losing their skilled work-force, their educated middle class, and the best of their young, causing, in Poland at least, a demographic crisis that may soon bring the country to its knees. Moreover, at the very moment when it is becoming difficult for Poland and the Baltic States to recruit a conventional defense force from an aging population, President Putin has installed nuclear attack missiles in Kaliningrad, and moved a fully mobilized army of 300,000 men to the Russian border.

In the run-up to the referendum, there was a frenzied attempt by David Cameron and his circle to turn the attention of the electorate away from migration to questions of economics and trade, as though this were all that EU membership has ever amounted to. It is true that a country's stability depends on trade. But it also depends upon trust—upon the sense that we are bound to each other by a shared loyalty, and that we will stand by each other in the real emergencies. Social trust comes from shared language, shared customs, instinctive law-abidingness, procedures for resolving disputes and grievances, public spirit, and the ability of the people to change their own government by a process that is transparent to them all. And those goods have been bound up for centuries with the allegiance of ordinary people to a place, a culture, a law, and a political process that they define as *their own*. They were goods tied to national identity.

The hope of the founders of the EU—Jean Monnet, Robert Schuman, Walter Hallstein, Altiero Spinelli, and others—was to create new forms of identity that would replace the national feelings of the European people. They were moved by the belief that national feeling is exclusive and, when challenged, belligerent, and they were seeking a more open and "softer" alternative. For commentators on the right, the Brexit referendum was proof that this project had failed. The referendum had given to the people an opportunity they would not otherwise have had, and which succes-

sive governments had conspired to remove from them, namely the opportunity to affirm their national identity *against* the EU, and in defiance of policies that compel them to share their country and its privileges with their foreign competitors.

Although the recent Italian referendum was ostensibly concerned with constitutional changes that would reduce the power of the Senate and accelerate the legislative process, it was understood by the people as a vote of confidence in the unelected Prime Minister, Matteo Renzi, and in the EU that was ultimately responsible for appointing him. As in Britain, the issue of identity was at the forefront of popular sentiment, and the massive "no" vote was a heartfelt cry from the people to take the question of their identity seriously. What has the EU done for Italy, in the crisis brought about by the daily arrival of thousands of migrants, many of them young men without families who have no intention to return? While representing all questions of migration and settlement as questions for Europe as a whole, the EU has no clear policy for dealing with the matter, and must in any case absorb the effects of Chancellor Merkel's decision to offer asylum to all and sundry, without regard for the feelings of those Germans who must bear the cost of this. In any future referendum in Europe, in whatever country and over whatever ostensible issue, it will be the question of migration, and the desire of the people for effective leadership in confronting it, that will determine the outcome of the vote.

Of course the American Presidential election was not a referendum. Nevertheless the issues raised by Donald Trump were the very same issues as those that are troubling the people of Europe—massive immigration into traditional working-class communities, the growth of minorities whose loyalty to the national "we" has yet to be proven, and the disruptive effect of the global economy and liberal attitudes on the old and settled ways of life. The same response has occurred among liberals in the United States as among liberals

in Europe: that these issues should not be openly discussed, and certainly not in such a way as to give oxygen to the "racism and xenophobia" that are always in danger of bursting into flames. And liberals have a point: there is a danger here, and a very real one, even if it remains questionable whether the danger is lessened or increased by the current habits of censorship.

All this has left the conservative movement at an impasse. The leading virtue of conservative politics as I see it is the preference for procedure over ideological programs. Liberals tend to believe that government exists in order to lead the people into a better future, in which liberty, equality, social justice, the socialist millennium, or something of that kind will be realized. The same goal-directed politics has been attempted by the EU, which sees all governance as moving towards an "ever closer union," in which borders, nations, and the antagonisms that allegedly grow from them will finally disappear. Conservatives believe that the role of government is not to lead society towards a goal but to ensure that, wherever society goes, it goes there peacefully. Government exists in order to conciliate opposing views, to manage conflicts, and to ensure peaceful transactions between the citizens, as they compete in the market, and associate in what Burke called their "little platoons."

That conception of government is, to me, so obviously superior to all others that have entered the imperfect brains of political thinkers that I find myself irresistibly drawn to it. But it depends on a pre-political unity defined within recognized borders, and a sovereign territory that is recognizably "ours," the place where "we" are, the home that we share with the strangers who are our "fellow countrymen." All other ways of defining the "we" of human communities—whether through dynasty, tribe, religion, or the ruling Party—threaten the political process, since they make no room for opposition, and depend on conscripting the people to purposes that are not their own. But procedural politics of the conservative

kind is possible only within the confines of a nation state—which is to say, a state defined over sovereign territory, whose citizens regard that territory as their legitimate home.

Ordinary people for the most part recognize this, which is why they voted as they did in the elections and plebiscites of 2016. And they look to conservative politicians to protect their home from the disintegrative forces that now impinge on it. At the same time very few politicians will dare to stand against the abuse that greets those who defend the call for national identity in open and explicit terms. The response of the media and world public opinion to Marine Le Pen, Nigel Farage, and Geert Wilders has been vitriolic in the extreme. Wilders has even been found guilty of "inciting discrimination and hatred" by a Dutch court, for having uttered unwise remarks about Moroccan immigrants to his country—remarks which might, for all that was said in court, be true, but which have been judged nevertheless to be unsayable.

The charge of "populism" is therefore beginning to bite. What has to be said by conservatives, if they are to reaffirm the first-person plural on which their kind of politics depends, cannot be easily said, for fear of the labels that bring all discussion to a stop. David Cameron was well aware of this, which is one reason why he did not try, in the run-up to the Brexit referendum, to allay popular fears about immigration. Even to raise the question would be to step beyond the boundary. And because he did not raise the question Cameron lost the referendum.

There is a way out of this impasse, however. It is surely possible now to bring the question of identity into the center of political discourse, so that it ceases to be addressed only in plebiscites, referenda, and the degrading social media. It is possible to begin discussions in Congress and Parliament on the legislation that may now be necessary to ensure continuity of our inherited first person plural. For we in the Anglosphere have a language in which to do

this—a language with a respectable past and an acknowledged political use. When we wish to summon the "we" of political identity we refer to our *country*. We do not use grand and ideologically tainted abstractions, like *la nation, la patrie*, or *das Vaterland*. We refer simply to this spot of earth, which belongs to us because we belong to it, have loved it, lived in it, fought for it, and established peace and prosperity within its borders.

This language enables politicians to address the question of immigration without incurring charges of racism and xenophobia. It is not race or faith that defines the true patriot, but attachment to this place that is ours. Whom do we welcome into this place, and on what terms? Those are legitimate questions, and the moment is opportune to take on board the disquiet that ordinary people feel, when the place that they regard as home is suddenly strange to them, and filled with others to whom they do not or cannot relate as neighbors. It is opportune also to recognize the difference between incomers who wish to settle and acquire the rights and duties of citizenship, and who are prepared for the long, slow apprenticeship that this requires, and the influx of communities who remain locked in their former way of life, who pay no heed to civic duties and who make no effort to assimilate to the surrounding secular order. Why not assert publicly that immigrants must be integrated if they are to be citizens, and that if they come in large numbers, so as radically to alter the way of life and surroundings of their hosts, this will inevitably make the process of integration difficult or impossible?

Above all, it seems to me, conservatives should revitalize the idea of "our country," not in narrow-minded or chauvinistic terms, but as the correct description of the pre-political "we." Liberals will respond with name-calling and moralizing—but not all of them, since liberals too can call on a tradition of patriotic sentiment for which "our country" is a legitimate standard. It was precisely this

idea, of a place that belongs to me because I belong to it, that animated the Brexit vote. And it is the same idea that has caused so many Americans to revolt against President Obama's stance on immigration, and notably his policy of offering amnesty to those who enter the United States of America illegally and who strive thereafter to profit from this crime. Bringing this idea into the center of the political process, and rescuing it in that way from the webiscite culture, will surely be a prelude to a coherent policy for the control of borders and the legitimate path to citizenship.

This does not mean that there is an easy response to mass migration: at some stage force will be necessary, if borders are to be secure, a point already recognized by many countries in Europe. Nor does it mean that pressures from the global economy can be easily excluded, or that free trade can be maintained while protecting vital indigenous industries. All such difficulties will remain, and the main task of the political process will be to arrive at whatever compromise solutions can be achieved in response to them. But in all these matters there is a clear way forward for conservatives, which is to take the sting out of populism, by addressing the issues which, to date, have been acknowledged only by official and unofficial plebiscites. We need to make those issues into the primary matter of political debate, and to rescue politics from populism by speaking clearly in the people's name.

VICTOR DAVIS HANSON

===

The Unlikeliest Populist

Leftists deride the "bad" populism of angry and misdirected griev-
ances lodged clumsily against educated and enlightened "elites," of-
ten by the unsophisticated and the undereducated. Bad populism
is fueled by ethnic, religious, or racial chauvinism, and typified by a
purportedly "dark" tradition from Huey Long and Father Coughlin
to George Wallace and Ross Perot.

Such retrograde populism to the liberal mind is to be contrast-
ed with a "good" progressive populism of early-twentieth-century
and liberal Minnesota or Wisconsin—solidarity through unions,
redistributionist taxes, cooperatives, granges, and credit unions to
protect against banks and corporations—now kept alive by Ber-
nie Sanders and Elizabeth Warren. Good leftwing populism rails
against supposedly culpable elites—those of the corporate world
and moneyed interests—but not well-heeled intellectuals, liber-
al politicians, and the philanthropic class of George Soros, Bill
Gates, or Warren Buffett, who make amends for their financial
situations by redistributing their millions to the right causes.

The Right is similarly ambiguous about populism. "Bad" pop-
ulists distrust government in sloppy fashion, failing to appreciate
the intricacies of politics that understandably slow down change.

"Bad" right-wing populists, given their unsophistication and wild emotions, are purportedly prone to dangerous excesses, American-firstism, social intolerance, and anti-capitalist bromides: think the pushback by the Tea Party or the Ron Paul zealots.

In contrast, "good" conservative populists are those who wish to trim the fat off complacent conservatism, reenergize the Republican Party with fresh ideas about small government and a return to social and cultural traditionalism, while avoiding compromise for compromise's sake. Good populists for conservatives might include Ronald Reagan or even Ted Cruz.

Within these populist parameters, Trump appeared far more the "bad" or "dangerous" populist.

Despite Trump's previously apolitical and elite background, he brilliantly figured out, even if cynically so, the populist discontent and its electoral ramifications that would erode the Democrats' assumed unassailable "blue wall" that ran from Wisconsin to North Carolina. In contrast, sixteen other talented candidates, some of whom were far more experienced conservative politicians, over a year-long primary race lacked Trump's intuition about the potential electoral benefits of courting such a large and apparently forgotten working-class population.

Critics would argue that Trump's populist strategy was inauthentic, haphazard, and borne out of desperation: he initially had few other choices to win the Republican nomination.

Trump began his campaign with exceptional name recognition and seemingly with ample financial resources. Yet he lacked the connections of Jeb Bush to the Republican establishment and donor base, the grass-roots orthodox conservative movement's fondness for Ted Cruz, the neoconservative brain trust that allied with Marco Rubio, and the organizations and reputations for pragmatic competence that governors such as Chris Christie, Rick Perry, or Scott Walker brought to the campaign.

Trump never possessed the mastery of the issues in the manner of Bobby Jindal or Rand Paul. Ben Carson was even more so the maverick political outsider. Nor was Trump as politically prepped as his fellow corporate newcomer Carly Fiorina. Despite his brand recognition, Trump's long and successful experience in ad-hoc reality television, millions of dollars in free media attention, and personal wealth, he started the campaign at a disadvantage and so was ready to try any new approach to break out of the crowded pack—most prominently his inaugural rant about illegal immigration.

By 2012 standards, Trump, to the degree he had voiced a consistent political ideology, would likely have been considered the most liberal of the seventeen presidential candidates. In the recent past he had chided Mitt Romney for talking of self-deportation by illegal immigrants, praised a single-payer health system, and had at times campaigned to the left of both the past unsuccessful John McCain and Mitt Romney campaigns. Yet in 2016 Trump found a way to reassemble the remnants of what was left of the Tea Party/Ross Perot wing of the Republican Party.

Such desperation might explain his audacity and his willingness to campaign unconventionally if not crudely. Yet it does not altogether account for Trump's choice to focus on what would become four resonant populist issues: trade/jobs, illegal immigration, a new nationalist foreign policy, and political correctness—the latter being the one issue that bound all the others as well. Trump's initial emphasis on these concerns almost immediately set him apart from both his primary opponents and Hillary Clinton.

Take trade. Doctrinaire Republican commercial policy was synonymous with advocacy for unfettered free trade. Even when foreign countries in the European Union or Japan subsidized their own exports and raised barriers to importation—well aside from China—

Republicans were not quick to retaliate on the principle than even unfair trade had its value: foreign subsidies forced American producers to tighten their belts and seek greater efficiencies in production and thus in the long term to lower costs to consumers and sharpen competitiveness. Consumers got cheaper imported goods that mitigated dismal domestic economic growth. In addition, the role of the largest economy and military in the world was purportedly to accept some trade liabilities and burdens (which it supposedly could afford) as part of the responsibility to help its weaker aligned partners and advance the globalized project in general.

Trump—perhaps because of his past as a developer and builder in the vicious arena of Manhattan real estate, and his own unfamiliarity with abstract free-market theories—instead reduced trade to a zero-sum game. Business people and their workers lost in such one-sided competitions, while government elites who pushed free trade policies were not personally affected when cheap and subsidized foreign competition undermined manufacturing, agriculture, and other businesses vulnerable to unfair foreign commerce. For Trump the issue was not just fair trade, but fairness itself in who benefitted and who lost from globalized commerce—an empathetic approach not usually associated with the combative wheeler-dealer.

Again, Trump, the billionaire Manhattanite and unlikely populist, argued not only that the working classes were hurt by globalization—at least in terms of jobs—but also that they felt those who were the architects of free trade were themselves exempt from the ramifications of their own ideology. Despite his wealth and privilege, Trump perhaps was able to channel his own past frustrations with bureaucrats, condescending Palm Beach country clubs, corrupt New York City officials, and liberal community activists into sympathy for those often neglected in Middle America. Trump, for all his glitzy lifestyle, exuded an empathy for his own workers, and,

by speech and comportment, he seemed more at ease with his carpenters and electricians than with his bankers. And for those who accused Trump of being precisely what he was railing against, he often countered that all the better he knew how to fight such corruption firsthand.

Trump's generic pejorative references to "they" and "them" included not just foreign trade manipulators, but also Washington policy makers who either were not hurt by globalization or did not care much about those who were. Trump soon was using the plural possessive pronoun, in speaking of "our miners," "our vets," and "our farmers," in terms of endearment never heard of in past elections, as he assured the hurting middle classes that their pain was not preordained but calibrated, and that they were not the estranged but the soon to be rescued.

It is hard to determine to what degree Trump early on adjusted his populism to fit the Electoral College terms. But it is no accident that the Democratic "blue wall" that had stymied both John McCain and Mitt Romney was largely a landscape of hurting white and blue-collar workers who were also culturally turned off by the Democrats' identity politics mantras that had ignored class for tribal affiliations. Trump apparently thought he could do in Michigan, Ohio, Pennsylvania, and Wisconsin what some Republicans had already done in formerly blue or swing states like Kentucky, Missouri, Tennessee, and West Virginia—mostly by stressing resurrecting construction, mining, and manufacturing, often in politically and environmentally incorrect terms. This was all Republican heresy, given long ago a tenet of free-market globalization postulated that "old" muscular industries would naturally die off in the United States and be outsourced to the former Third World, while "information," "high value," and "knowledge-based" technologies and services would more than make up for losses of manufacturing. Displaced factory workers were supposed to "retrain," relocate, or

recalibrate, not whine that the local smokestack plant had moved to Indonesia.

Next, Trump zeroed in on immigration in the same populist manner. Prior Republicans had insisted that the new demographics—and past lost elections to Barack Obama's identity politics-campaigning—mandated "comprehensive immigration" reform, a euphemism for amnesty without prior guarantees of border security and enforcement. Trump suspected that elites like himself never directly experienced the downsides of illegal immigration: hit-and-run accidents, increased gang crime, drugs, swamped emergency rooms, crowded social service offices, and schools full of non-English speakers. Unlike his rivals, he neither ignored the real-life roughness of illegal immigration nor ridiculed as illiberal and worse those who experienced the consequences first-hand.

Trump, initially almost alone, saw in a tough immigration stance a number of populist openings that would transcend political affiliations and win over Democratic working classes:

First, why should some foreign nationals not be subject to federal laws, while American citizens could not similarly pick and choose which laws to follow? Demand for measured and legal immigration was not xenophobic, but rather a question of simple fairness and equality under the law.

Second, at a time of anemic economic growth, near-record labor non-participation, and fierce competition for jobs, why was the United States allowing foreign nationals to enter the country's work force under illegal auspices in a way not accorded immigrants who sought legal entry?

Third, the burdens on social services in some communities by illegal arrivals from Latin America and Mexico were felt to fall most heavily on the lower middle classes and poor minorities who had to compete for increasingly limited entitlements and subsidies.

Fourth, other candidates saw any tough immigration stance en-

tailing deportation as suicidal, given new Latino voting strength, especially in the American Southwest. Trump instead saw Latino politics in a different light: not only was the community not monolithic, given vast differences between Cubans, South Americans, and Mexicans, and given assimilation, integration, and intermarriage, but often the downsides of illegal immigration fell most heavily on American citizens of Hispanic background.

More concretely, the Latino population concentrated mostly in states that were either already irrevocably blue (California and likely Colorado, New Mexico, and Nevada) or stubbornly still red (Texas and Arizona). In contrast, the furor over illegal immigration was strongest in swing states of the Midwest, where the Latino population was not likely to affect state totals. For all the talk of the new Latino demographic powerhouse, Trump bet that his immigration rhetoric would win over new middle-class voters in key swing states, and appeal to a fourth to a third of Latinos, while not affecting the eventual totals in largely predetermined red and blue states. True, Trump said things about illegal immigrants that other politicians would never dare, but he did so with a belief that demography in 2016 was not his own destiny.

On foreign policy, Trump saw America's role largely as an extension of his emphasis on domestic populism—despite the looming shadow of 1930s populist isolationism that is now synonymous not just with anti-Semitic America Firstism, but also with deadly naiveté that led to unnecessary American losses in World War II. Trump often disingenuously insisted that he had opposed the Iraq war from the beginning (he had not) and attacked costly nation-building in general, cognizant that, by 2016, Afghanistan, Iraq, and Libya were easily tagged as a waste of American blood and treasure and such interventions only made things worse in the Middle East. In contrast, most Republican candidates saw Iraq by 2011 as a sort of wash—perhaps too costly an endeavor in lost blood and treasure to repeat else-

where, but nonetheless at last quiet and a South Korea–like success, if not for the abrupt and reelection-calibrated withdrawal by President Obama. His Republican neo-conservative critics in the flagship magazines and newspapers went ballistic over Trump's supposedly America First appeal, but they themselves had no political constituency, and their fevered attacks only fed into his own narrative of an elite foreign policy that served theorists who dreamed such things up, not working people who were asked to reify them.

Trump also recalibrated Iraq and other interventions such as Afghanistan and Libya as distractions from long overdue nation-building at home. Why invest resources in areas where the United States was despised when Americans were themselves either out of work or stuck in low-wage jobs? If the United States were to get involved to address existential threats, it would be on its own Jacksonian terms: sporadic bombing of enemies without ground engagements, in the manner one mows the lawn while not complaining that grass continues to grow and demands such constant maintenance cutting.

Finally, Trump cemented his populist message by mocking political correctness. Illegal immigrants in contrived politically correct parlance were synonymous with "dreamers," as if all 10–15 million illegal entrants had never committed a serious crime, were all employed, and had long years of U.S. residence. Trump's writ instead suggested otherwise: a sizable minority of illegal aliens had committed crimes, or had just arrived by flooding across the border on the scent of amnesty, or were able-bodied but without work histories. Elites in both parties knew this was to some extent true, but feared that the mere use of the word deportation in any context would lose Latino votes.

If Trump deliberately used the politically incorrect term "illegal aliens," he also made it a point to repeat "Merry Christmas" and "radical Islamic terror," reminding his audiences that the Obama

administration showed more deference to the Muslim world than it did the long-held Christian traditions of the majority of its citizens. Trump, then, was a champion of traditionalist nomenclature and by extension 1950s values, even if his own checkered life did not match the moral universe that he sought for others.

He sided with the police against the Black Lives Matter demonstrations, apparently counting on the fact that statistics bore out his impressions that African-American youth were not being gunned down by police at any greater ratios than other groups who commensurately came into contact with law enforcement. On the environment, Trump talked of conservation in 1950s terms and assured out-of-work voters that mining and fuel production were not incompatible with "clean water and air."

There were accusations that Trump's populist appeals were dog whistles to the former clingers, irredeemables, and deplorables of the white working classes, with an aim to embrace white solidarity. In response, Trump went into the inner city, and broadened his message to include minorities who were to be seen as similar victims of unfair trade, illegal immigration, and globalization—as if a resurrected economy growing at a rate of 3–4 per annual GDP would make obsessions on race, class, and gender irrelevant. Unlike most past varieties of leftwing populism, Trump did not believe in a peasant notion of limited good, but instead thought a growing pie gave everyone a bigger slice.

Trump's implicit message was that, in the age of Barack Obama envisioning the electorate as a series of hyphenated groups, the white working class naturally might piggyback onto such tribal solidarity, especially given loud and often chauvinistic prognostications of its eventual demographic demise. In sum, Trump crafted a populist message that was geared to winning back the working classes of the Midwest swing states—in a year when Barack Obama's loyal minority constituents might not completely transfer

their fealty to a sixty-nine-year-old white multimillionaire, mired in a series of Clinton Foundation and email scandals.

Why then did Trump's rivals not appreciate the populist resonance of these issues? Some of them were from the same 1 percent economic stratum as Donald Trump and the majority lived likewise in large urban centers. Others, unlike Trump, were governors such as Scott Walker and Chris Christie who had come to power through populist appeals against unions, big government, and callous elites and knew what resonated with grassroots. Ted Cruz was a Tea Party advocate—the same populist movement that had once sent the relatively unknown Marco Rubio to the U.S. Senate.

Yet almost all the Republican front-runners shared long tenures in state and federal government, were reliant on New York–Washington advisors and think tanks, and dialed into daily coastal opinion journalism. They had mostly bought into orthodox Republican economics that only unfettered free trade brought prosperity, that we were in a postindustrial economy in which high-tech and green jobs (not smokestack manufacturing and production) were the wave of the future, and that the new—and unfavorable—demographics led to compromise with the purveyors of identity politics and open borders, and at least lip service to an array of politically correct orthodoxies.

Jeb Bush and Marco Rubio had become loud advocates of "comprehensive immigration reform" compromises with the Obama administration, apparently oblivious that while Obama talked of "security," the southern border after 2012 had become wide open—and millions of Americans were dealing first-hand with the consequences. Moreover, Trump's populist ideas of jawboning corporations to stay put and not offshore jobs and capital were antithetical to the entire doctrine of free-market libertarian economics, and smelled of leftist intrusive government interference in the market place. As the candidates were coached by Washington foreign policy makers

they adopted certain establishment orthodoxies: NATO was sacrosanct and thus mere criticism of its asymmetrical contributions endangered its sanctity; the European Union, however flawed, was still preferable to the alternative of squabbling independent democracies; Russia had spurned resets from both Bush and Obama and of course was hell-bent on reformulating the Soviet Empire even if it meant the destruction of its autonomous neighbors.

Trump in contrast had no investment in either the Washington establishment or its bipartisan policies, and sensed his new blue-collar constituencies did not either. He simply asked why some hallowed transatlantic institutions and trade organizations seemed to burden the United States financially without commensurate economic benefits. Trump's rivals were never quite able to envision foreign policy in terms of domestic populist concerns—a chief tenet of classical populism—and to the extent they did, they quickly dismissed him as a Charles Lindbergh isolationist in times that were supposedly beginning to resemble the late 1930s. In response, Trump doubled down, perhaps because he sensed his newfound Middle America supporters were often Independents and Democrats, and thus ironically had long ago been seasoned with traditional Democratic critiques of Republican administrations' interventions.

In style, with the exception perhaps of Ted Cruz, Trump opponents played by Romney's Marquess of Queensberry political rules. Trump did not—and saw populist advantage in matching his vocabulary and style to the unorthodoxy of his message. While some Republican national candidates had sought to appeal to the white working classes, they did not dare talk of the "forgotten men and women" or match Trump's apocalyptic visions of a ruined America that needed to become "great"—again. Style-wise, most Republicans were consensus builders who had come to power by give-and-take compromise, not as Trump had, by demonizing and bulldoz-

ing the opposition once he saw an opening—as if the nomination were a brawl to build a Manhattan skyscraper and thus to defeat rival contractors by winning over corrupt officials, union bosses, environmentalists, bankers, and community activists. Trump proved right that an out-of-work die maker did not want lectures from the winners of globalization on free-market economics, the centrality of NATO, or a need to offer some sort of amnesty to illegal aliens—even if in the abstract these were consensus and logical positions. The forgotten man instead more likely gravitated to someone who insisted the entire system was rigged and was culpable for voters in southern Michigan or western Pennsylvania being out of work—while other elites on the coast were not.

Populism is often a state of mind as much as political messaging. It can hinge on symbols as much as doctrines. When a woman is out of work or stuck in a low-wage job, she does not much care for the niceties of speech or dress—all the more so if she lives in the country, towns, or rural cities under 50,000. Trump's outlandish mile-long tie, his brawling personal invective, his neurotic ad hominem tweeting, his red baseball hat, his dyed comb-over, his orange skin, his past strange friendships with the televised wrestling crowd and outlaws like the former boxer Mike Tyson, and his Queens accent—all proof of his buffoonery to the elite—came across as visible force-multiplying nullifiers of his privilege, and, oddly, bridges of authenticity to the middle classes.

In contrast, his opponents logically assumed that the tradition-bound middle classes of fly-over country wanted to project their best images to the coastal centers of power—in the fashion of a sober, judicious, well-dressed, well-spoken, and well-mannered Paul Ryan or Mitch McConnell. But the more Jeb Bush, Marco Rubio, and Ted Cruz attacked Trump for his assorted vulgarities, the more Trump became an outsider and a sympathetic victim of those who had become out of touch with their own constituents. Left un-

said was that the Right often derides the wonkish Pajama Boy Left as a motley group of elite, nasal-voiced youngsters whose worldly experience consists mostly of leaving the Ivy League to settle in to network with politicians from Dupont Circle. But Republicans as well have often showcased young, smug ideologues who talked grandly of orthodox free-market economics in a fashion that reminded the working classes that such megaphones would be helpless outside the East Coast.

Rural and small-town America value politeness and manners, but candor and authenticity even more so—and to such a degree they will overlook crudity if accompanied by authenticity. Trump showed the cunning of an animal zeroing in on sacred cows in crude fashion and in a way unthinkable to his politer and more mannered rivals who were long invested in the traditional political system in which gaffes are defined by disastrous expressions of truth.

But more importantly, Trump's targets also shared one attribute that had often escaped notice: all of Trump's targets, from Marco Rubio to Ted Cruz to Hillary Clinton, had attacked Trump first and as celebrities and permanent politicians they had grown a bit too full of themselves. When a coiled Trump bit back, his supporters saw it as overdue comeuppance, not gratuitous vulgarity, and a metaphor for their anger against those who often provocatively ridiculed the -isms and -ologies of supposedly backward America.

So Middle America saw a pattern to Trump's madness: he rarely preempted a twitter war but simply counterpunched and hit back twice as hard. He feigned bluster and recklessness to jar his media and political opponents into thinking he could say anything to anyone at any time anywhere, and thus earned a wide deterrent path. And strategically Trump always seemed to demand three times as much as he was likely willing to settle for eventually. The 2016 proverb proved correct: Trump supporters really did take him seriously but not literally, as the media and the political establish-

ment discounted his seriousness on the literal basis of his astounding expressions.

Icons like John McCain and Megyn Kelly took on Trump first and were scandalized by his crude reprisals. Trump got attention by wild charges against the Chinese and Muslim refugees entering the country from war-torn zones—only later would he recalibrate his charges to target countries of origin rather than religious affinity. And it is likely that on immigration Trump believes that his threats to deport anyone residing illegally were necessary to obtain a secure and fortified border, to deport criminals and those able-bodied without work histories, and to ensure legal immigration was more meritocratic. People in business, who are not salaried, or who buy and sell, were far better able to understand the method to Trump's negotiating madness than were professional journalists, academics, and bureaucrats whose incomes were far more secure.

Finally, how did the country grow so far apart, to the extent that half the population that resided in 85 percent of the nation's geography was more or less politically unknown to major politicians, celebrities, academics, and the media—at least to the extent that the latter wrote off Trump's persona and strategy as hopelessly naïve and doomed to fail politically?

The obvious answer is what Middle America consumed as media, politics, and culture was often delivered by a tiny coastal cadre who ventured overseas far more frequently than to Northern Ohio or southern Wisconsin, and rarely talked to anyone other than like kind. "The swamp" was also an incestuous "echo chamber"—a phrase cynically used by the would-be novelist and Obama's deputy national security advisor Ben Rhodes (brother of the CBS News president David Rhodes) who boasted of deceiving his own kindred media. Huma Abedin, Hillary Clinton's "body woman," is married to the former and now disgraced Congressman Anthony Weiner. The former National Security Advisor Susan Rice was married to the

former ABC television producer Ian Cameron. The former Obama press secretary, and current Senior Vice President of Worldwide Corporate Affairs for Amazon, Jay Carney, married Claire Shipman, the senior national correspondent for ABC's *Good Morning America*. The most recent Obama press secretary, Josh Earnest, married Natalie Wyeth, a veteran of the Treasury Department. The Washington reporter John Dickerson is son of former Washington media fixture Nancy Dickerson; Anderson Cooper of CNN is the son of Gloria Vanderbilt. Presidential politics in turn had become almost dynastic. If the frontrunner Hillary Clinton had won the presidency in 2016, then just two families would have produced four out of the last five presidents—twenty-four of the last thirty-two years. The lists of such careerist beltway incest could be expanded endlessly.

In contrast, over the last two decades an odd genre of reality TV had emerged that portrayed Middle Americans as strange but fascinating aborigines in shows like *Duck Dynasty*, *Ice Road Truckers*, or *Ax-Men*—along with various takes on living in Alaska, mining, or catching fish. Inadvertently or not, the shows seemed to convey admiration for strange nineteenth-century folk, in which muscular strength is critical for survival—even as the dress, diction, and education of lumberjacks, fishermen, and truck drivers to urban audiences supposedly explained their poverty and ostensible pathologies.

It was striking how often our political leaders were not shy of caricaturing these supposedly reactionary Americans. Mark Dayton, the governor of Minnesota, lambasted any Minnesotans who had dared to doubt the wisdom of welcoming mostly unvetted refugees from Somalia: "If you are that intolerant, if you are that much of a racist or a bigot, then find another state. Find a state where the minority population is 1 percent or whatever." Dayton then gave the game away with, "Our economy cannot expand based on white, B+, Minnesota-born citizens. We don't have enough."

Other politicians graded Middle America far more harshly

than Dayton's B+. Hillary Clinton all but wrote off a quarter of the electorate:

> You know, to just be grossly generalistic [*sic*], you could put half of Trump's supporters into what I call the basket of deplorables. Right? The racist, sexist, homophobic, xenophobic, Islamaphobic—you name it. And unfortunately there are people like that. And he has lifted them up. He has given voice to their websites that used to only have 11,000 people—now 11 million. He tweets and retweets their offensive, hateful, mean-spirited rhetoric. Now, some of those folks—they are irredeemable, but thankfully they are not America.

"Not America" was redolent of Obama's various riffs on the supposedly backward and unenlightened American. When he lost the 2008 Pennsylvania primary, Obama had similarly scoffed about such strange people who could not appreciate his messianic genius, in his infamous "clingers" analysis:

> Typically, when people feel stressed, they turn on others who don't look like them. . . . And it's not surprising, then. They get bitter, they cling to guns or religion or antipathy to people who aren't like them, or anti-immigrant sentiment, or anti-trade sentiment as a way to explain their frustrations.

Obama on a September 2016 trip to Laos reiterated his earlier contempt for the clingers when he connected the dismal economy under his watch to a new conservative populism: "Typically, when people feel stressed, they turn on others who don't look like them."

The current coastal sensation and writer on racial issues Ta-Nehisi Coates was likewise not shy about his own contempt: "When people who are not black are interested in what I do, frankly, I'm always surprised. . . . I don't know if it's my low expectations for white people or what."

Note that Hillary Clinton did not campaign once in Wisconsin. Barack Obama seems never to have gotten over his 2008 primary defeat in Pennsylvania. When Ta-Nehisi Coates disparages "white people" (and celebrates his "low expectations" of them) who read his work, he is referring to fellow sophisticated, upper-middle class urbanites who are accustomed to and apparently do not mind such stereotyping—not the far greater populations of the white working classes outside of Coates's circle.

Amid such stereotypes and generalizations, it is not surprising how egocentric elites assumed that their own values were shared by all of America. The "Pajama Boy" poster boy for the Affordable Care Act sipped hot chocolate in his pajamas as if most of America walked around with footsies and retro glasses. Why did the Obama administration think that portraying an adult as a prolonged and smug adolescent would win over America to Obamacare?

Did Barack Obama worry about the optics much when he welcomed the rapper Kendrick Lamar into the White House and declared a song from Lamar's *To Pimp a Butterfly* album to be his favorite of the year? The album cover portrayed a prostrate dead white judge with his eyes X-ed out—the corpse a focus for celebration by African-American rappers portrayed toasting his demise on the White House lawn. Hip Washingtonians might have thought that cool; Middle Americans might have asked what would have been the reaction if the roles and races were reversed?

Why would corporate America and the coastal media assume that multimillionaire and largely failed San Francisco 49ers quarterback Colin Kaepernick would not turn off National Football League audiences when he refused to stand for the playing of the National Anthem, and then offered America half-baked rants on their supposed racism and backwardness?

What we learned on Election Day is that progressive culture—identity politics, radical feminism, boutique environmentalism,

metrosexual careerism—appeals to no more than half the country, even if it's the more influential and wealthier half. When Middle America found itself targeted by globalization and was culturally caricatured for its supposed irredeemable and deplorable habits by the smug winners of internationalism, is it a surprise that it looked desperately for a politician who promised to put them back to work and to honor rather than deride their manner of living?

A renegade Manhattan billionaire understood the angst of Middle and often rural America far better than seasoned conservative professional politicians (many of them from fly-over states), the mainstream media, and Hillary Clinton and Barack Obama—and then, like all successful populists, he crafted messages to make them feel they could be as prosperous and respected as were their critics who dismissed them.

CONRAD BLACK

====

Avenue to Renovation

Populism is generally taken to mean a political movement that challenges the incumbent political elite and may overwhelm it. If in doing so, or at a subsequent stage, the movement becomes violent or departs from the confines of the orthodox constitutional system altogether, it ceases to be populist and becomes revolutionary or anarchic. In long-running democracies, economic fluctuations and occasional vagaries of talent of the political leadership assure that there will be populist political activity that will try to win big political prizes by constitutional means and by exploiting and evoking public discontent with the political class.

Though the United States has been fertile populist ground, its populist movements have never seriously threatened to overthrow the existing method of choosing governments. The United States was born of a revolution, but it was preeminently an act of secession, challenging remote British rule and establishing local self-government. It did not overturn the socioeconomic organization of the country. Even the Civil War, an insurrection, was conducted in defense of the institution of slavery.

The United States ranks with the United Kingdom, Canada, Australia, Switzerland, the Netherlands, Belgium, Luxembourg,

and parts of Scandinavia as the only countries that have been autonomous for over a century, where there has been no serious revolutionary violence directed at the continuity of governmental institutions. In France, Germany, Italy, Spain, Russia, China, Japan, and Turkey, the history is long and replete with upheavals and complete breakdowns of government, as well as many unsuccessful, but not merely frivolous, attempts to dispense abruptly with the existing institutions and people of government.

However inflammatory American political rhetoric may become by the standards of other stable democracies, it operates within the existing political and constitutional practices. Though the anti-Trump forces did their rather unimpressive best to conjure up the vision of mob rule and street bullying, the efforts sank "like a hot rock," in an infelicitous phrase of the Senate Majority Leader Mitch McConnell of Kentucky, which he has walked briskly back into amnesia. (The senator was envisioning dropping Trump, not having his wife in Trump's cabinet.)

Beneath the appearance of shot-from-the- hip, self-inflicted verbal wounds, the Trump campaign, while appearing to be populist in its spontaneity and boosterism ("It will be huge!") was very carefully calibrated. With any sort of perspective, the real key to the 2016 election lies in two facts. The first is that Mrs. Clinton, with great difficulty, kept the Democratic Party of Roosevelt, Truman, Stevenson, Kennedy, Johnson, Humphrey, and Bill Clinton out of the hands of the wild-eyed Left.

The second key fact is that Donald Trump managed to crush the heirs of post-Reagan Republicanism, the Bushy procession of indistinct opposition, who had the flexibility of Eisenhower without the charm of Ike or the prestige of a victorious five-star theater commander in history's greatest war; and the nondescript aspect of Nixon without his feral, sometimes sublime political cunning, or his hammerlock on the suburban bourgeoisie for

whom life is a virtuous struggle. By the narrowest of margins, Mrs. Clinton kept control of the Democratic Party out of the hands of Senator Bernie Sanders, who would have caused the election of any of the seventeen Republican contenders for the nomination. With somewhat more leeway, but narrowly enough, Trump threw out the post-Reagan Republican bathwater without fumbling the gurgling infant into the arms of the agile paleo-conservative smoothie, Senator Cruz.

For only the third time in a hundred years, the political center moved in an election (as in 1932 and 1980), but remains, as it did then, well within the thirty-yard lines. What occurs at such times is, when referred to at all, generally called "fusionism." Relatively powerful populist enthusiasms, i.e., those not embraced by a majority of the powers that be in either party, are carried to victory by a contender. Then, some aspects of this outlier perspective are eventually homogenized in revisions to laws, regulations, and practices.

In the main English-speaking countries, parties tend to carry on in this way for generations. The American Whigs cracked up because they could not find a position on slavery that would counter the confidence trick of Jefferson, Madison, Monroe, and Jackson for the Democrats as the party that would preserve Southern society (slavery), while reassuring the North that they alone would keep the South in the Union. The Compromise of 1850, crafted by the greatest of the Whigs, the three-time presidential candidate Henry Clay, and the greatest of the pre–Civil War Northern Democrats, Stephen A. Douglas, effectively guaranteed a civil war in each territory as it determined whether it would seek admission to the Union as a free or slave state, and provided for the relentless hounding of fugitive slaves in a manner that offended most conscientious Americans (especially after it was upheld by the U.S. Supreme Court in the egregious *Dred Scott* case).

The first serious outburst of domestic populism was formalized by the founding of the Republican Party from groups that simply could not abide any longer the degeneration of the great American experiment, "the new order of the ages," into a squalid series of compromises with those who could justify the ownership of human beings by other human beings, in a time when all the great nations of the West, led by Great Britain and France, had abolished slavery. The first year that the Republicans could nominate a candidate, 1856, they put forward an eccentric and controversial explorer and colonel, John C. Fremont.

The second populist activity of this period, in the same year of 1856, was the last stand of the old party of American bigotry. Because they met in secret halls where admission was achieved by saying the password "I don't know," the group became very aptly named the "Know Nothings," though the official name was the American Party, which received the support of the continuing Whigs. Former President Millard Fillmore was the American Party's presidential candidate, on a platform which was reduced to platitudinous nativism and implicitly supported banning Roman Catholics and the foreign-born from public office, as well as twenty-one years of residency for the achievement of citizenship.

The Republicans and Know-Nothings ran against James Buchanan, a dough-faced (slavery-appeasing) Democrat, former Secretary of State (in which position James K. Polk, the last strong Democratic president before the Civil War, judged him incompetent), and minister to Great Britain. Buchanan won, 45 percent (1.84 million votes) to 33 percent (1.36 million votes) for Fremont's Republicans and 22 percent (875,000 votes) for Fillmore—174 electoral votes to 114 Republican to 8 for the American Party. The great American experiment had made its last throw at the dishonorable compromises of eighty years. Buchanan was bound to fail as president; he had the personality of a helpless compromiser and none of the qualities

required. The Know Nothings were doomed and unmourned. The first exercise in non-reactionary populism, the Republicans, was bound to win, soon.

The third American populist quest of this time was the Southern insurrection itself. In the decade bought by the Compromise of 1850, the U.S. population increased from 23 to 31 million, mostly in the North, so that in 1861 the demographic balance was 22.4 million free people in the North, to 5.1 million plus 3.5 million slaves in the South. The South nonetheless interpreted the election of Lincoln, the Republican candidate in 1860 who sought only to restrict slavery to where it already existed, as justifying its secession from the Union.

The South was spoiling for a fight. They had not seen a serious and purposeful Northern president since the Adamses, and John Quincy had been ejected from the White House by Andrew Jackson more than forty years earlier (and, though intelligent, worthy, and principled, he was no strongman). This is the danger of appeasement—the South had forgotten that there were strong men in the North. Lincoln had warned the South for two years that Republican victory would not justify secession, that secession would not be tolerated by the North, and that, while both sides were equally brave, the South could not defeat the North in a war because Southerners were not adequately numerous.

Between December 9, 1860, and February 1, 1861, South Carolina, Mississippi, Florida, Alabama, Georgia, and Louisiana all seceded, claiming the new president was a regional candidate, an enemy of slavery, who would continue what was considered to be a war against slavery. Virginia, Arkansas, North Carolina, and Tennessee voted in their legislatures to secede if there were any effort to coerce a seceding state to remain in the Union. Referenda were held, even after the legislative votes for secession, in Tennessee, Texas, and Virginia, that yielded 25 to 35 percent negative votes, even though no serious federalist argument was allowed.

Secession, of course, brought civil war and ultimate Union victory. Only with the deaths of 750,000 Americans, the smashing of five states to rubble and ashes, and the assassination of the nation's greatest leader, did this Southern stab at populism end.

For a hundred years afterwards, only the whites voted in the South, despite the emancipation of the slaves, and huge numbers of European immigrants arrived in the great port cities of the North and moved westwards, generally provided for by the Democratic bosses in those cities. As the Democrats had held office for fifty-two of the sixty years prior to Lincoln, the Republicans did so for forty-four of the fifty-two years starting with Lincoln, losing the South en bloc, as they had before the war, but prevailing as the party of native-born Americans and the conservators of the Union in most of the North. Counterintuitively, federal expenses on pensions to Civil War veterans and their families steadily increased for forty years, as the Republicans bought votes to counter the Democratic strength in the proliferating Irish, German, Italian, and East European communities. From 1876 to 1892, the Democrats won the presidential popular vote four times, and trailed by only 6,000 out of nearly ten million cast in 1880, but were only elected twice. As originally adopted, the Constitution credited the South with 60 percent of the African-American slave population for purposes of calculating members of Congress and the Electoral College. Now 100 percent of African Americans were counted, but practically none of them voted. The South was decisively beaten on the battlefield, but not politically.

The extreme narrowness of the competition between the parties was only broken by the next foray into populism by a national party. This was the triumph of the chimerical panacea of bimetallism, sponsored by the golden-tongued thirty-six-year-old Nebraskan orator, editor, and ex-congressman William Jennings Bryan, who equaled Clay's record of running three times unsuccessfully for president (1896, 1900, 1908). In 1896, the Democrats, in addition to

bimetallism, demanded sharply lower tariffs, a judicial attack on industrial monopolies, an enhanced legal status for labor unions, and even flirted with a tax on high incomes (which would not even be constitutional for another seventeen years). It was an imaginatively radical platform.

But bimetallism was a simplistic idea and the Republicans had no difficulty portraying it as a menace to sound money, especially after, by tragic luck, the Ohio supporter of big business, William McKinley, was assassinated in 1901, making the greatest contemporary populist of all, Theodore Roosevelt, president. Roosevelt attacked John Pierpont Morgan's financial empire rather symbolically (yet named one of Morgan's partners, Robert Bacon, Secretary of State), made a great issue of conservation, passed some reform measures in accuracy of labeling and marketing of food and drugs, and swaddled himself in a new nationalism by building the Panama Canal and making the United States a great naval power, sending the Great White Fleet around the world. Sound money populism, pitched to the rising middle class and bolstered by robust patriotism in the world, easily defeated the populism of monetary tinkerers from under-populated, silver-producing states. Bryan led the Democrats into a cul-de-sac, as they lost in 1896 by 600,000 votes, by 850,000 with Bryan again in 1900, and in 1908, though Bryan had cooled off considerably, Roosevelt's (temporarily) chosen successor, William Howard Taft, defeated Bryan by 1.3 million votes; even tepid populism wasn't making it. (Theodore Roosevelt denounced Bryan as a yokel, "a yodeler . . . a human trombone.")

So perished American populism again, though it was buried by imaginative Roosveltian counter-populism. There had been third-party movements when neither of the main parties addressed occupational discontents: the Popular Party of 1892—disgruntled farmers and workers led by the former congressman (and the some-time-Republican and Democrat) James Weaver—took 8.5 percent

of the vote, but did not change the election result, and the party vanished. The Socialist Party in 1912 won a little over 6 percent for the perennial candidate Eugene V. Debs, and in 1924, when the Democrats took 103 ballots to choose John W. Davis, an almost non-political candidate, as a compromise between factions, a briefly revived Progressive Party led by Robert La Follette of Wisconsin garnered 16 percent of the vote. But again, it did not alter the result of the election and the Progressives vanished when the liberal (Roman Catholic) Governor Alfred E. Smith of New York was the Democratic nominee in 1928. Third parties never win in the United States, even when led by an ex-president (Van Buren in 1848, Fillmore in 1856, Theodore Roosevelt in 1912). Populism only has a chance when it takes over an existing party, as the Republicans took over the Whigs in 1856, Bryan took over the Democrats in 1896, Theodore Roosevelt the Republicans in 1901, and Donald Trump the Republicans in 2016.

The Roosevelt–Taft split brought back the Democrats with Wilson, who was barely reelected over a reunited Republican Party in 1916. After a brief cameo appearance as a world idol and the first person to inspire the masses of mankind with the vision of enduring peace and a start at world government, Wilson suffered a disabling stroke and the country flopped back to the Republicans in a landslide in 1920, espousing Prohibition and isolationism. The ultimate Goodtime Charlie, Warren Gamaliel Harding, followed by the legendarily taciturn Calvin Coolidge and Herbert Hoover, the renowned engineer and former dispenser of aid to war-starved Europeans, presided over a rollicking time of irresponsible government. Recession was successfully fought off with tax cuts, but tariffs rose, immigration was slammed almost shut, and an immense equity-debt bubble was actively encouraged, producing the epic crash of 1929 and the Great Depression that ensued. The policy prescription adopted was the worst that could have been found:

even higher tariffs, tax increases, and a reduced money supply. This handed the government for five straight terms to the Democrats under Franklin D. Roosevelt and Harry S Truman, who governed as liberals and were effective war leaders also, but Roosevelt the great patrician was no populist. Truman the small businessman and municipal judge came closer, but was essentially Roosevelt's heir.

Roosevelt was frequently reviled as a radical, but he salvaged 95 percent of the capitalist system, and his Republican successor, Eisenhower (whom he had promoted militarily), retained almost all of his domestic program. The world had definitively opted to fight economic reversals with public-sector spending at every encounter, and while the economic cycle was moderated, all currencies began a gradual descent in buying power, and eventually possessed a value that, far from being measured in two precious metals, or against gold alone, was measured only in other currencies. The value of money, as a concept, has been on an inexorable eighty-year slide; and the workfare programs ingeniously developed by Roosevelt to absorb unemployment rates of up to 30 percent in the early Thirties (when there was no direct relief for the unemployed) gradually degenerated into a rather indiscriminate practice of taxing money from people who have earned it and redistributing it to people who haven't, generally in return for their votes, without requiring any work from them as Roosevelt had, while coloring the whole process, somewhat misleadingly, as social justice.

After the generally very successful Roosevelt–Truman period and the peace and prosperity of the Eisenhower era, the Republicans and Democrats were, in presidential politics, about even, as the virtual draw in the 1960 presidential election between Kennedy and Nixon indicated. (Because it still held most of the South as a one-party state, the Democrats had the edge in the Congress, for a few more years.) Eisenhower, who was often an imaginative leader, as in his Atoms for Peace and Open Skies proposals and his

Interstate Highways program (modeled on what he had seen in Germany as military governor there), was not an especially activist president and was less of a natural advocate of change than the Democrats who bracketed him. He famously regarded the Democrats, an informal coalition of Northern urban liberals and Southern conservative segregationists, as "Extremes of the left, extremes of the right, with political chicanery and corruption shot through the whole business." (He was referring to the party of Roosevelt, Truman, Adlai Stevenson, Kennedy, Johnson, and Sam Rayburn, all politicians of considerable distinction; what he might have thought of Obama, the Clintons, Al Sharpton, and Bernie Sanders is a real challenge to the imagination.)

The country revolted against the Democrats for miring the United States in the Vietnam War, where over a million draftees fought an elusive enemy with less than America's full capacity to wage war, and for an objective short of outright victory in a cause that was not obviously sufficiently important to the national interest to justify such an effort. Richard Nixon extracted the country from the war while preserving a non-communist government in Saigon, and he astutely triangulated relations with China and the Soviet Union. But he inexplicably allowed a nonsensical escapade of campaign activists to destroy his administration and force him out of office. Given the Democrats' desertion of Indochina, which was their war originally, it was the strangest and most tragic scenario in American history—one no one could have imagined, and the presidency fell momentarily back into the hands of the Democrats. Jimmy Carter, an unworldly and somewhat feckless altruist, was responsible for the only occasion since 1896 when either party failed to win consecutive terms in the White House.

The Carter years saw an extreme spike in oil prices and an economic slowdown, and what the president described as a "malaise" (of which his opponents considered his presence in the White House

to be the chief symptom). With double-digit unemployment, inflation, 20 percent interest rates as part of the Federal Reserve policy of cracking inflation by inducing a back-breaking recession—one of America's all-time great fusionists emerged. Ronald Reagan had almost taken the nomination from the incumbent, the admirable if ungalvanizing Gerald Ford, in 1976. The office, in the mysterious American way, now sought the man. Ronald Reagan was a unique combination of traditional values, skepticism about state intervention, supply-side economics, and a Truman–Eisenhower view of an escalated Cold War, without McCarthyism or paranoia. When asked his plan for the Cold war, he responded: "We win and they lose."

Reagan was the perfect fusionist because he was a genuine American traditionalist and patriot, but also a professional showman, real Hollywood tinsel; he always knew how to present. His detractors called him a "good communicator," but he was a hypnotic public speaker, a benign demagogue. He had the glitz and the magic, and the human touch; would Washington, with a bullet in his chest, have said to the waiting doctors in the hospital, "I hope you're all Republicans"? Such a felicitous political chief and effective government executive started with 90 percent of Republicans, Norman Rockwell's middle America and Richard Nixon's silent majority, and added working-class Democrats in millions.

In Reagan's last election, against the perfectly inoffensive Walter Mondale, not someone easily portrayed as dangerous, as Goldwater and McGovern had been, and Donald Trump almost was, Reagan took forty-nine states and won by 17 million votes. There was a populist ingredient in his mighty coalition, but it was subsumed unrancorously into a tidal wave of agreement to let America be America—a suite of purposeful and congenial attitudes on top of a sharp tax-cut and a well-designed defense upgrade. Ronald Reagan ran the broadest Church in the biggest tent in American history, at least since James Monroe ran unopposed in 1820. When he warned,

in his famous address on behalf of Barry Goldwater in 1964, that a vote for Lyndon Johnson was "the first step into a thousand years of darkness," reasonable people thought it good campaign knock-about polemics. When he called for a Constitutional amendment against abortion, his pro-choice supporters were happy to regard it as the understandable views of an amiable septuagenarian.

Nixon wrote of Reagan's successor, George H. W. Bush, that he was "a good man with good intentions" but had "no discernible pattern of political principle . . . no political rhythm, no conservative cadence, and not enough charismatic style to compensate." The great Reagan coalition started to unwind quite quickly. Bush led the nation and a vast coalition with great distinction in evicting Iraq's Saddam Hussein from Kuwait, but reneged on his promise of "no new taxes," irritating the Reagan conservatives without, as Nixon warned, replacing them with centrist independents. The Democratic candidate in 1992 was the politically agile moderate young governor of Arkansas, William J. Clinton, and Bush had allowed a large chunk of maverick Republicans to gather around the eccentric Texas billionaire Ross Perot's third party candidacy. Perot complained about the deficit, taxes, and drugs, and in the unique American manner of very wealthy men who are politically disgruntled, became a populist figure who was useful to Clinton in siphoning off various categories of Republicans. Perot took 19 percent of the vote, almost 20 million ballots, putting Clinton across with 43 percent of the vote to 37 percent for Bush.

The ensuing eight years with Clinton were a time of policy moderation and unchallenging foreign policy as the United States was the world's only Great Power. Clinton maintained his principal sources of political support in good heart, such as minorities and the young middle class. The observant could see the first signs of slippage among working-class Democrats, some of whom Clinton had won back from Reagan. As passing years would demonstrate,

though Clinton prudently eliminated the deficit, he encouraged the housing bubble by promoting commercially unviable mortgages legislatively and by executive order. This was a political free lunch, as the percentage of families who owned their homes rose and money from grateful developers and building trade unions flowed to the Democrats, but a debt bubble comparable to the 1920s over-margined equities market grew right under the noses of the Federal Reserve and Treasury. Clinton was also reckless about the expansion of the current account deficit and did nothing to reduce oil imports and prices.

There were moral and ethical issues that grew to alienate large sections of opinion. The President's own extramarital peccadilloes offended many. But more damaging to the Clintons eventually were the antics of the Clinton Foundation and the appearance of what seemed, two terms later, when Mrs. Clinton was secretary of State, to be a pay-to-play casino where there may not have been costs to the taxpayers or direct inducements to public office holders, but appearances, for a family which coveted a return to the White House, were far from optimal. There also soon arose allegations that the president and his national security team had responded inadequately to various terrorist provocations, that escalated vertiginously early in the term of the next administration.

Bill Clinton was followed for two terms, and again by a narrow margin (ultimately 537 votes among almost six million votes cast in Florida in 2000), for the Republican candidate, Governor George W. Bush of Texas, son of the former president. His administration was overshadowed by the terrorist crisis that erupted when skyjacked airliners brought down the World Trade Center Towers in New York and damaged the Pentagon on September 11, 2001. Bush generally handled the terrorist threat well, but the reinvasion of Iraq, partly to eliminate weapons of mass destruction, of which no current evidence was unearthed, and which were tolerated to be

developed by neighboring Iran, substantially eroded public confidence in the regime. And with most of the conventional ground forces military capability tied up throughout the second Bush era in Iraq and Afghanistan, trying to cope with an incomprehensible tribal guerrilla conflict in both countries, the public approval rating of the administration reached dangerously low levels, just as the housing debt and sub-prime mortgage crisis blew up at the start of the 2008 election campaign. President Bush's response that "The sucker could go down" (in reference to the economy), as the banking systems of almost every advanced Western country except Canada collapsed and had to be shored up by massive deposits and relief measures from the central banks, denuded his regime of almost all public support.

The forces of public anger and disillusionment that feed populist agitation had built to very appreciable levels and were available for the bold election of America's first non-white president, Barack H. Obama. President Obama retained a reasonably buoyant level of personal popularity, but for his last term, two thirds of Americans thought the country was in decline. The workforce shrunk by 15 million, and a widespread perception arose that over-generous trade deals, high corporate taxes that drove out manufacturers, and the toleration of twelve million illegal migrants flooding for over twenty years across the Mexican border have sandbagged the American worker. The federal debt rose in eight years by 125 percent from where it had been on inauguration day, 2009, after 233 years of American independence. The economic growth rate was sluggish throughout Obama's second term despite mountainous pump-priming. A precipitate withdrawal from Iraq helped produce the most virulent terrorist organizations in history, people little concerned to save their own lives as they killed others. Sixty percent of the population of Iraq was now under the effective domination of Iran, which was effectively permitted by treaty to take

up nuclear weapons in ten years (if it chooses to wait that long, a practically unverifiable matter). Russia, which Richard Nixon and Henry Kissinger had effectively expelled from the Middle East in the Seventies, made a most untimely comeback and became a power of great importance there with only fifty combat aircraft and token ground forces as Obama and his advisors waffled and promised a "Red Line" of intolerance of Syrian gassing of its own citizens and then backed down.

Hillary Clinton had served as Secretary of State in the first Obama term. Thus, a member of the Bush or Clinton families had been president, vice president, or Secretary of State without interruption for thirty-two years (1981–2013), and Mrs. Clinton and former Florida Governor Jeb Bush both sought their parties' presidential nominations in 2016. The Bushes became a dynasty because George Bush was the first president since Theodore Roosevelt who had sons with political aptitude. The Clintons only became a dynasty because Hillary Clinton was the first president's wife since Eleanor Roosevelt who had any political aptitude. And the country was saddled with these worthy-enough but not meritocratically exalted families indefinitely. In this atmosphere, public discontent and populist susceptibilities achieved historic proportions.

The country had changed administrations every two terms starting in 1992 and removed control of the Congress from each of the three administrations. The state of the Union, domestically and in the world, appeared to most to have deteriorated steadily from the second Clinton term on, for the first time in American history, while these two families handed the greatest offices in the land back and forth between them. Washington, flattered by the entertainment community and protected by a docile and unrepresentatively leftish media, exuded complacency.

Only one person came forward to challenge the whole cast of characters, to call the Bushes incompetent, the Clintons dishonest,

Obama a failure, the press toadies, the pollsters flacks and lackeys, and the whole system a sleaze factory in which a bipartisan group of self-serving and inept insiders were just gaming the system for their own incumbencies and the devil take the country and its voters. The flamboyant and clangorous billionaire developer, casino owner, and sports and television impresario Donald Trump seemed an unlikely pied piper. He was prone to support absurd causes, such as denying that Obama was born in the United States, and was known to read and take half-seriously the most spurious media, such as the *National Enquirer*, but he promised to build a southern border, to promote economic growth, to repatriate jobs with an incentive tax structure that would stop mollycoddling Wall Street deal-makers, to reopen unsuccessful trade agreements, to end the freeloading of America's so-called allies and the insolences of its enemies, and to redefine the national interest in a coherent line between George W. Bush's trigger-happy adventurism and Barack Obama's pacifistic, Panglossian quest to have America's allies and enemies change roles and places.

The entire political class proclaimed Trump's absurdity and unsuitability, but he kept winning the Republican primaries. As some of his reflections on illegal immigration were politically incorrect, the hue and cry was sent up that he was a racist. When an eleven-year-old off-mike tape of very coarse reflections on women Trump made in conversation with a lesser member of the ubiquitous Bush family was released, he was reviled as a sexist. Hillary Clinton had troubles of her own; she muddied the waters by describing "half" Trump's scores of millions of supporters as "deplorable." When she finally won her nomination, well after Trump had mopped the floor with the entire Republican establishment as well as the far right, there was no Democratic campaign left except the portrayal of Trump as a racist, misogynistic ogre who incarnated vulgarity, greed, and philistinism.

Trump was running against Washington, not in the genteel manner of Reagan, who was running against Washington even after he had lived in the White House for six years, but in the nasty strictures of someone who really was storming Babylon and was capable of tossing out chunks of the bureaucracy as Jackson did with his "spoils system" in 1829. Trump was running against almost every person in Washington D.C., and about 96 percent of them voted against him, though only 93 percent voted for Hillary Clinton. Attacking Trump was the only Democratic argument. Trump reviled the Clintons as crooks and Bill Clinton as a serial rapist. It was low and unedifying, though entertaining in its crudeness. Trump was not always pandering to rich friends in Wall Street and Hollywood passing the hat for him. (Trump went up a point in the polls when the entertainer Madonna promised oral sex for every man who voted for Hillary Clinton.) Trump didn't need rapsters and witless starlets to pull the crowds for him.

The more the entrenched forces who had excluded the angry and had mismanaged America attacked him, the more the people came. Trump used the social media and the talk show giants, Rush Limbaugh, Laura Ingraham, and Ann Coulter, as substitutes for the traditional media. Ms. Coulter reflected in her splendid upper-class New England–New York accent, a little like Eleanor Roosevelt's, that America could not be subjected to watching her "wallow around in those neon pantsuits" for the next few years.

The consensus was almost unanimous: Trump could not win. His victory was an upset comparable to that of Harry Truman against Thomas E. Dewey in 1948, except that all the right people supported Truman, however condescendingly, and no one supported Trump, except the people.

The initial reaction showed the profundity of the surprise at the people's verdict: unfounded electoral challenges (there was nothing like the Chicago Daley machine's theft of ballot boxes and Lyn-

don Johnson's resurrection of legions of dead voters in Texas in 1960). The only skullduggery was the Clinton vote larger than the voters' list in some African-American districts of Milwaukee. There were television spots asking members of the Electoral College to change their minds and spare the nation a Trump barbarity. There were a few electors who switched, but most away from Hillary.

If any Bush, Clinton, or Obama is heard from as a coming candidate for the headship of the nation again, it will be on a straight meritocratic basis and after the appropriate interval when spurs are won and the country is exposed to other families—the old-fashioned way, like the Adamses, Harrisons, and Roosevelts.

What has occurred is the supreme triumph of populism in American history and in the modern democratic world. Even Andrew Jackson had been a prominent general, albeit in Gilbert and Sullivan wars and in crushing the natives almost as brutally as Mussolini did the Ethiopians, and he had briefly been a senator and congressman, and ran once (and was the leading vote-getter in a four-way race) before he was elected president. Trump is the only person ever elected president who has never held a public office or a high military position, the oldest and wealthiest person ever elected to the office.

Among the great Western nations, only the United States has the constitutional and psychological ability to conduct a full exercise in populism. Some of the campaign against it as demagogy has been justified, though not the charge of mob rule. Yet in the last year, it was the only avenue to national renovation.

ROGER KIMBALL

The Imperative of Freedom

It is curious how certain words accumulate a nimbus of positive associations while others, semantically just as innocuous, wind up shouldering a portfolio of bad feelings.

Consider the different careers of the terms "democracy" and "populism."

Do you know any responsible person who would admit to being opposed to democracy? No one who does not enjoy a large private income would risk it. But lots of people are willing to declare themselves anti-populist. The discrepancy is curious for several reasons.

For one thing, it is a testament to the almost Darwinian hardiness of the word "democracy." In the fierce struggle among ideas for survival, "democracy" has not only survived but thrived. This is despite the fact that political thinkers from Plato and Aristotle through Cicero and down to modern times have been deeply suspicious of democracy. Aristotle thought democracy the worst form of government, all but inevitably leading to ochlocracy or mob rule, which is no rule.

In *Federalist* 10, James Madison famously warned that history had shown that democratic regimes have "in general been as

short in their lives as they have been violent in their deaths."
"Theoretic politicians," he wrote—and it would be hard to find
a more contemptuous deployment of the word "theoretic"—such
politicians may have advocated democracy, but that is only because
of their dangerous and utopian ignorance of human nature. It was
not at all clear, Madison thought, that democracy was a reliable
custodian of liberty.

Nevertheless, nearly everyone wants to associate himself with
the word "democracy." Totalitarian regimes like to describe them-
selves as the "Democratic Republic" of wherever. Conservatives
champion the advantages of "democratic capitalism." Central
planners of all stripes eagerly deploy programs advertised as en-
hancing or extending "democracy." Even James Madison came
down on the side of a subspecies of democracy, one filtered
through the modulating influence of a large, diverse population
and an elaborate scheme of representation that attenuated (Mad-
ison said "excluded") the influence of "the people in their collec-
tive capacity."

"Democracy," in short, is a *eulogistic* word, what the practical
philosopher Stephen Potter in another context apostrophized as
an "OK word." And it is worth noting, as Potter would have been
quick to remind us, that the people pronouncing those eulogies
delight in advertising themselves as, and are generally accepted as,
"OK people." Indeed, the class element and the element of moral
approbation—of what some genius has summarized as "virtue sig-
naling"—are key.

It is quite otherwise with "populism." At first blush, this seems
odd because the word "populism" occupies a semantic space close-
ly adjacent to "democracy." "Democracy" means "rule by the *demos*,"
the people. "Populism," according to *The American Heritage Dictio-
nary*, describes "A political philosophy directed to the needs of the
common people and advancing a more equitable distribution of

wealth and power"—that is, just the sorts of things that the people, were they to rule, would seek.

But the fact is that "populism" is ambivalent at best. Sometimes, it is true, a charismatic figure can survive and even illuminate the label "populist" like a personal halo. Bernie Sanders managed this trick among the eco-conscious, racially sensitive, non-gender-stereotyping, anti-capitalist beneficiaries of capitalism who made up his core constituency.

But it was always my impression that in this case the term "populist" was fielded less by Sanders or his followers than by his rivals and the media in an effort to fix him in the public's mind as one of the many lamentable examples of not-Hillary, who herself was presumed to be popular though not populist.

There are at least two sides to the negative association under which the term "populist" struggles. On the one hand, there is the issue of demagoguery. Some commentators tell us that "populist" and "demagogue" are essentially synonyms (though they rarely point out that *demagogos* simply meant "a popular leader," e.g., Pericles). The association of demagoguery and populism describes what we might call the command-and-control aspect of populism. The populist leader is said to forsake reason and moderation in order to stir the dark, chthonic passions of a semi-literate and spiritually unelevated populace.

How dark? In the April 20, 2017 issue of *The New York Review of Books*, the historian Christopher Browning has a review of a book about Hitler's rise to power. At least, that is the ostensible subject of the review. The real subject of this disgusting and disingenuous essay is to lambast a caricature that Browning calls "Trump the populist." There are, Browning allows, "many significant differences between Hitler and Trump." Think about that: there are "many significant differences between Hitler and Trump." As Francisco says at the beginning of *Hamlet* "for this relief much thanks." But

of course it is the alleged, not to say fantastical, similarities between Hitler and Trump that Browning conjures up that the reader is meant to carry away with him. The lesson of Hitler's rise is that he should have been squashed at the beginning: "do it early," Browning advises, as if Donald Trump bore *any* relevant similarity to the Nazi Führer and must therefore be eliminated now, before it is too late.

On the other hand, there is the issue of the fertile but unedifying soil of that populace upon which the demagogic leader works. Anyone who has looked at the commentary on Brexit, the campaign and early months of the Trump administration, or the recent French election will have noted this.

Consider, to take but one example, how often the word "anger" and its cognates are deployed to evoke the psychological and moral failings of both the populist multitude and its putative leaders. In a remarkable, apocalyptic effusion published in the early hours of November 9, 2016, David Remnick, the editor of *The New Yorker*, warned that the Trump presidency represented "a rebellion against liberalism itself," an "angry assault" on the civil rights of women, blacks, immigrants, homosexuals, and countless others. Later commentators warned about our "angry, cynical times," the "raw, angry and aggrieved" tone of Trump's rhetoric, the unchaperoned "anger" of Americans who felt they "had been left behind." CNN dilated on how "Trump's Anger Could Lead Down a Dangerous Road," while *The Washington Post* promised to take its readers "Inside Trump's Anger and Impatience" and *The New York Times* endeavored to explain "How Festering Anger at Comey Ended in His Firing."

There are occasional acknowledgments that the diagnosed "anger" may be understandable, even justified. But we are left with the unmistakeable impression that the phenomenon as a whole is something vicious and irrational. Anger "festers." It leads to "sudden," i.e., impulsive decisions. The road it steers us toward could

be "dangerous." (Ah, how cheap is possibility: when we read that "could be" dangerous, do we also think, as we should, that it might just as well *not* be?)

Populism, in short, seems incapable of escaping the association with demagoguery and moral darkness. Like the foul-smelling wounds of Philoctetes, the stench is apparently incurable. Granted, there are plenty of historical reasons for the association between demagoguery and populism, as such names as the brothers Tiberius and Gaius Gracchus, Father Coughlin, Huey Long, not to mention Mr. Browning's friend Adolf, remind us.

Still, I suspect that in the present context the apparently unbreakable association between populism and demagoguery has less to do with any natural affinity than with cunning rhetorical weaponization. "Populism," that is to say, is wielded less as a descriptive than as a *delegitimizing* term. Successfully charge someone with populist sympathies and you get, free and for nothing, both the imputation of demagoguery and what was famously derided as a "deplorable" and "irredeemable" cohort. The element of existential depreciation is almost palpable.

So is the element of condescension. Inseparable from the diagnosis of populism is the implication not just of incompetence but also of a crudity that is part aesthetic and part moral. Hence the curiously visceral distaste expressed by elite opinion for signs of populist sympathy. When Hillary Clinton charged that half of Donald Trump's supporters were an "irredeemable" "basket of deplorables," when Barack Obama castigated small-town Republican voters as "bitter" folk who "cling to guns or religion or antipathy to people who aren't like them or anti-immigrant sentiment or anti-trade sentiment," what they expressed was not disagreement but condescending revulsion.

I think I first became aware that the charge of populist sympathies could have a powerful political, moral, and class delegitimiz-

ing effect when I was in London last June to cover the Brexit vote. Nearly everyone I met, from Tory ministers to taxi drivers, from tourists to tradesmen, was a Remainer. The higher up the income and class scale you went, the more likely it was that your interlocutor would be in favor of Britain's remaining in the European Union. And the more pointed would be his disparagement of those arguing in favor of Brexit. The Brexiteers were said to be "angry," yes, but also ignorant, fearful, xenophobic, and racist.

Except that they weren't, not the ones I met, anyway. For them, Brexit turned on a simple question: "Who rules?" Is the ultimate source of British sovereignty Parliament, as had been the case for centuries? Or is it Brussels, seat of the European Union?

The question of sovereignty, I believe, takes us to the heart of what in recent years has been touted and tarred as the populist project.

Consider Britain. Parliament answers to the British voters. The European Union answers to—well, to itself. Indeed, it is worth pausing to remind ourselves how profoundly undemocratic is the European Union. Its commissioners are appointed, not elected. They meet in secret. They cannot be turned out of office by voters. If the public votes contrary to the wishes of the E.U.'s commissars in a referendum, they are simply presented with another referendum until they vote the "right" way. The E.U.'s financial books have never been subject to a public audit. The corruption is just too widespread. Yet the E.U.'s agents wield extraordinary power over the everyday lives of their charges. A commissioner in Brussels can tell a property owner in Wales what sort of potatoes he may plant on his farm, how he must calculate the weight of the products he sells, and whom he must allow into his country. He can outlaw "racism" and "xenophobia"—defined as harboring "an aversion" to people based on "race, colour, descent, religion or belief, national or ethnic origin" and specify a penalty of "at least" two years' imprisonment for

infractions. He can "lawfully suppress," as the London *Telegraph* reported, "political criticism of its institutions and of leading figures," thus rendering the commissars of the E.U. not only beyond the vote but also beyond criticism.

It's a little different in the United States. I'll come to that below. At the moment, it is worth noting to what extent the metabolism of this political dispensation was anticipated by Alexis de Tocqueville in his famous passages about "democratic despotism" in *Democracy in America*. Unlike despotism of yore, Tocqueville noted, this modern allotrope does not *tyrannize* over man—it infantilizes him. And it does this by promulgating ever more cumbersome rules and regulations that reach into the interstices of everyday life to hamper initiative, stymie independence, stifle originality, homogenize individuality. This power, said Tocqueville, "extends its arms over society as a whole."

> It does not break wills, but it softens them, bends them, and directs them; it rarely forces one to act, but it constantly opposes itself to one's acting; it does not destroy, it prevents things from being born; it does not tyrannize, it hinders, compromises, enervates, extinguishes, dazes, and finally reduces each nation to being nothing more than a herd of timid and industrious animals of which the government is the shepherd.

Tocqueville's analysis has led many observers to conclude that the villain in this drama is the state. But the political philosopher James Burnham, writing in the early 1940s in *The Managerial Revolution*, saw that the real villain was not the state as such but the bureaucracy that maintained and managed it. It is easy to mock the apparatchiks who populate the machinery of government. Thus James H. Boren writes wickedly that "the noblest of all of man's struggles are those in which dedicated bureaucrats, armed with the spirit of dynamic inaction, have fought to protect the ramparts of

creative nonresponsiveness from the onslaughts of mere citizens who have demanded action in their behalf." But the comic potential of the morass should not blind us to the minatory nature of the phenomenon. Indeed, it presents a specimen case of the general truth that the preposterous and the malevolent often co-mingle. The shepherd of which Tocqueville wrote was really a flock of shepherds, a coterie of managers who, in the guise of doing the state's business, prosecuted their own advantage and gradually became a self-perpetuating elite that arrogated to itself power over the levers of society.

Anatomizing this sleight-of-hand is at the center of "James Burnham's Managerial Elite," Julius Krein's essay in the inaugural issue of *American Affairs*. "Although the managerial elite uses the state as an instrument to acquire power," Krein notes, "the real enemy is not the state but rather the managerial separation of political and economic power from the liberal social contract."

This separation of the real power of society from the economy and political life renders the managerial elite all but untouchable. And this, as Burnham saw, was the property neither of liberalism nor of conservatism but rather of anterior forces that engulfed both. "The contradiction of contemporary conservatism," Krein writes,

is that it is an attempt to restore the culture and politics of bourgeois capitalism while accelerating the economy of managerialism. Because of its failure to recognize this contradiction, "much of conservative doctrine is, if not quite bankrupt, more and more obviously obsolescent," as Burnham wrote in 1972. Since then it has only evolved from obsolescent to counterproductive. At this point, expanding "free markets" no longer has anything to do with classical American capitalism. It is simply the further emancipation of the managerial elite from any obligations to the political community. Likewise, promoting democracy as an abstract, universalist principle only undermines the sovereignty of the American people by

rejecting national interests as a legitimate ground of foreign policy.

Sovereignty, Burnham saw, was shifting from Parliaments to what he called "administrative bureaus," which increasingly are the seats of real power and, as such, "proclaim the rules, make the laws, issue the decrees." As far back as the early 1940s, Burnham could write that "'Laws' today in the United States . . . are not being made any longer by Congress, but by the NLRB, SEC, ICC, AAA, TVA, FTC, FCC, the Office of Production Management (what a revealing title!), and the other leading 'executive agencies.'" And note that Burnham wrote decades before the advent of the EPA, HUD, CFPB, FSOC, the Department of Education, and the rest of the administrative alphabet soup that governs us in the United States today. As the economist Charles Calomiris points out in his short but important book *Reforming Financial Regulation After Dodd-Frank* (2017), we are increasingly governed not by laws but by ad hoc dictats emanating from semi-autonomous and largely unaccountable quasi-governmental bureaucracies, many of which meet in secret but whose proclamations have the force of law.

I am convinced that the issue of sovereignty, of what we might call the *location* of sovereignty, has played a large role in the rise of the phenomenon we describe as "populism" in the United States as well as Europe. For one thing, the question of sovereignty, of who governs, stands behind the rebellion against the political correctness and moral meddlesomeness that are such conspicuous and disfiguring features of our increasingly bureaucratic society. The smothering, Tocquevillian blanket of regulatory excess has had a wide range of practical and economic effects, stifling entrepreneurship and making any sort of productive innovation difficult.

But perhaps its deepest effects are spiritual or psychological. The many assaults against free speech on college campuses, the demand for "safe spaces" and "trigger warnings" against verbal or fashion-in-

spired "micro-aggressions" (Mexican hats, "offensive" Halloween costumes, etc.) are part of this dictatorship of political correctness. In *The Road to Serfdom*, Friedrich Hayek said that one of the "main points" of his argument concerned "the psychological change," the "alteration of the character of the people," that extensive government control brought in its wake. The alteration involves a process of softening, enervation, infantilization even: an exchange of the challenges of liberty and self-reliance—the challenges, that is to say, of adulthood—for the coddling pleasures of dependence. Max Weber spoke in this context of "*Ordnungsmenschen*," men who had become increasingly dependent on an order imposed upon them from above. Breaking with that drift becomes more and more difficult the more habituated to dependence a people becomes. In this sense, what has been described as a populist upsurge against political correctness is simply a reassertion of independence, a reclamation of what turns out to be a most uncommon virtue, common sense.

The question of sovereignty also stands behind the debate over immigration: indeed, is any issue more central to the question Who governs? than who gets to decide a nation's borders and how a country defines its first person plural: the "We" that makes us who we are as a people?

Throughout his campaign, Donald Trump promised to enforce America's immigration laws, to end so-called "sanctuary cities," which advertise themselves as safe havens for illegal aliens (though of course they do not call them "illegal aliens"), and to sharpen vetting procedures for people wishing to immigrate to America from countries known as sponsors of terrorism.

The President sometimes overstated and not infrequently misstated his case. Semantic precision is not a Trumpian speciality. But political effectiveness may be. Behind the *Sturm und Drang* that greeted Trump's rhetoric on immigration, we can glimpse two very

different concepts of the nation state and world order. One view sees the world as a collection of independent sovereign countries that, although interacting with one another, regard the care, safety, and prosperity of their own citizens as their first obligation. This is the traditional view of the nation state. It is also Donald Trump's view. It is what licenses his talk of putting "America First," a concept that, *pace* the anti-Trump media, has nothing to do with Charles Lindbergh's isolationist movement of the late 1930s and everything to do with fostering a healthy sense of national identity and purpose.

The alternative view regards the nation state with suspicion as an atavistic form of political and social organization. The nation state might still be a practical necessity, but, the argument goes, it is a *regrettable* necessity inasmuch as it retards mankind's emancipation from the parochial bonds of place and local allegiance. Ideally, according to this view, we are citizens of the world, not particular countries, and our fundamental obligation is to all mankind.

This is the progressive view. It has many progenitors and antecedents. But none is more influential than "Perpetual Peace: A Philosophical Sketch," a brief essay that Immanuel Kant published in 1795 when he was seventy-one. The burden of the essay is to ask how perpetual peace might be obtained among states. The natural condition of mankind, Kant acknowledges, is war. But with the advent of "enlightened concepts of statecraft," mankind, he suggests, may be able to transcend that unfortunate habit of making war and live in perpetual (*ewigen*) comity.

Kant lists various conditions for the initial establishment of peace—the eventual abolition of standing armies, for example—and a few conditions for its perpetuation: the extension of "universal hospitality" by nations was something that caught my eye. Ditto "world citizenship." "The idea of . . . world citizenship," he says at the end of the essay, "is no high-flown or exaggerated notion. It is

a supplement to the unwritten code of the civil and international law, indispensable for the maintenance of the public human rights and hence also of perpetual peace."

Kant makes many observations along the way that will be balm to progressive hearts. He is against "the accumulation of treasure," for example, because wealth is "a hindrance to perpetual peace." By the same token, he believes that forbidding the system of international credit that the British empire employed "must be a preliminary article of perpetual peace." Credit can be deployed to increase wealth, *ergo* it is suspect. Kant says that all states must be "republican" in organization. By that he means not that they must be democracies but only that the executive and legislative functions of the state be distinguished. (Indeed, he says that democracy, "properly speaking," is "necessarily a despotism" because in it the executive and legislative functions of governments are both vested in one entity, "the people.") He looks forward to the establishment of a "league of nations" (*Völkerbund*), all of which would freely embrace a republican form of government.

It would be hard to overstate the influence of Kant's essay. It stands behind such progressive exfoliations as Woodrow Wilson's "Fourteen Points," not least the final point that looked forward to the establishment of a League of Nations. You can feel its pulse beating in the singing phrases of the 1928 Kellogg-Briand Pact, which outlawed war. It is worth noting that among the initial fifteen signatories of that noble-sounding pact, along with the United States, France, and England, were Germany, Italy, and Japan. What does that tell us about the folly of trusting paper proclamations not backed up by the authority of physical force? It is one thing to *declare* war illegal; it is quite another to enforce that edict.

Kant's essay also directly inspired the architects of the United Nations and, in our own day, the architects of the European Union and the battalions of transnational progressives who jettison de-

mocracy for the sake of a more-or-less nebulous (but not therefore un-coercive) ideal of world citizenship.

I would not care to wager on how many of the hysterics who congregated at airports across the country to protest Donald Trump's effort to make the citizens of this country safer were students of Kant. Doubtless very few. But all were his unwitting heirs. "Universal hospitality": how the protestors would have liked that! (Though to be fair to Kant, he did note that such hospitality "is not the right to be a permanent visitor.") I have no doubt that the motivation of the protestors had many sources. But to the extent that it was based on a political ideal (and not just partisan posturing or a grubby bid for notoriety and power), the spirit of Kant was hovering there in the background.

Kant was not without a sense of humor. He begins his essay by noting that he took his title from a sign outside a Dutch pub. "Pax Perpetua" read the sign, and below the lettering was the image of a graveyard. Perhaps the universal perpetuity of death is the only peace that mankind may really look forward to. Kant clearly wouldn't agree, but it was charming of him to acknowledge that the idea of a genuine perpetual peace for mankind might be regarded by many as nothing more than a "sweet dream" of philosophers.

What has been called the populist spirit aims to rouse us from that "sweet dream"—what James Madison might have called the "theoretic" reverie of the meddling class whose designs for our salvation always seem to involve the extension of their own power and prerogative. In this sense, the issue of sovereignty also stands behind the debates over the relative advantages and moral weather of "globalism" vs. "nationalism"—a pair of terms almost as fraught as "democracy" and "populism"—as well as the correlative economic issues of underemployment and wage stagnation. "Theoretic" politicians may advocate "globalism" as a necessary condition for free trade. But the spirit of local control tempers the cosmopolitan proj-

ect of a borderless world with a recognition that the nation state has been the best guarantor not only of sovereignty but also of broadly shared prosperity. What we might call the ideology of free trade—the globalist aspiration to transcend the impediments of national identity and control—is an abstraction that principally benefits its architects. As R. R. Reno, the editor of *First Things*, pointed out in a recent Op-Ed for *The New York Times*, "Globalism poses a threat to the future of democracy because it disenfranchises the vast majority and empowers a technocratic elite."

In the end, what James Burnham described as the "managerial revolution" is part of a larger progressive project. The aim of this project is partly to emancipate mankind from such traditional sources of self-definition as national identity, religious affiliation, and specific cultural rootedness, partly to perpetuate and aggrandize the apparatus that oversees the resulting dissolution. Burnham castigates this hypertrophied form of liberalism (what we might call "illiberal liberalism") as "an ideology of suicide" that has insinuated itself into the center of Western culture. He acknowledges that the proposition may sound hyperbolic. "Suicide," he notes, may seem "too emotive a term, too negative and 'bad.'" But it is part of the pathology that Burnham describes that such objections are "most often made most hotly by Westerners who hate their own civilization, readily excuse or even praise blows struck against it, and themselves lend a willing hand, frequently enough, to pulling it down." The issue, Burnham saw, is that modern liberalism has equipped us with an ethic too abstract and empty to inspire real commitment. Modern liberalism, he writes,

does not offer ordinary men compelling motives for personal suffering, sacrifice, and death. There is no tragic dimension in its picture of the good life. Men become willing to endure, sacrifice, and die for God, for family, king, honor, country, from a sense of absolute duty or an exalted vision of the meaning of history. . . .

And it is precisely these ideas and institutions that liberalism has criticized, attacked, and in part overthrown as superstitious, archaic, reactionary, and irrational. In their place liberalism proposes a set of pale and bloodless abstractions—pale and bloodless for the very reason that they have no roots in the past, in deep feeling and in suffering. Except for mercenaries, saints, and neurotics, no one is willing to sacrifice and die for progressive education, medicare, humanity in the abstract, the United Nations, and a ten percent rise in Social Security payments.

In his view, the primary function of liberalism was to "permit Western civilization to be reconciled to dissolution," to view weakness, failure, even collapse not as a defeat but "as the transition to a new and higher order in which Mankind as a whole joins in a universal civilization that has risen above the parochial distinctions, divisions, and discriminations of the past."

What has been called "populism" is a visceral reaction against these forces of dissolution.

Around the time that Donald Trump took office, his chief strategist Steve Bannon said that his goal was to "deconstruct the administrative state." The phrase "administrative state"—also called "the regulatory state" or "the deep state"—has lately floated into common parlance. In *The Administrative Threat*, the legal scholar Philip Hamburger describes it as "a state within a state," a sort of parallel legal and political structure populated by unelected bureaucrats. This amorphous congeries of agencies and regulations has become, Hamburger argues, "the dominant reality of American governance," intruding everywhere into economic and social life.

Article I of the Constitution vests all legislative power in Congress, just as Article III vests all judicial authority in the Court. The administrative state is a mechanism for circumventing both. As such, Hamburger argues, the administrative state operates outside the Constitution.

When the Constitution places all legislative powers in Congress, it gives Congress not only the power to make law but also the power to unmake it. And it thereby bars the executive from suspending or dispensing with the law. When the Constitution, moreover, places the judicial power in the courts and guarantees the due process of law, it precludes the executive from telling the courts not to apply the law, and prevents the courts from abandoning their own judgment about what the law requires.

Binding citizens not through Congressionally enacted statutes but through the edicts of the managerial bureaucracy, the administrative state is "all about the evasion of governance through law, including an evasion of constitutional processes and procedural rights." Accordingly, Hamburger concludes, the encroaching activity of the administrative state represents "the nation's preeminent threat to civil liberties."

Hamburger draws an analogy between the behavior of the administrative state and the behavior of such despotic monarchs as James I, Charles I, and James II. Instead of persuading Parliament to repeal or revise a statute, the British king simply evaded its force by decreeing that some or all of his subjects were not subject to its strictures. His power was absolute not merely in the sense that it was all but unlimited but also in the sense that it was independent or outside of the law. Students of Latin will recall the Ablative Absolute, a construction in which an ablative phrase is *absolutum*, "loosened" from or independent of the main clause of a sentence. Hamburger shows how the growth of the administrative state represents an extralegal "revival of absolute power" in this sense, one that threatens to transform Constitutional rights and guarantees into mere "options" that the government bestows or withholds at its pleasure. "The evasion," he notes, "thereby changes the very nature of procedural rights. Such rights traditionally were assurances against the government. Now they are but one of the choices for

government in its exercise of power. Though the government must respect these rights when it proceeds against Americans in court, it has the freedom to escape them by taking an administrative path."

Just as British kings in the seventeenth century evaded Parliament through such expedients as the Star Chamber and the exercise of royal prerogatives and royal waivers—what John Adams castigated as "those badges of domination called prerogatives"—so the administrative state today operates in violation of the Constitution and beyond the authority of Congress. Barack Obama decreed that certain politically unpalatable provisions of the Affordable Care Act not be enforced, and presto, they were not enforced, even though they were the law of the land. He instructed his Department of Justice to intervene to prevent Arizona and other states from enforcing certain aspects of immigration law. He even forced public institutions to accommodate self-declared "transgender" persons in the toilets of their choice; he connived with lawsuits punishing bakers and Catholic hospitals and hobby shops who chose not to join this week's politically correct campaign for the sexually exotic. The Constitution may have vested all legislative power in Congress and entrusted all judicial power to the courts, but the administrative state sidesteps those requirements by erecting a parallel bureaucratic structure of enforcement and control.

"Eighteenth-century Americans," Hamburger notes, "assumed that a rule could have the obligation of law only if it came from the constitutionally established legislature elected by the people." Today, Americans find their lives directed by a jumble of agencies far removed from the legislature and staffed by bureaucrats who make and enforce a vast network of rules that govern nearly every aspect of our lives.

One of the most disturbing aspects of Hamburger's analysis is the historical connection he exposes between the expansion of the franchise in the early twentieth century and the growth of admin-

istrative, that is to say, extra-legal, power. For the people in charge, equality of voting rights was one thing. They could live with that. But the tendency of newly enfranchised groups—the "bitter clingers" and "deplorables" of yore—to reject progressive initiatives was something else again. As Woodrow Wilson noted sadly, "The bulk of mankind is rigidly unphilosophical, and nowadays the bulk of mankind votes." What to do?

The solution was to shift real power out of elected bodies and into the hands of the right sort of people, enlightened people, progressive people, people, that is to say, like Woodrow Wilson. Thus Wilson welcomed the advent of administrative power as a counterweight to encroaching democratization. And thus it was, as Hamburger points out, that we have seen a transfer of legislative power to the "knowledge class," the managerial elite that James Burnham anatomized.

A closer look at the so-called "knowledge class" shows that what it knows best is how to preserve and extend its own privileges. Its activities are swaddled in do-gooder rhetoric about serving the public, looking after "the environment," helping the disadvantaged, etc., but what they chiefly excel at is consolidating their own power.

In *Thoughts on the Cause of the Present Discontents* (1770), Edmund Burke criticized the Court of George III for circumventing Parliament and establishing by stealth what amounted to a new regime of royal prerogative and influence-peddling. It was not as patent as the swaggering courts of James I or Charles I. George and his courtiers maintained the appearance of parliamentary supremacy. But a closer look showed that the system was corrupt. "It was soon discovered," Burke wrote with sly understatement, "that the forms of a free, and the ends of an arbitrary Government, were things not altogether incompatible." That discovery stands behind the growth of the administrative state. We still vote. We still have a bicameral legislature. But behind these *forms* of a free government, the essen-

tially undemocratic activities of an increasingly arbitrary and un-accountable regime pursue an expansionist agenda that threatens liberty in the most comprehensive way, by circumventing the law.

At the same time, however, a growing recognition of the totalitarian goals of the administrative state has fed what many have called a populist uprising here and in Europe. "Populist" is one word for the phenomenon. An reaffirmation of sovereignty, underwritten by a passion for freedom, is another, possibly more accurate, phrase.

CONTRIBUTORS

Conrad Black is a Canadian-born British peer, former publisher of *The London Daily Telegraph*, *The Spectator*, *The Chicago Sun-Times*, and *The Jerusalem Post*, and founder of Canada's *National Post*. He is a columnist and regular contributor to several publications, including the *National Review Online*, *The New Criterion*, *The National Interest*, *The New York Sun*, and the *National Post*. Lord Black is an experienced financier, was the head of the Argus and Hollinger corporate groups for many years, and remains active in this field in a number of private companies. He is a graduate of Carleton (Ottawa), Laval (Quebec), and McGill (Montreal) universities and is an accomplished historian with a prolific body of work. As an acclaimed author and biographer, Lord Black has published comprehensive histories of both Canada and the United States, as well as authoritative biographies of Maurice Duplessis and presidents Franklin D. Roosevelt and Richard Nixon.

Daniel Hannan is a writer and journalist. After seventeen years as a Member of the European Parliament, campaigning for British withdrawal from the EU, he succeeded in abolishing his job in the Brexit referendum on June 23, 2016. He is the author of nine books, including *New York Times* bestseller *Inventing Freedom: How the English-Speaking Peoples Made the Modern World* (Broadside Books, 2013) and the *Sunday Times* bestseller *Why Vote Leave* (Head of Zeus, 2016). His latest book is *What Next: How to get the best from Brexit* (Head of Zeus, 2016).

Victor Davis Hanson is the Martin and Illie Anderson Senior Fellow in classics and military history at the Hoover Institution, Stanford

University. He is a syndicated columnist for Tribune Media Services, writes a weekly column for *National Review*, and has written over twenty books on agrarian, military, and cultural history. Hanson has received the National Humanity Medal, the Bradley Prize, the Buckley Prize, and the Eric Breindel Award for opinion journalism. He is the fifth generation to live on his family farm in central California.

ROGER KIMBALL is Editor and Publisher of *The New Criterion* and President and Publisher of Encounter Books. He is a regular contributor to *American Greatness*, *PJ Media*, and many publications in the United Kingdom. Mr. Kimball lectures widely and has appeared on national radio and television programs as well as the BBC. Mr. Kimball's latest books include *The Fortunes of Permanence: Culture and Anarchy in an Age of Amnesia* (St. Augustine's Press, 2012), *The Rape of the Masters: How Political Correctness Sabotages Art* (Encounter Books, 2003), *Lives of the Mind: The Use and Abuse of Intelligence from Hegel to Wodehouse* (Ivan R. Dee, 2002), and *Art's Prospect: The Challenge of Tradition in an Age of Celebrity* (Ivan R. Dee, 2002).

ANDREW C. MCCARTHY is a senior fellow at National Review Institute and a contributing editor at *National Review*. He is a bestselling author whose most recent books are *Faithless Execution: Building the Political Case for Obama's Impeachment* (Encounter Books, 2014) and *Islam and Free Speech* (Encounter Broadside, 2015). He is a former chief assistant United States attorney best known for successfully prosecuting the "Blind Sheikh" jihadist cell that bombed the World Trade Center in 1993.

GEORGE H. NASH is author of *The Conservative Intellectual Movement in America Since 1945* (Basic Books, 1976) and *Reappraising the Right: The Past and Future of American Conservatism* (Intercollegiate Studies Institute, 2009). A historian, lecturer, and independent

scholar, he is the author of the first three volumes of a definitive, scholarly biography of Herbert Hoover and is the editor of two previously unseen Hoover memoirs. Dr. Nash holds a Ph.D. in history from Harvard University and is a Senior Fellow of the Russell Kirk Center for Cultural Renewal. He received the Richard M. Weaver Prize for Scholarly Letters in 2008.

JAMES PIERESON is a senior fellow at The Manhattan Institute and President of the William E. Simon Foundation. He is the author of several books, most recently *Shattered Consensus: The Rise and Decline of America's Postwar Political Order* (Encounter Books, 2015). He has written essays and reviews for many magazines and newspapers, including *The New Criterion, The Weekly Standard, Commentary, National Review, The Wall Street Journal,* and *The Washington Post.*

SIR ROGER SCRUTON is a writer and philosopher whose work has appeared in conservative publications on both sides of the Atlantic. His recent books include *The Ring of Truth: The Wisdom of Wagner's "Ring of the Nibelung"* (Allen Lane, 2016) and *The Disappeared* (Bloomsbury Reader, 2015), a novel about the "clash of civilizations." He lives in Malmesbury, England, and teaches a graduate course in philosophy for the University of Buckingham.

FRED SIEGEL is the author, most recently, of *The Revolt Against the Masses: How Liberalism Has Undermined the Middle Class* (Encounter Books, 2014) and *The Prince of the City: Giuliani, New York, and the Genius of American Life* (Encounter Books, 2005), which received the cover review in the *New York Times Book Review.* His previous book, *The Future Once Happened Here: New York, D.C., L.A., and the Fate of America's Big Cities* (Free Press, 1997), was named by Peter Jennings as one of the 100 most important books about the U.S. in the twentieth century. He has written widely on American and Eu-

ropean politics and was described as "the historian of the American city" in a November 2011 profile in *The Wall Street Journal*. The former editor of *City Journal*, he has written for the *Wall Street Journal*, the *New York Times*, *The Atlantic*, *Commentary*, *The New Republic*, *Dissent*, and many other publications. He has also appeared widely on TV and radio. A former senior fellow at the Progressive Policy Institute in Washington, D.C., Mr. Siegel is currently a scholar in residence at St. Francis College in Brooklyn and a senior fellow at the Manhattan Institute.

BARRY STRAUSS is a classicist, military historian, and leadership expert. He is the author of eight books, most recently, *The Death of Caesar: The Story of History's Most Famous Assassination* (Simon & Schuster, 2015), which has been hailed as "clear and compelling" by *TIME*, "brilliant" by *The Wall Street Journal*, "engrossing, exhaustive yet surprisingly easy to read" by *Barrons*, and "an absolutely marvelous read" by *The Times* of London. His books have been translated into eleven languages. He is Bryce and Edith M. Bowmar Professor of Humanistic Studies at Cornell University.

INDEX

Abedin, Huma, 148
Acemoğlu, Daron, 56
Acheson, Dean, 67
Adair, Douglas, 91
Adams, John, 187
Adams, John Quincy, 99, 157
Administrative state, populism's revolt against, 185–189
Administrative Threat, The (Hamburger), 185–188
Adorno, Theodor, 70
"Advice to My Country" (Madison), 95–96
Affordable Care Act (2010), 16, 77, 78, 79, 151, 187
Afghanistan, 141, 166
"After Germany's Conquest of the United States" (Mencken), 63
Agnew, Spiro, 14–15
AIG, 75
Alinsky, Saul, 105
Alter, Jonathan, 74
Alternative for Germany party, 18–19
Alternative Right (alt-right), 24–25
"America First" rhetoric: Trump and, 18, 118, 142, 181; World War II isolationists and, 11, 141
American Affairs, 24–25, 178
American Exceptionalism, youth's lack of knowledge about, 13–14
"American Greatness" website, 24–25

American Party (Know Nothings), 156–157
"Anger," used to describe populists, 174–175
Anti-communism: intellectual history of conservatism and, 4–5, 6, 7–8, 9, 10–11, 25; McCarthy and, 66–68
Anti-Intellectualism in America (Hofstadter), 72
Arab Spring, West's misinterpretation of, 99, 115–116
Aristotle, 35–36
Articles of Confederation, 86–89
Atlantic, 62–63
Authoritarian Personality, Frankfurt School and, 68–71
Autorität und Familie (Fromm), 68–69
Avaaz.org, 122

Bacon, Robert, 159
"Ballad for Americans, A" (Robeson), 65–66
Bannon, Stephen K., 21, 23, 24, 111, 185
Bell, Daniel, 70
Bimetallism, elections and, 158–159
"Bitter clingers," Obama's comments about, 175, 188
Black Lives Matter, 143
Blair, Tony, 49
Boehner, John, 79
Boren, James H., 177–178
Bouazizi, Mohamed, 115–116

Bradley Project on America's National Identity, 13

Brant, Irving, 86

Browning, Christopher, 173–174

Bryan, William Jennings, 14, 34, 45–46, 64, 72, 102–103, 158–159, 160

Buchanan, James, 156–157

Buchanan, Patrick, 11, 17–18

Buckley, William F. Jr., intellectual history of conservatism and, 5, 6–7, 8, 9, 14, 24

Burke, Edmund, 44, 57, 123, 131, 188

Burnham, James, 5, 177–179, 184–185, 188

Bush, George H. W., 164

Bush, George W., 12, 49, 99, 106, 116, 165–166, 168

Bush, Jeb, 136, 144, 146, 167

Calhoun, John C., 95

California, 100

Calomiris, Charles, 179

Cameron, David, 98, 129

Carney, Jay, 149

Carson, Ben, 137

Carter, Jimmy, 162–163

Cato (play), 26

Chambers, Whittaker, 4, 66, 67, 71

Change.org, 122

Chao, Elaine, 110, 154

Charter of Fundamental Rights and Freedoms, of European Union, 52

Chicago Council on Global Affairs, 112

Christie, Chris, 144

Cicero, mixed constitution of, 29, 31, 33, 36–38, 40

Civil War era elections, 155–158

Claremont Review of Books, 24–25, 76

Clay, Henry, 155, 158

Cleon, 33–34

Climate change, Trump and Paris Agreement, 111–115

Clinton, Hillary, 10, 12, 103; Clinton Foundation and, 165; "deplorables" comment and, 126, 150, 168, 175; election of 2016 and, 80, 99, 100, 107, 126, 147, 149, 150, 151, 152, 154–155, 168, 169; as secretary of state, 167

Clinton, William J., 12, 164–165, 169

Clinton Foundation, 165

Clodius, 31, 33

CNN, 174

Coates, Ta-Nehisi, 150–151

Cohn, Gary, 111

Cold War, Reagan and, 163

College campuses, free speech issues on, 179–180

Commentary, 7, 20

Compromise of 1850, 155–156, 157

Conscience of a Liberal, The (Krugman), 74

Conservatism, post–World War II intellectual history of: historical components, 1–9; post–Cold War tensions within, 9–12; Trumpism and, 17–25; twenty-first century trends and challenges of, 12–17, 25–26

Conservative Mind, The (Kirk), 3–4

Constitution, of U.S., 81–96; administrative state and, 185–186; Electoral College and presidential elections decided by states, 100–101; as impediment to populism, 83–84; Madison's

instincts toward democracy, majority rule, and factions, 84–96; modern critiques of, 82; opponents' use against Trump, 81–83, 84; Tea Party and, 74–79; Treaty Clause of, 113

Coolidge, Calvin, 160

Cooper, Anderson, 149

Coughlin, Father Charles, 14, 19, 66, 84, 135, 175

Coulter, Ann, 169

Cowley, Malcolm, 63

Credit crunch. *See* Great Recession of 2008

Cruz, Ted, 136, 144, 145, 146, 147, 155

Currie, Lauchlin, 67

Davis, John W., 160

Dawkins, Richard, 45

Dayton, Mark, 149

Debs, Eugene V., 160

Demagogues: administrative state and, 186; falsely associated with populism, 14, 33–34, 39–40, 41, 119, 173–175

Democracy: anti-populists and questioning of value of, 59–63; as "eulogistic" word, 171–172. *See also* Representative government

Democracy in America (Tocqueville), 95, 177–178

"Deplorables," 58, 143, 152, 175, 188; Hillary Clinton's comment about, 126, 150, 168, 175

DeVos, Betsy, 110

Dickerson, John, 149

Dionne, E. J., 74

Disquisition on Government, A (Calhoun), 95

Douglas, Stephen A., 35, 155

Dred Scott v Sanford, 155

Duggan, Larry, 67

Earnest, Josh, 149

Eclipse of Reason (Horkheimer), 69

Eisenhower, Dwight D., 161–162

Electoral College, 100–101, 139, 170

Elites, populares and populism and, 28–29, 32–33, 35–42

Engels, Friedrich, 69

Epstein, Joseph, 60

European Union, 43–57; extractive versus inclusive state and, 56–57; oligarchy and, 46–57; populism, scapegoating, and false influences of agency and intentionality, 45–46; role of government in, 131; sovereignty issues and, 176, 182–183; United Kingdom's vote to leave (Brexit), 48–50, 53–57, 83, 97, 98, 119–121, 127–130, 132, 134, 176; United States and democracy contrasted, 47, 49, 51–52, 57

Extractive state model, 56–57

Fannie Mae, 75

Farage, Nigel, 119, 132

Federalist Papers, 84, 85, 88, 89–90, 93, 171–172

Fillmore, Millard, 156

Fillon, François, 98

Fiorina, Carly, 137

First Things, 9

Fitzpatrick, Vincent, 63

Flynn, Michael, 110n

Ford, Gerald, 163

Foreign policy, Trump and, 141–142, 144–145, 146

France, 18–19, 98

Frankfurt School, Marxism and influence of, 68–74, 78, 80

Freddie Mac, 75

Free-market economics, intellectual history of conservatism and, 2. *See also* Trade and globalization

Fremont, John C., 156

French Revolution, 93

Friedman, Milton, 2

Fromm, Erich, 68–69

Fuller, J. F. C., 28

Fusionism: elections and, 155, 163; intellectual history of conservatism and, 6, 11, 12

German philosophy, and anti-populism, 58–80; Frankfurt School's influence, 68–74, 78, 80; left-wing origins of anti-populism, 63–65; Mencken and, 59–63, 80; right-wing populism, 65–68; Tea Party's constitutionalism and politicians' treatment of, 74–79; Trump and, 79–80

Germany, 98–99

Giffords, Gabby, 74–75

God Delusion, The (Dawkins), 45

Goldberg, Jonah, 102–103

Goldman Sachs, 75, 110–111

Goldwater, Barry, 7, 72–73, 164

Gracchus, Tiberius Sempronius, 27–30, 34, 36–37, 40, 42

Great Depression, 160–161

Great Recession of 2008, 16, 17, 75; disenchantment with politicians and, 49–50

Hamburger, Philip, 185–188

Hamilton, Alexander, 86, 87, 89–90, 94, 115

Harding, Warren Gamaliel, 160

Harrison, William Henry, 99

Hayek, Friedrich, 2–3, 180

Hayes, Rutherford B., 99

Hearst, William Randolph, 19

Heidegger, Martin, 69

Henninger, Daniel, 73–74, 77

Hiss, Alger, 67, 71

Hitler, Adolf, 69, 118, 120, 173–174

Hobson, Fred, 60

Hofstadter, Richard, 70, 71–74, 78

Hollande, François, 98

Hoover, Herbert, 160

Horkheimer, Max, 69

House Un-American Activities Committee, 66, 68

Housing bubble: Bush and, 166; Clinton and, 165

Hume, David, 91

"Idea of a Perfect Commonwealth, The" (Hume), 91

Ideas Have Consequences (Weaver), 3

Immigration: disenchantment with politicians in European Union and, 50–51, 53; Europe's wave of populism and, 98–99; illegal, and intellectual history of conservatism and, 12–13, 17; national identity and, 125–130, 133–134; populism and, 116–117; sovereignty issues and, 180–181; Trump and, 104, 140–141, 144, 146, 148, 180–181

Inclusive state model, 56–57

Internet: intellectual history of conservatism and, 10–11, 19–21;

speed of public opinion without thought, 121–123
Iran, 106–107
Iraq War, 49, 141, 165–167
ISIS/Islamic State, 106, 107, 117
Italy, 83, 97–98, 127, 130

Jackson, Andrew, 14, 19, 157, 170
Jefferson, Thomas, 86, 90, 93
"Jews & Europe, The" (Horkheimer), 69
Jindal, Bobby, 137
Johnson, Lyndon, 169–170

Kaepernick, Colin, 151
Kant, Immanuel, 181–183
Kazin, Alfred, 63
Kellogg-Briand Pact (1928), 182
Kelly, John, 109
Kelly, Megyn, 148
Kemp, Jack, 21
Kennedy, John F., 161
Kirk, Russell, 3–4
Kissinger, Henry, 167
Know Nothing Party, 156–157
Krauthammer, Charles, 10
Krein, Julius, 178
Kristol, Irving, 7
Krugman, Paul, 74–75
Kuwait, 164

La Follette, Robert, 58–59, 66, 160
Lamar, Kendrick, 151
Larson, Edward, 59
Latino politics, Trump and, 141, 142
Le Pen, Marine, 98, 119, 132
League of Nations, 182
Leave campaign, in United Kingdom, 49, 53–54

Lee, Mike, 107–109
Liberal Fascism (Goldberg), 102–103
Liberalism, primary function of, 185
Libertarianism, intellectual history of conservatism and, 2–3, 5–6, 7–8, 9, 25
Libya, 141
Lincoln, Abraham, 157–158
Lippmann, Walter, 64
Long, Huey, 14, 19, 84, 135, 175
Loughner, Jared, 74–75
Ludendorff, Erich, 62

Maastricht Treaty, 128
Macron, Emmanuel, 98
Madison, James, 171–172, 183; writing of U.S. Constitution and, 83, 84–96
Madison's Metronome: The Constitution, Majority Rule, and the Tempo of American Politics (Weiner), 86
"Mailed Fist and Its Prophet, The" (Mencken), 60–61
Mailer, Norman, 72
Majority rule, Madison and Constitution and, 83, 84–96
Managerial Revolution, The (Burnham), 177–179
Mattis, James, 109
May, Theresa, 98
McCain, John, 139, 148
McCarthy, Joseph, 14, 20, 66, 67–73
McConnell, Mitch, 79, 110, 146, 154
McKinley, William, 159
McMaster, H. R., 109
Mencken, H. L., 23, 59, 72, 80
Merkel, Angela, 98–99, 116, 130
Meyer, Frank, 6
Mill, John Stuart, 3–4

Mnuchin, Steven, 111
Mondale, Walter, 163
Monroe, James, 163
Morgan, John Pierpont, 159
Multiculturalism, intellectual history of conservatism and, 9, 13
Multinational corporations, disenchantment with politicians in European Union and, 54–55
Murray, Charles, 20–21
Musk, Elon, 111–112
Mussolini, Benito, 120

Nascia, Scipio, 30
National Front, in France, 18–19
National Review, intellectual history of conservatism and, 5, 6, 10, 18, 20
National security, Trump and, 106–107
NATO, 106, 107
Neoconservatism, intellectual history of conservatism and, 7–8, 9, 10, 11
"Never Trump" movement, 22–23
New York Times, 11, 64, 111, 174, 184
New Yorker, 81, 174
NGOs, disenchantment with politicians in European Union and, 54
Nietzsche, Friedrich, 59–62
Nixon, Richard, 14, 161, 162, 167
North American Free Trade Agreement, 105
Notes of the Debates in the Federal Convention (Madison), 90
Notes on Democracy (Mencken), 64

Obama, Barack H., 98, 100; administrative state and, 187; amnesty for immigrants, 134; "bitter clinger" comments, 175, 188; political Right and, 16; presidency of, 166–167, 168; Tea Party and, 74–79; Trump's policy differences with, 104, 105, 106, 107, 111–114, 118, 150–151; Trump's populism contrasted with, 140, 142–144, 152
Oligarchy, European Union and, 46–57
Optimates, in ancient Rome, 32–33, 37–40
Origins of the Family, Private Property and the State, The (Engels), 69

Packer, George, 74
Paleoconservatism, 11–12
Paranoid personality concept, 73–74
"Paranoid Style in American Politics, The" (Hofstadter), 73
Paris Agreement, on climate change, 111–115
Paul, Rand, 137
Pelosi, Nancy, 76–77
Perot, Ross, 17–18, 135, 164
"Perpetual Peace: A Philosophical Sketch" (Kant), 181–183
Perry, Rick, 110
Plutarch, 29
Podhoretz, Norman, 7
Poland, 129
Political correctness, Trump and, 142–143
Polk, James K., 156
Polybius, 27
Pompeo, Mike, 110
Popular Front, 65–66
"Popular Sovereignty," 35
Populares, in ancient Rome, 27–42; Cicero and mixed constitution,

29, 31, 33, 36–38, 40; elites and, 28–29, 32–33, 35–42; Gracchus and agrarian crisis, 27–31, 34, 36–37, 39, 40, 42; modern populism and, 31–36, 41–42

Popularity, populism contrasted, 120–121

Populism: defined, 172–173; democracy and, 171–172; disparaged in European Union, 43–44; election of Trump and, 97–100, 117–118, 154–155; electoral history of U.S., since 1850, 155–167; historical examples of movements, 84; Lee and "principled," 107–109; of Left and Right, 101–103, 135–136; liberal and conservative forms of, 14–15, 17; negative associations and, 173–175; as reaction to administrative state, 185–189; sovereignty issues and, 176–185, 189; stable democracies and, 153–154; twenty-first century surge in, 97–99; word used to delegitimize people and actions, 175–176

Potter, Stephen, 172

Price, Tom, 110

Priebus, Reince, 110

"Principled populism," 107–109

Pruitt, Scott, 110

Putin, Vladimir, 107, 111, 129

Public Interest, 7

Quintus, 37

Radical Right, The (Bell, ed.), 70, 71, 74

Reagan, Ronald, 15, 163–164; intellectual history of conservatism

and, 2, 9, 18, 24

Reforming Financial Regulation After Dodd-Frank (Calomiris), 179

Religious Right, intellectual history of conservatism and, 8–9

Remain campaign, in United Kingdom, 54, 56, 98

Remnick, David, 174

Reno, R. R., 184

Renzi, Matteo, 97–98, 130

Representative government, 119–134; internet technology and speed of decisions without thought, 121–123; liberal opinions of populism, 119–121, 132; need for understanding of "we" of national identity, 123–134

Reynolds, Glenn, 78

Rhodes, Ben, 148

Rice, Susan, 148–149

Road to Serfdom, The (Hayek), 2–3, 180

Robeson, Paul, 65–66

Robinson, James A., 56

Rome. *See* Populares, in ancient Rome

Romney, Mitt, 99–100, 104, 137, 139, 145

Roosevelt, Franklin, 4, 14, 19–20, 46, 161

Roosevelt, Theodore, 159–160, 167

Rousseau, Jean Jacques, 121

Rubio, Marco, 136, 144, 146, 147

Rules for Radicals (Alinsky), 105

Ryan, Paul, 3, 21, 146

Sanders, Bernie, 17, 112, 117, 135, 155, 173

Santayana, George, 63

Santelli, Rick, 76

Schengen, 53
Scope trial, Mencken and, 59, 64
Scotland, 127
Separation of powers, in U.S. Constitution, 82, 85, 90, 93–94, 109
September 11, 2001 attacks, 165
Sessions, Jeff, 109
Smith, Alfred E., 160
Sovereign debt crisis of 2010, 77
Sovereignty, populism and issues of, 176–185, 189
Soviet Union, penetration of American government, 66–68
Suicide, Western civilization and liberalism, 184
Summer for the Gods: The Scopes Trial and America's Continuing Debate over Science and Religion (Larson), 59
Syria, 106, 167

Taft, William Howard, 159
Taxation, in European Union, 56
Tea Party movement: constitutionalism and politicians' treatment of, 74–79; intellectual history of conservatism and, 15–17
Teachout, Terry, 60
Thoughts on the Cause of the Present Discontents (Burke), 188
Thus Spake Zarathustra (Nietzsche), 61, 62
Tillerson, Rex, 111
Tocqueville, Alexis de, 95, 115, 177–178
Tomasky, Michael, 76, 77
Trade and globalization: populism and, 102; sovereignty issues and, 183–184; Trump and, 19–21,

104–106, 137–140, 144, 146
Traditionalism, intellectual history of conservatism and, 3–4, 5–6, 7–8, 9, 11, 25
Trans-Pacific Partnership, 105, 115
Transparency International, 55
Trilling, Lionel, 66
Troubled Assets Relief Program, 75
Truman, Harry S, 161, 169
Trump, Donald: administrative appointments made by, 109–111; campaign against "Washington," 168–169; changing opinions and policies of, 103–105; climate change and Paris Agreement, 111–115; foreign policy and, 141–142, 144–145, 146; immigration and, 104, 140–141, 144, 146, 148, 180–181; intuition about and message of populism, 136, 142–152; liberals' reactions to victory of, 169–170; national security and, 106–107; opponents' use of Constitution against, 81–83, 84; political correctness and, 142–143; populism and election of 2016, 48–49, 79, 97–100, 117–118, 122, 130, 154–155, 160, 163, 167–170; trade and globalization and, 104–106, 137–140, 144, 146; Trumpism and intellectual history of conservatism and, 17–25

United Kingdom, Brexit vote to leave European Union, 48–50, 53–57, 83, 97, 98, 119–121, 127–130, 132, 134, 176
United Kingdom Independence Party, 18–19

Index

United Nations, 112, 113, 182

United States: democracy in, contrasted to European Union, 47, 51–52, 57, 79; electoral history since 1850, 155–167

Van Buren, Martin, 160

Vienna Convention on Treaties (1969), 114

Vietnam War, 162

Voegeli, William, 74, 76

Walker, Scott, 144

Wall Street Journal, 21

Wallace, George, 18, 135

Warren, Elizabeth, 135

Washington Post, 112, 174

Weaver, James, 159–160

Weaver, Richard, 3

"Webiscites," 121–123, 125, 134

Weekly Standard, 12, 20

Weiner, Anthony, 148

Weiner, Greg, 86

White, Harry Dexter, 67

"White Negro, The" (Mailer), 72

Why Nations Fail (Robinson and Acemoğlu), 56

Wilders, Geert, 119, 132

Will, George, 101

Williamson, Kevin D., 105

Wilson, Edmund, 63–64

Wilson, Woodrow, 160, 182, 188

World War I, Mencken's German sympathies, 58, 60–63

World War II, America First isolationism and, 11, 141